THE LIBR

GV
1785.
C53
M53

Violette Editions

Edited by
Suzanne Cotter and Robert Violette

Editorial adviser for Michael Clark Company
Ellen van Schuylenburch

Essays by
Michael Bracewell, Suzanne Cotter and Stephanie Jordan

Interviews, texts, photographs and other contributions from
Richard Alston, Karole Armitage, Charles Atlas,
Mikhail Baryshnikov, Christine Binnie, Val Bourne, Julian Broad, Leslie Bryant,
Henrietta Butler, Michael Clark, Dee Conway, Kate Coyne, Gaultier Deblonde,
Ravi Deepres, Peter Doig, Sophie Fiennes, Malcolm Garrett, Bruce Gilbert,
Richard Glasstone, Hugo Glendinning, David Gothard, David Gwinnutt,
Chris Harris, Matthew Hawkins, Richard Haughton, Melissa Hetherington,
Jeffrey Hinton, David Holah, Nick Knight, Thomas Krygier, David LaChapelle,
Laurie Lewis, Sarah Lucas, Judith Mackrell, Tony McCann, Chris Nash,
Nigel Norrington, Lorcan O'Neill, Jann Parry, Grayson Perry, Jane Quinn, Pierre Rutchi,
Steven Scott, Michael Stannard, Andrea Stappert, Susan Stenger,
Stevie Stewart, Ellen van Schuylenburch, Arabella Stanger, Wolfgang Tillmans,
Alan Tittmuss, Jake Walters, Fred Whisker, Darryl Williams,
Simon Williams and Cerith Wyn Evans

MICHAEL CLARK

Contents...

Editors' Note 17
Suzanne Cotter & Robert Violette

Suzanne Cotter 21
Originality. Repeated.

Val Bourne 30
David Gothard 33
Jane Quinn 35

New Puritans 38
Do you me? I Did 50

David Holah & Stevie Stewart 54
Jeffrey Hinton 59
Steven Scott 61

not H.AIR 64
our caca phoney H.our caca phoney H. 70
Hail the New Puritan 80
A film by Charles Atlas

Michael Bracewell 90
An Evening of Fun in the Metropolis of Your Dreams

Charles Atlas 100
Cerith Wyn Evans 103
Christine Binnie 111
Grayson Perry 112
Lorcan O'Neill 115
Sophie Fiennes 117
Sarah Lucas 122
Michael Clark on Leigh Bowery 124
Peter Doig 126

No Fire Escape in Hell 128
Because We Must 138
I Am Curious, Orange 148
Because We Must 162
A film by Charles Atlas

...continued

Bruce Gilbert 168
Susan Stenger 171

Heterospective 174
mmm... 180
O 196

Jann Parry 208
Richard Glasstone 211
Richard Alston 214
Karole Armitage 218
Mikhail Baryshnikov 221

current/SEE 222
Before and After: The Fall 226
OH MY GODDESS 232

Stephanie Jordan 239
Michael Clark: **Stravinsky Project**

Stravinsky Project
Part I: O 256
Part II: mmm... 266
Part III: I Do 280

Judith Mackrell 296
Matthew Hawkins, *Member of the Thinking* 298
Leslie Bryant 309
Kate Coyne, Melissa Hetherington, Simon Williams 312
Ellen van Schuylenburch 320

come, been and gone 324

Chronology of Works 333
Arabella Stanger

Portraits of Michael Clark
pages 1–11

1–2
Of a feather, FLOCK, 1983.
P: Chris Harris.

3–4
Parts I–IV, 1983.
P: Chris Harris.

5
New Puritans, 1984.
P: Richard Haughton.

6
I Am Curious, Orange, 1988.
P: Richard Haughton.

7
mmm..., 1992.
P: Pierre Rutchi.

8–9
mmm..., 1992.
P: Hugo Glendinning.

10–11
come, been and gone, 2009.
P: Jake Walters.

Editors' Note
Suzanne Cotter & Robert Violette

In 2003, the critical art journal **Afterall** profiled the work of Michael Clark, commissioning an essay by the author of the introduction to this book (and one of its editors). It became immediately apparent to the author that a coherent overview and critical discussion of Clark's oeuvre was greatly needed. This led initially to the idea of revisiting the spaces of Modern Art Oxford, where Clark had performed in 1984, a conversation overtaken by Clark's appointment as Artistic Associate by the Barbican Centre, London, out of which came the **Stravinsky Project**.

It transpired that the impetus to make this book reaches even further back, to 1998, to conversations between Clark and the publisher at the time that Violette Editions produced a monograph on Leigh Bowery, in which Clark wrote an important tribute to his late friend and collaborator. The publisher had also encountered both Clark and Bowery during his eight years of editing publications at the Anthony d'Offay Gallery in London, beginning with these artists' separate performances there in 1988 and 1989.

In 2007, aware of each other's work and keen mutual interest in Clark, and encouraged by Greg Hilty and Michael Bracewell, we decided to combine our curatorial and editorial experience to make a comprehensive publication.

Over the last four years an enormous effort has been made to collect the available photography and documentation on Clark — much of which had been thought lost — and to interview Clark's principal collaborators and associates, who have contributed invaluably to this book. They have afforded us a privileged view not only of the artist and his work, but also of a period of a truly British avant-garde, and we are immensely grateful for their cooperation. Now, in this volume, the totality of Clark's creative output to date can be considered retrospectively and in a manner that we hope throws light on an extraordinary career that extends beyond dance and choreography to encompass music, fashion and the visual arts.

This book was made under the generous and arm's-length guidance of Michael Clark himself. We remain deeply grateful for his patient and gracious collaboration. At the epicentre of our research was Ellen van Schuylenburch, who, as a fellow performer, assistant and friend to Clark since the early 1980s, has shared her unsurpassed knowledge of his work. We owe to them both a debt of gratitude that is impossible to express adequately, for their help in assuring this publication's authority. Our thanks also extend to the board of the Michael Clark Company and to its dedicated office staff for their enthusiastic support of this project.

This book consists of three essays, numerous texts based on interviews as well as hundreds of images spanning more than 30 years. The essays tackle individually three aspects of Clark: his position as an artist, his social context and his choreography. Interviews with Clark's collaborators and peers from the 1980s to the present are organised according to the nature of the connection: cultural agents; costume and production designers; musicians; visual artists; choreographers and dance experts; and, finally, dancers. The original tone of these interviews has been preserved.

Wordplay has always fascinated Clark, and the titles of his works have often made use of puns, unconventional spellings and irregular capital letters. This book remains faithful throughout to the manner of Clark's titling. Additionally, with Clark, we have inserted into these pages adaptations of images previously used in stage projections or in programmes and other printed matter that he has originated.

For the stunning images in this book that record Clark's work since the early 1980s, we would like to express our grateful thanks to the photographers. We would also like to extend special thanks to the following individuals: Sadie Coles, Greg Hilty, Karole Armitage, Charles Atlas, Mikhail Baryshnikov, Val Bourne, Holly Conneely, Sophie Fiennes, Richard Glasstone, Hugo Glendinning, the late Chris Harris, Matthew Hawkins, Branislav Henselman, Richard Houghton, Stephanie Jordan, Studio Frith (Frith Kerr, Amy Preston, Nora Dorhmann), Jenna Lambie Ridgway, Roy Luxford, Stanford Makishi, Mike Markiewicz, Charles McDonald, Andrew Nairne, Chris Nash, Jane Quinn, Josephine Rodrigues, Wolfgang Tillmans, Jake Walters and Cerith Wyn Evans.

Too

Soon

Michael Clark, 1990, during the tour for **Because We Must**, Parco Department Store Theater (Tokyo International Theater Festival). P: Courtesy Michael Clark Company.

Suzanne Cotter
Originality. Repeated.

mc is an artist.
This is the highest compliment I could pay him as a dancer
and I've thought long and hard about it.

Guy Mannes Abbott, programme notes, **Before and After: The Fall**

Avant-garde is the term that comes to mind when describing choreographer Michael Clark. An extraordinary talent and cultural icon, his performances have provoked euphoria, outrage and obsessive fascination. In the 1980s, he affected something of a seismic shift in the culturally elite world of classical ballet in which he trained, transposing onto it the underground culture of music and fashion that has come to define the period. Visually sumptuous, the sets, costume designs and company of collaborative creators brought together by Clark tested, if not exploded, the limits of ballet's canon in a high-volume, ecstatic flow of energy. To attend a Michael Clark performance was an event, provocative and electrifying. Music was loud and dance was BIG. If the dance world followed his progress with a certain nervous exhilaration, compelled by his gift as a dancer yet sceptical of the extravagant transgressions that were his stage productions, a broader public that spanned the pop and experimental art world became avid followers.

With his retirement from the public eye during the second half of the 1990s, Clark seemed to embody the figure of the Romantic artist, a fated prodigy consumed by his own work at a young age. His five-year absence also caused a generational lapse between those who had experienced a Michael Clark performance and those who had not. With his return to performing towards the end of the decade, Clark's trajectory as an artist has proved unfalteringly radical. He has continued to develop ever new choreographic works, a process that has involved absorbing and confronting history, his own and that of classical dance's modernity, all the while responding to new imperatives and possibilities to create.

From his earliest works, **Of a feather**, **FLOCK**, **Parts I–IV**, **Do you me? I Did**, through to the visually sumptuous **No Fire Escape in Hell** and **I Am Curious, Orange** with Mark E. Smith and The Fall, Clark revealed both his choreographic talent and what has been described as 'his instinctual understanding of dance as a profoundly visual art'. Over the more than 25 years that he has been making work, his range has been consistently impressive, from the insistent punk aesthetic of **New Puritans** and the post-punk minimalism of **current/SEE** and **Satie Stud**, to the modernism of **mmm…**, the classicism of **Swamp** and **O**, and the charged melancholy of **come, been and gone**, fast becoming recognised as a masterwork within his repertoire.

Clark's productions offer a *Gesamtkunstwerk* of sensory complexity, in which movement, sound, lighting and design (of costume and sets), in multiple media, form striking and richly textured visual and spatial compositions. Yet Clark is also capable of producing intimate works, in which the viewer shares the space of the dancers, such as those he has conceived

for art galleries, usually at the request of close artist friends. In recent years, Clark has begun to realise his ambition to create an open studio environment, in which an untrained public can witness, if not enter into, certain stages of the choreographic process. In each situation, the form of address and the impact of the performance assume different perceptual conditions.

The sophistication and the subtlety of Clark's variations on a choreographic theme, often revisited over time, are accompanied by an equal ability to inhabit music, and, by extension, the use of language, rendering it in both a physical and visual form. Musician Susan Stenger has remarked on the experience of working on **current/SEE** as Clark 'making the sound visible'. Clark's intuitive synaesthesia is coupled with a trained dancer's internalised sense of time in the immediacy and ephemeral nature of performance, as bodies carry out their movements according to, or against, a structure of beats, and in its enduring as a physically internalised experience, through the repetition of movements from rehearsal to rehearsal, and from performance to performance. This understanding of music's physical as well as emotional qualities, in its relationship to duration and to the physical dimensions of space, and in its ability to transport an audience into a realm of shared experience, has been a defining quality of his work.

Clark's conception of a work also extends beyond the performance proper, reflecting his visual, aural and linguistically playful sensibility, in the programme design and content through to the experience of the audience in a particular venue or setting. The rock concert-like mood of anticipation before a performance is generated as much by Clark's choice of music or cinematic prelude – David Bowie or Lou Reed, or the screening of archival footage of Stravinsky conducting – as the audience he attracts. Intermission is a fluid space of events like the filmed performance of the Krautrock group Can screened between the parts of **OH MY GODDESS** – or a choreographed interlude in which Clark performs a solo of startling vulnerability to Bowie's 'Afterall' in **come, been and gone**.

With an entrepreneurial and creative flair that is often compared with Diaghilev's Ballets Russes, Clark's collaborations with visual artists, fashion designers, composers and musicians have been a fundamental part of his work since he was first invited in 1981 by David Gothard to become choreographer-in-residence at London's Riverside Studios, which at the time was proving a laboratory for crossover between performance, art and dance. Nourished by his classical training at The Royal Ballet School, the creative ferment of Riverside proved richly fertile for Clark, who used this former BBC television studio as a live–work space. Gothard has described the atmosphere of focus and delightful serendipity of those days, where, amongst others, artist Bruce McLean and architect Will Alsop were in residence, aspiring novelist Hanif Kureishi worked as a secretary and Samuel Beckett directed his plays in the theatre.

At Riverside, Clark attracted a growing circle of young artists and innovators of the underground art and music scene, among them Cerith Wyn Evans, a protégé of Derek Jarman and then student at the Royal College of Art, Charles Atlas, the Neo Naturists, of whom artist Grayson Perry was an incidental member, Trojan and Leigh Bowery. His nascent company of dancers from diverse dance backgrounds and physiques included the classically and Cunningham-trained Ellen van Schuylenburch, Matthew Hawkins, who had been a

Michael Clark in rehearsal
for **O**, 1994. P: Alan Tittmuss.

dancer with the Royal Ballet, and Gaby Agis, coming from the release-centred techniques of modern dance, a reflection of Clark's experimentation with different types of trained bodies.

Clark's collaborators, who would go on to include the rising design team David Holah and Stevie Stewart of Bodymap, the graphic designer Jamie Reid, and musicians including Mark E. Smith and Bruce Gilbert from Wire, informed Clark's visual and spatial aesthetic. Describing the process, Clark has said:

> *I know in the early days, although I was working with people who were great friends, I was respectful of their decisions and what they wanted to do. I wasn't always comfortable, but I was quite strict with myself. What I knew about design and theatre and dance was that the group or director would have someone come in to please them. I didn't want that.*

London's burgeoning underground club culture also offered an active agent. Clark orchestrated his own club nights, announced on samizdat-like flyers, produced with the simplest of graphic means on cheap quality photocopy paper and distributed after his performances. It was his attraction to and ability to absorb into his work both the popular and subversive culture of 1980s post-punk and high camp that was to become a defining and influential aspect of his productions at which the mandarins of Britain's 'high arts' would rub shoulders with a burgeoning and eclectic bohemia of rock stars, artists and musicians, many of whom, according to the critics, 'had never seen dance outside of a club or disco'.

Together with the absorption into his work of this cultural and critical moment, Clark's experience of modern and contemporary dance with Richard Alston, the redefining of dance's relation to chance and music in the work of Merce Cunningham and John Cage, with whom he studied in the summer of 1981, and Karole Armitage, with whom he danced in New York and at Riverside, was influential. His knowledge of the Judson Church Theater and the work of Yvonne Rainer and Trisha Brown, and their democratisation of movement through the use of 'found' actions taken from daily life, and their performances in spaces

Michael Clark, 1998. P: Wolfgang Tillmans.

other than the proscenium theatre, in gymnasiums, in parks, on top of buildings, also offered a young Clark a rich landscape from which to reflect and draw ideas.

Clark's originality was in his desire to make aspects of this history relevant to his own specific circumstances. Van Schuylenburch recalls Clark taking the title of **Do you me? I Did** from the black-and-white catalogue of Rainer's work from 1970, in which notation takes the form of texts. If his choice of music, from Iggy Pop and the Sex Pistols to The Fall and Laibach, and his use of unconventional spaces for his rehearsals and performances – Regent's Park, working men's clubs, the Haçienda, Brixton Academy – owed something of a debt to the cross-disciplinary approach to performance in the 1960s and early 1970s, Clark subverted and invigorated the stony-faced mantra of 'no to spectacle, to comedy, to narrative, no to virtuosity' with an exuberant flaunting of cultural mores that challenged the sexual and political conservatisms of the day. His productions provided charged spectacle, his choreography expressed dimensions of life lived in its most instinctual, highlighting relationships between the individual and the group, sexuality and play, qualities that performance curator Catherine Wood has identified in terms of 'Clark's intuitive understanding of ballet's origins in pagan ritual and dance as a drive'.

The explicit sexuality of Clark's earlier staged works, in which prosthetic dildos and vaginas, bare bottoms and a cross-dressing androgyny were bawdily celebrated, evolved in the early 1990s with Clark's interpretation of Stravinsky's canonical works, **The Rite of Spring** and **Apollo**. Clark's versions, respectively, **mmm...** and **O**, the latter title a reference to Anne Desclos' erotic 1954 novella **The Story of O**. In what would be the beginnings of the three-part **Stravinsky Project** in the 2000s, Clark's renewed dialogue with the classical and modernist tradition of Stravinsky reflect both a desire to focus attention on his choreography and a steady defiance of expectation. It also revealed Clark's ambition to situate his work within a certain avant-garde trajectory. **mmm...**, staged in an empty depot behind London's Kings Cross, fulfilled the Dionysian excess that had come to be equated with a Michael Clark production, including Clark dancing in a toilet-bowl costume designed by Bowery, his mother, Bessie, topless on stage, and a semi-naked Joanna Barrett as the sacrificial virgin, sporting a Hitler moustache and dancing her ecstatic solo in confrontational frontality at the stage's edge. His production of **O** at the Brixton Academy in 1994 – alongside high drama moments such as Clark, as Apollo, being born on stage to Bessie herself – revealed a more refined paring down of his lush visuality to privilege an emphasis on movement and form.

Underpinning Clark's artistic project has been a necessarily productive and reflexive dialogue with classical dance, or, as he describes it, breaking rules 'by understanding them from the inside'. Naturally open and stimulated by experimentation, in dance as well as in art and music, his drive to express a language that would resonate with the world as it is seems always to have been a primary motivation:

> *Sometimes I think that choreography is like creating an ideal world on stage, because there isn't one, it's a kind of ordering. I can't really do that because that would be dishonest. But it can be a wonderful thing to see. I'm not saying that work has to reflect reality, but you have to acknowledge that things aren't all perfection and harmony.*

In Clark's art of wilful dissonance, harmony is but a tantalising moment of suspense within a spectrum of anti-positions. One only has to view 1980s television clips of Clark, in floating costume, languidly performing the most classical of movements to T.Rex's Marc Bolan singing 'Cosmic Dancer' to appreciate the compelling disruptiveness of his work. In an interview with the painter Elizabeth Peyton, Clark reflected on his use of punk music from Iggy Pop and the Sex Pistols:

Punk struck a chord. It seemed the opposite of the quest for beauty.

Reminiscent of Picasso's tireless explorations of the human figure, Clark's use of classical movement has incorporated the expressive use of the body, inspired by the classical Cecchetti technique, with movements of the untrained dancer, Leigh Bowery, David Holah and his mother Bessie, among them. His choreography embodies exquisite poise at each moment threatened by physical collapse, in which the staged precision of classical form is subject to loss of control and spectacular flaunting of convention. Dance critic Jann Parry observed: 'No-one could combine the same paradoxical elements of beauty and brutality, order and anarchy, vulgarity and serenity'. He has appropriated the language of ballet – the pantomime, the solo, the tutu-wearing ballerina – subverting their traditionally gendered roles and role-playing with gleeful transgression. The horizontal and the floor are privileged over the vertical. And the vertical is contorted into a held moment of maximum tension before releasing into a fluid *enchaînement* with another body. The dancers are as objects, composed in time and space, or propelled as corporeal vectors. Cutting through this intensity are finely timed notes of mischief. Clark blindfolds his dancers turning them on point in a giddy pirhouette, or, at the maximum intensity of a choreographed moment for his company of dancers, runs across a stage spurting water, a reference to the artist Bruce Nauman, referencing Marcel Duchamp, as **Fountain**.

Costumes and props have also defined a compensatory form of movement, underpinned by Clark's subtle insertion of social narratives. In **I Am Curious, Orange**, a collaboration with Mark E. Smith and The Fall, dancers shared the stage with the band. Clark, resplendant in brocaded jacket, dancing on crutches, and dancers perform a choreographed football match on stage in reference to the accession to the English throne of the Protestant William of Orange, translated by way of the contemporary sectarianism of the Scottish football teams Rangers and Celtic. For **I Do**, Clark's interpretation of Bronislava Nijinska's **Les Noces** as the third part of his **Stravinsky Project**, the dancers shared the stage with choral singers. As if to suggest the containment of her future life, Kate Coyne, as the bride, was confined to a position of precarious balance, *en pointe* with shoulders wrapped in a sumptuous, egg-shaped knitted cape designed by Stevie Stewart, after a 1965 Yves Saint Laurent wedding dress inspired by Russian Babushka dolls. As in so much of Clark's oeuvre, movement and image are allied in a suite of narrative registers that shift and concatenate, from one sequence to the next.

During an age in which culture is defined by marketing demographics, in which choreographers, musicians and artists are brought together with a view to the blockbuster spectacle that makes for guaranteed box office appeal, audiences are often left in a desultory state of wanting. Within this perspective of the palatably *outré*, the influence of Clark would

A presentation by Michael Clark Company, with volunteer non-dancers, at the end of a research and development residency at Tate Modern, August 2010. P: Hugo Glendinning.

seem to have been assimilated – one wonders whether a younger generation enthralled by contemporary Pop diva Lady Gaga recognise the debt to Clark's aesthetic – although never paralleled. While assured a place in the pantheon of dancer/choreographers that make up a history of post-modern British dance, it is in the realms of the visual art world that his significance has come to be increasingly recognised.

Given the history of modern art, Clark's work reflects signature elements of avant-garde practice – live performance and the ephemeral event, the mixing of media across artistic disciplines, his use of the found and the crafted, a discordant seduction. Already in the early 1980s, at Riverside and performing in Britain's original *Kunsthallen*, MOMA Oxford and Arnolfini, Bristol, Clark was something of an acknowledged presence. His performance **Heterospective**, with Stephen Petronio, Russell Maliphant, Leigh Bowery and Pearl, at Anthony d'Offay's Dering Street gallery in 1989, and an invitation extended, although not taken up, to be part of the British Art Show the following year, signalled an acknowledgement of Clark's cultural position. Over the past decade, Clark's post-punk underground status, his highly visual approach to performance and his history of collaborations with musicians, film-makers and artists has resonated within an increasingly pluridisciplinary – or 'post-disciplinary' – visual art practice and curatorship, and a coincidental revisiting of seminal moments in performance since the 1960s. While no stranger in the early 2000s to the pages

of **Vogue** and **Tatler**, in 2008, following his presentation of **Stravinsky Project** at the Rose Theater at New York's Lincoln Center, Clark was the subject of a 16-page exposition and art-historical analysis in the equally glossy but critically respected **Artforum**.

Behind this historicising project and attention is the simple recognition of Clark as an artist of significant influence, who continues to explore the possibilities and limits of his medium to increasingly generative effect. He has continued to collaborate with musicians, designers and contemporary artists including Angela Bulloch (as a guitarist in Susan Stenger's bass guitar band Big Bottom), Sarah Lucas and, most recently, the painter Peter Doig, conceiving his choreography in ever more sophisticated perceptual and experiential dimensions. At the time of writing this text, Clark has been leading an open studio over a period of several weeks with 100 members of the public in Tate Modern's vast Turbine Hall, developing a new work that will be presented in its spaces in 2011.

Even with the most detailed of documentation, from choreographic notation to drawings and photographic records of costume and set designs, the essentially ephemeral nature of dance defies capture. As a medium and a form, it is infinitely live, transmitted through interpretation and reinterpretation. Clark applies this process to his own repertory of work – a repertory of such conceptual and choreographic richness that one could become lost in the attempt to translate a single work through mere description – such that earlier choreographies reappear, recast or develop in new works, themselves subject to developments and additions over the course of a single season. With Clark, the tension between originality and repetition, not only with respect to the canon of classical ballet but also to the work and its repetition through performance, is like so many of Warhol's screen-prints of Liz Taylor or the Mona Lisa, so many versions in transformation, just as he has described his dancers in earlier works as 'the original flower that is imprinted and printed again and again'.

The revisiting of a work and its conceptualisation into an expressive lexicon of possibility is recognisable to anyone familiar with the methodologies of the visual artist. Clark has often been described as a perfectionist, which is undoubtedly true. However, it is equally relevant to consider his artistic experimentation and process as an underlying force. His collaborations, his continued exploration of 'the live' as a medium – be it through film, music, concepts of entertainment and the theatrical or the mutability of the performance itself from one night to the next – all point to the expanded plasticity with which he approaches his work. Each reiteration bears the mark of a new shade and texture and a new chapter, such that the work is always presented anew. This pursuit and sustained challenging of expectation is a hard-won freedom, but one that Michael Clark, the artist, continues to exercise, completely and with undeniable consequence.

Michael Clark and Otto, 1998. P: Wolfgang Tillmans.

Val Bourne

The first time I saw Michael on stage was in Leicester, at the now-demolished Haymarket Theatre; the company was Rambert. It was a piece by Richard Alston, **Bell High**, and this extraordinary boy was in it – I think he was still a teenager. He had just joined Rambert, having been at the Royal Ballet School. He was quite extraordinary, and unbelievably gifted. Everyone was saying: 'Who is this gorgeous creature?'

It wasn't long afterwards that he was invited to be in residence at Riverside, which had just recently opened. He was growing restless, I think, and probably perceived Rambert as part of the establishment – which, to a degree, it was. Riverside offered him the possibility of being choreographer-in-residence. While David Gothard was at Riverside it was really a hub of activity; because Dance Umbrella was based there, it was possible to see just about the best of contemporary performance without ever having to leave the building. It was fantastic. And so Michael, at a young age, became artist-in-residence at Riverside, with the opportunity to make and show work there.

It was very unusual for an individual to be making work like that without having served more time with one of the larger or smaller companies. Michael did some incredible work under the guidance and patronage of Peter Gill, director at Riverside, and David Gothard, who was his associate and programmer. David introduced Michael to a lot of artists he thought he should meet (not necessarily dance people), and of course Michael had an inquisitive mind. That was an exciting time. He was working with people like Gaby Agis and Leslie Bryant, and David Holah and Stevie Stewart would certainly have been around.

Dance Umbrella was launched in 1978, when I was dance officer at Greater London Arts, and the first two festivals happened under their auspices. Imagine it: I was doing a full-time job as well as running a festival with Nicholas Hooton and David Gothard from Riverside, and Jan Murray from **Time Out**. Jeremy Rees, from the Arnolfini in Bristol, was also on the board. We just did it, and Greater London Arts and the Arts Council pretty well paid for it. But after the first two festivals they realised that their operating costs had doubled, and we were sort of evicted. It was a fantastic time, and Michael was so original. Even people with a classical pedigree could recognise Michael's undoubted virtuosity. It was a way in for them, a way to watch very innovative contemporary ideas, because they couldn't ignore them.

A lot of people equated contemporary dance with Isadora Duncan expressing herself without any technique or whatever, so it was easy to be dismissive. But with Michael you couldn't, because the technique was there. It was a bit like Picasso, who could draw and decided not to use it. For him it was a choice not to use the technique, which sometimes it isn't. I think it's like seeing a very fast car cruising.

I think Michael was what the French call *branché* – really plugged in to contemporary culture – which a lot of people were not. Someone like Wayne McGregor is plugged in to culture as it is now – although he's into different things like neurology or technology, it's of his time – and Michael was plugged in to what was then, his time, when a lot of dancers were cocooned in their classrooms. I can speak from my own experience at the Royal Ballet School. I don't know how Michael ever found the time to do anything else. When we were students we would get there at 8.30 in the morning and be working in the theatre three or four nights a week, in opera or in dance. We got out at 11.30 at night and then had to show up first thing next morning, so it was difficult not to be immersed in what you did – I'm one of the ones who really doesn't remember the 1960s, and I wasn't even taking drugs.

Michael wasn't, however, the only one that was doing something completely different. For example, the very first choreographer to be associated with Riverside was Rosemary Butcher, who had been in the States and was brought into Riverside by Peter Gill to work with actors. One of the reasons he chose her was because she was working in trainers, so she was prepared to work on a concrete floor – most dancers wouldn't set foot on it. So there were other people following different paths, but Michael was almost theatrical in some ways; he was flamboyant and unafraid. There was a group called the Neo Naturists and we all looked at them and thought, My God! Michael's eye lit on many things.

He was working a lot with Cerith Wyn Evans, doing video and all kinds of things that not many people were doing at all. I remember seeing extraordinary things in Riverside; television sets and clunky technology – it wasn't portable in the same way than it is now. But it was a huge amount of fun. Earlier, Richard Alston had made **Soda Lake** for Michael so when Rambert was performing at Riverside in Studio 1, he decided to show **Soda Lake** in Studio 2. It was short but absolutely exquisite. It featured a Nigel Hall

sculpture that looked like a disembodied basketball net with a single pole and a circle. All you could see was a halo, whichever way you looked at it, either above or in its reflection on the floor. There was something about Michael's extreme youth set against the coldness of the sculpture – the pole and the circle and this very vulnerable young man. It was implacable in a sense; it was heart-stopping.

Michael brought a whole new audience to dance, and in that sense he has something in common with Merce Cunningham. In Merce's case it was originally visual artists and theatre people that came to see his work, and in Michael's case it was visual artists, music people and film-makers. That element of it was different; even now, when you see Michael and his company at the Barbican or at Sadler's Wells, it's not the usual dance audience. I like that fact. It's a bit depressing to see the same people all the time.

Michael has never been frightened of big stages, and he has a very good spatial sense. Sometimes you see him pacing the stage at the Barbican, and realise he's trying to get the measure of it. He's always had a clear idea of what he wants to do. **Stravinsky Project** was very bold, because he was inviting comparison with highly regarded productions such as Balanchine's **Apollo**, Nijinska's **Les Noces** and Pina Bausch's **Rite of Spring**, and putting himself on the line. People are very conservative and the critics were absolutely divided. But there were all these other people who wouldn't have gone to a Stravinsky programme but Michael showed them a way into it that they could relate to and understand without feeling excluded.

In the early days, Erica Bolton and Jane Quinn also worked at Riverside, and were Dance Umbrella's publicists when Riverside was our main base of operation. Chris Harris was our graphic designer and Steve Scott was the technical manager. It was a tight-knit community and a very creative place. Erica and Jane subsequently became Michael's managers, so all the big productions – the ones presented at Sadler's Wells – were under their auspices. After a while, Michael didn't really need Dance Umbrella; he could survive independently. The company were touring all over the world. Michael was at the height of his popularity, and because of their knowledge of marketing, Erica and Jane made him an international star. He was flying very high, Icarus-like, and got burned, badly.

After his sabbatical in the 1990s, Michael got in touch and we made a decision to support him at Dance Umbrella. We organised the first tour, and Alex Poots came in to manage the Roundhouse project. I think that the work Michael is making now is just as important as what he made before. Even more importantly, people aren't going on about the fact that Michael isn't dancing. For a dancer/choreographer, that is such a difficult transition to make. The better you are as a dancer, the harder it's going to be.

I think Michael's has been an incredible journey, that in some way parallels the development of contemporary dance in this country. Although he wasn't there right at the beginning (which would have been in the mid- to late 1960s, when London Contemporary Dance Company was launched and Rambert made the transition from classical to contemporary), it's not been very long when you think about it – Michael began 10 years into it. The thinking then was that contemporary dance was very much the preserve of young people and that by the time they reached 40 they would see the light and realise that classical ballet was the real thing. But it's certainly grown up now: in the last Dance Umbrella I directed, most of the choreographers were in their 50s. There are so many different strands to it now. In the beginning, British choreographers were either graduates of London Contemporary Dance School or Dartington College of Arts. Now there are many, many different influences, through which Michael has woven his own individual and uncompromising contribution. It would have been much easier for him to have remained within the establishment, but that was never going to be Michael's route.

Interview by Suzanne Cotter,
6 December 2008

Val Bourne trained at the Royal Ballet School, London, and performed with the Royal Ballet and with Sadler's Wells Royal Ballet. In 1968 she became press and marketing officer for London Festival Ballet and a year later moved to do the same job for Ballet Rambert. After a year in the dance department at the Arts Council, Val was appointed as the first dance officer for Greater London Arts, where she organised the first two Dance Umbrella Festivals together with Ruth Glick, in 1978 and 1980. As artistic director, she was the key figure in establishing Dance Umbrella as the UK's most important festival devoted to contemporary dance. In 1985, she was awarded a 'Bessie', the New York Dance and Performance Award. In 1989 she received the first Digital Dance Premier Award and, in 1990, the International Theatre Institute's award in recognition of her outstanding contribution to British and international dance. In 1991, she was awarded an OBE and, in 1997, the Chevalier de l'Ordre des Arts et des Lettres. She was awarded a CBE in the Queen's Birthday Honours 2004. She retired as artistic director of Dance Umbrella in 2006.

Michael Clark at the opening of an exhibition
of work by the late film-maker Derek Jarman, Institute
of Contemporary Arts, London, 1984. P: Steve Pyke.

David Gothard

I put on Tadeusz Kantor's **Dead Class** on the Edinburgh Fringe in 1976, in association with Richard Demarco. I was at a fundraiser party for Ricky and Kantor, and there was this rather extraordinary woman called Erica Bolton who'd been running John Latham's little gallery. I spoke with such passion about Kantor that Erica responded overnight and she got on with co-ordinating it in the old Doctor Who studios at Hammersmith, which is what Riverside Studios was. It's very relevant because that was not long before Michael's story begins in London. Riverside, as an empty, beautiful building, was sort of accessible.

One of the first things that happened to me in the empty Riverside Studios was that the electrician who was rewiring the old dubbing studios asked if I minded if his son came in and practised his band there – and it was the Sex Pistols! This is the reason why Rosemary Butcher came there, which leads to Michael. Rosemary was at home there, because she'd come to this empty building with the Sex Pistols, and she showed me slides of a performance that she'd done for Jeremy Rees at the Arnolfini. It was a kind of Dance Umbrella before Dance Umbrella. Rosemary was in plimsolls, basically. She had come back from being with Merce Cunningham in New York, and before that, from Dartington College of Arts. There was a strong connection with American visual artists who ended up in Dartington, in particular Steve Paxton, who invented contact improvisation and who was a colleague of Yvonne Rainer and Trisha Brown, working with Robert Rauschenberg and members of the Judson Dance Theater.

So Erica was putting up scaffolding at Riverside, and I was in Edinburgh worrying about putting Kantor on at the College of Art (I chose the Sculpture Court). Then Chris Harris wandered up Crisp Road and saw Erica putting up scaffolding in what looked like a Courrèges suit, and he went: 'Ere, you can't do that. Let me help!' That's how this rather important printer wandered in. He later became the great photographer of those early years. The fact that Riverside became a home for people who would volunteer and then do a proper job, or those who were not accepted anywhere else, was very relevant to Michael.

As with Michael's early life, it was all about how you could get away with it as long as you were socially respectable. And Hammersmith provided that. There was fury in the dance world, because Robin Howard and London Contemporary Dance Theatre tried to have Riverside Studios as their new base, and they lost out to what happened later. The period was terribly important – the politics, the Sex Pistols, the old Labour party before Thatcher. There was this bright person in Hammersmith's leisure and recreation office called Nick Hooton, who had the good idea that Riverside could be used for the arts. Because it was the beginning of a lack of funding, pre-Thatcher, they set up an independent trust. The Hammersmith location was important, because it's west London and there's a liberal arts establishment there who could pull strings.

An arts centre in those days, in Arts Council terms, meant Battersea Arts Centre, or the Institute of Contemporary Arts. In other words, you were small-scale and had one technician who put on a light, or you were an institution protected by state funding. In funding terms, an arts centre was not meant to be the concern of theatre or dance departments. So they agreed to set up an independent trust with one third political, Hammersmith nominations; one third invited worthies, luminaries in the arts; and the final third elected by the other two thirds. Peter Gill became the director but was told there had to be a programme for all the arts (Peter subsequently left Riverside to set up the National Theatre Studio). They let me do Kantor in the empty building – me and Christian Boltanski and Wiesław Borowski from Warsaw hanging the exhibition – with people like Margot Fonteyn queuing in the street to get in. I was given a five-minute snippet on the BBC to introduce Kantor in an arts programme. That's what did it, the event itself.

After the success of Kantor, Peter Gill approached me and asked if I would be the programme director. It was a year before we got our official licence, during which time we tried things out on a special licence at weekends. So Rosemary Butcher came in, as well as performing on these special weekends; the only reason she could do it was because she danced in plimsolls. Traditional dancers couldn't work on the stone floors at the film studios. This was fundamental to how dance emerged at Riverside. You couldn't do any other dance there unless you lay down a wooden floor. Then she brought along Richard Alston, who did performances there. We quickly decided it should relate to classes. Rosemary was responsible for early-evening classes. This was very relevant to people coming from other areas of dance, who wanted to learn about new dance forms.

This cross-fertilisation went on for at least five years. Dance at that time was either the Martha

Graham technique from London Contemporary, or it was Rambert, which was very romantic, or it was kind of ethnic. The year after Riverside was created, Dance Umbrella was formed. So there were two worlds, Umbrella and one independent of Umbrella, both bringing in important Americans, Trisha Brown and Steve Paxton by way of Dartington. I knew that the New York City Ballet and George Balanchine were coming to the Royal Opera House. So I wrote to Balanchine and told him there was a new dance audience at Riverside and asked him to come and do a workshop there. By a miracle he wrote back and said that on their one free Sunday, they would do an anthology of his work at Riverside Studios.

I used to let people barter their talent. Peter Gill had given me the authority to select people without it going to any committee. The people who were invited to Riverside as choreographer-in-residence, like Michael, had to give us a show and also had to talk to the audience about it. And there were all sorts of amazing young talents there from every field. Will Alsop and many others who were in residence. Hanif Kureishi was my typist. Riverside, for the whole of that decade, had an old-fashioned nightwatchman. That meant that when we all went home at 11 o'clock at night, we left Jim the nightwatchman in charge, and that's when the fun and games began. All the mice would come out of their dressing rooms. Technicians, instead of being technicians, started expressing their artistic side. The Riverside Art Gallery began because Bruce McLean knocked a wall down with a sledgehammer. Michael had his own base in an old dressing room, which was the focus of his living there — and I mean living.

Very soon we had Michael as instigator, finding clubs together with Leigh Bowery. I observed it most when I was with them all at Brooklyn Academy of Music, where you'd have Andy Warhol waiting after a performance to take Michael and Leigh off to the latest club. And of course Michael was always above the latest club, because he always wanted to find his own club. And that's really what that period was, a sort of where-do-we-go-now. Well, they were beginning their own.

The lobby at Riverside was an area where you met people, and where you worked, with no loud music; you'd look and the Lisson Gallery would have a sculpture installation in the corner, and there'd be a few naughty bits over there. But it meant that there was curiosity and people breaking away. Karole Armitage left to form her own company; Michael went to New York, dancing with Karole. People like Thomas Dolby, who developed the synthesiser, were always in the lobby working. He was Gaby Agis's boyfriend. But Michael went further.

The team at Riverside were brilliant in those days. And we learned it. Steven Scott, who was the technical director, became a real collaborator with Michael. Erica and Jane learned to be Erica and Jane. If Riverside didn't get a cover on **Time Out** every week or every month, we'd close — because things were leading up to the first crisis with the Thatcher government, because we were only an arts centre. Michael always needed some kind of real backing and handling, and Erica and Jane were perfect as a bridge.

It's no good putting on Michael as a fringe alternative. He's always had the genius of Diaghilev; he's always had taste. Michael was like Diaghilev in the sense that he knew that Bodymap or Leigh could give you something that was important but not chic; when you look at those recent packages at Sadler's Wells, you get fantastic costumes done by great young fashion designers, but it's all about making us feel good. What Michael could do — and it's unique — was identify those people from his club life; they were integral to his being the composer and the choreographer. He wrote the whole thing. His mother's going on tonight, naked! But it all made complete sense.

Michael has always been brilliant at developing the language of choreography. He was also as close to Nijinsky as the Brits could ever get, not to mention being our only serious long-term hope in choreography over this period. Frederick Ashton believed in him. And I know that Ninette de Valois (who was always fuming that Michael was the last bit of nonsense, as it were) kept her eye on what was going on with him. I had her telephone number so that I could ring her up and tell her where he was performing. What Michael did, in the streets or elsewhere in the middle of the night, did give us Diaghilev. In the period we are talking about, Michael was the genius, the real thing.

Interview by Suzanne Cotter,
23 April 2009

During Riverside Studios' golden decade from the mid-1970s to the mid-1980s, David Gothard introduced the work of Tadeusz Kantor to England, setting a precedent for his becoming programme director, then artistic director, when Peter Gill left to found the National Theatre Studio. He is Associate Artist at the Abbey Theatre, Dublin, and regularly works with Peak Performances, Montclair, New Jersey.

Jane Quinn

It was the turn of the 1970s into the 1980s. We had all absorbed the influence of the American postmodernists while we were at Riverside Studios, seeing a procession of Merce Cunningham, Trisha Brown, Douglas Dunn, the spare austerity of Lucinda Childs; we had even seen New York City Ballet perform there. And then Karole Armitage, whose punk aesthetic and extraordinary technical virtuosity were a revelation.

In effect, Riverside Studios, under the patronage of the great impresario David Gothard, was our school of arts. Relationships were subtly encouraged between artists. From the rooftop studios of the Theatre Design School to the photography studio of Chris Harris; the late-night graphic work of Jamie Reid; the gallery created by Bruce McLean and Paul Richards; the riverfront architectural practice of Will Alsop; Samuel Beckett rehearsing the actors from San Quentin Drama Workshop; Peter Greenaway showing films in Studio 2; performances by legendary artists in every discipline, from Tadeusz Kantor to John Cage – the restless flow of artists moving through Riverside affected everything.

It was around that time that I saw Michael perform in Richard Alston's solo **Soda Lake** in Studio 2 at Riverside. It was a sublime event that everyone who was there remembers.

Michael was beginning to choreograph his own work at Riverside. He worked with Karole, with Ashley Page and Gaby Agis. He was photographed by Chris Harris in some of the best dance photography ever produced.

Michael decided to start his own company. And with David Gothard's encouragement, he came to us. We had no experience of managing a dance company, but Michael had no experience of creating one, so the experiment was on both sides.

In 1984, Michael Clark & Company burst into life. Already it expressed all the key ideas of Michael's art: collaboration, sucking in all the surrounding culture, being part of its audience's real life, a total vision of now. With a poster designed by Jamie Reid, music taken from the club scene of the time, and young dancers of exceptional skill and personality, the show opened at Riverside.

People have described Michael as an iconoclast. I don't think this is right. He is quite simply a great artist of our time, who knows instinctively how to take his art, a construct of the 19th century, and twist it towards the present. I think if I had to ascribe any particular parallel, it would be with Merce Cunningham.

He shares that complete attachment to his dancers. He lives for his company and they live for him. Michael also shares another little-understood sensibility with Merce, which I can only describe as 'vaudevillean'. It is that willingness to let the dance be infiltrated or subverted in the interests of making it live and relevant.

Charles Atlas and Leigh Bowery were exceptional influences in that early period. We discussed with Michael who he most wanted to work with when it came to lighting the shows. He immediately said Charlie. Charlie not only lit all Michael's shows and continues to do so to this day, but also directed two memorable films with Michael – as well as being groundbreaking treatments of dance in film, they remain unique documents of a period in London's cultural life.

Leigh was already part of Michael's life in London. Bringing him into the company made a lasting contribution not just to the look of the company, but its spirit. The floor-length dress worn by Michael in powder blue, which on close observation turned out to be covered with tiny swastikas; the outrageous cross-dressing, the extreme make-up, the tottering platform boots, the tweed jackets fringed with hundreds of kirby grips. Each item, handmade by Leigh at his sewing machine late at night, has become an

Michael Clark in a publicity shot for **New Puritans**, 4 March 1984. P: Richard Haughton.

artwork in its own right. His gentle but giant presence in the company made a major contribution.

Michael's mother, Bessie, also became incorporated into the company, appearing in a number of the shows. She was never sentimental, and unswervingly supportive of everything that Michael did. There was a proud inevitability about her presence in the work.

At the heart of Michael's working practice is the daily class with his company. At that time, these classes were led by his former teacher, Richard Glasstone. The rigour and formality of the classes is far from the perceived eclecticism of the final stage shows. They are the shared experience of every dancer throughout their working lives. The meticulous attention to technique is one of the hallmarks of Michael's work. It is difficult to perform.

Driven by his own extraordinary virtuosity and effortless technique, Michael is always searching to extend the language of ballet. There is still a restrained and elegant classicism in his vocabulary of tilts and distorts, taking the dancer dangerously off-balance, pushing the lines further and at more aggressive angles. There is still a formality in the structures but, like a young Picasso steeped in the classical tradition, Michael can stray further and further away from the core language while the reference points remain visible. I still believe he is the only choreographer who has proved the capacity of ballet to be a modern art form.

Design for his shows equally places the classical alongside the modern. At Sadler's Wells, sets for one of the shows came about through the discovery of beautiful painted scenery from classic ballet works of the 19th century, and simply installing them alongside the Pop Art symbols of the time, referencing anything from Gilbert & George to McDonalds. (The ultimate postmodern paradox came when performing in New York: Andy Warhol turned up in the audience.)

Michael's art is generous. It can encompass the formal and the informal, the high and the low. And yet whether it is the stage or the screen, Michael has a complete mastery of the frame of performance. His copious notebooks attest to his ability to conceive every detail of the structure of his shows, down to the set designs, the poster designs, the editing of the music. He may be working with the best creators in the world and their signature work is contained in his shows, but they still remain inside a tightly defined structure set by him alone.

Interview by Suzanne Cotter and Robert Violette, 9 January 2009

Jane Quinn is a founding partner of arts PR consultancy Bolton & Quinn. Bolton & Quinn managed Michael Clark & Company between 1984 and 1989.

Erica Bolton & Jane Quinn
130 Hammersmith Grove, London W6 7HB Tel. (01) 748 9440/9183

PRESS RELEASE

BRITAIN'S HOTTEST YOUNG DANCER LAUNCHES NEW COMPANY

At only 21, Michael Clark is already acclaimed in Britain and Europe as one of the most exciting dancer/choreographers to emerge in the last 10 years, "a volcano in our midst", with a rock-star following among an ever-increasing young audience. MICHAEL CLARK & COMPANY will be launched at Riverside Studios London on 2 August, and will go on tour throughout Britain this autumn.

The Company will feature four dancers including Michael Clark, who will start work on a new full evening programme of his own choreography at the beginning of June. His collaborators on this exciting new project will be the remarkable fashion team BODY MAP, whose designs were the unanimous hit of London Fashion Week; the celebrated American film-maker/designer, CHARLES ATLAS, famed for his work with Merce Cunningham and Karole Armitage, and the new-wave rock composer BRUCE GILBERT.

MICHAEL CLARK studied classical ballet at the Royal Ballet School and joined Ballet Rambert at the age of 17, where he shot to attention in the choreography of Richard Alston. He started choreographing his own work whilst still a student and finally left Rambert to work independently at the beginning of 1982. His work has frequently aroused controversy, particularly his more recent choreography following a period dancing with Karole Armitage's Company in New York and Paris. He has created close links with the fashion and rock world, working with fashion designers including Leigh Bowery and David Holah of Body Map, and dancing in rock promo-videos (most recently the band SCRITTI POLITTI). In February he appeared in Derek Jarman's new Super-8, recorded at the ICA and in May, he will start work on a fantasy film autobiography with Charles Atlas, co-produced by WGBH Television in Boston and the Institut de l'Audio-Visuel in Paris, which will be shot on location in London.

Dates at Riverside Studios: 2 - 8 August.

2 March 1984

PRESS ENQUIRIES ERICA BOLTON/JANE QUINN 748 9440/9183

NEW PURRITANS

These pages and page 39: Michael Clark and Ellen van Schuylenburch in publicity shots for **New Puritans**, 4 March 1984. Van Schuylenburch's make-up by Trojan; Clark's by Leigh Bowery. P: Richard Haughton.

'New Puritans'
Lyrics by Mark E. Smith for The Fall

(New Puritan. Uncommon eyes.)
The grotesque peasants stalk the land
And deep down inside you know
Everybody wants to like big companies.
Bands send tapes to famous apes
Male slags, male slates, famous apes.
K. Walter Keaton, now grey thoughts.
The whole country is post-gramme
(Echoes of the past)
Hail the new puritan!
Righteous maelstrom
Cock one!
And all hardcore fiends will die by me
And all decadent sins will reap discipline
New puritan.
This is the grim reefer
The smack at the end of the straw
with a high grim quota
Your star Karma Jim
New Puritan.
The conventional is now experimental
The experimental is now conventional
It's a dinosaur cackle
A pterodactyl cackle
In LA, a drunk is sick on
Gene Vincent's star
On Hollywood Boulevard.
Ha ha ha ha
Stripping takes off in Britain's black spots
The Kensington white rastas run for cabs.
This I've seen
New puritan
In Britain the stream electric pumps in a renovated pub.
Your stomach swells up before you get drunk
The bars are full of male slags
At 10.35 they play 'Send in the Clowns'
Why don't you ask your local record dealer
How many bribes he took today?
What do you mean 'What's It Mean? What's It Mean'?
What's it mean? What's it mean?
New puritan
New puritan
Hail the new puritan
Out of hovel-cum-coven-cum-oven
And all hardcore fiends will guide by me
And all decadent sins will reap discipline
New puritan.
I curse your self-copulation of your lousy record collection.
New Puritan says, 'Coffee Table LPs never [breathe]'
New Puritan.

Michael Clark performing **New Puritans** at Riverside Studios, August 1984. P: Chris Harris.

Michael Clark, Matthew Hawkins, Julie Hood
and Ellen van Schuylenburch performing **New Puritans**,
Riverside Studios, London, August 1984. P: Chris Harris.

Pages 46–47: Michael Clark, Matthew Hawkins and Ellen van Schuylenburch performing **New Puritans**, Riverside Studios, London, August 1984. P: Chris Nash.

These pages: Michael Clark, Julie Hood and Ellen van Schuylenburch performing **New Puritans**, Riverside Studios, London, August 1984. P: Chris Harris.

DO
YOU
ME
M?
¿I
DID

Pages 50–51: Michael Clark and Ellen van Schuylenburch in a publicity shot for **Do you me? I Did**, 1984. P: Richard Haughton.

These pages: Michael Clark and Julie Hood (above) and Michael Clark, Matthew Hawkins, Julie Hood and Ellen van Schuylenburch (opposite) performing **Do you me? I Did**, Riverside Studios, London, August 1984. P: Chris Nash.

David Holah & Stevie Stewart
Bodymap

SUZANNE COTTER When did you meet Michael?

STEVIE STEWART We first met in 1984. It was our first big fashion show, **Cat in the Hat Takes a Rumble with a Technofish**. Before that we'd had two other shows. This one was such a success. We were in the press and we were the darlings of the fashion world.

DAVID HOLAH I knew Michael already; he was a friend of mine from around the corner in Camden and we knew each other from going out to clubs.

SS I remember he used to come down to Godwin Court…

DH We had friends in common, and we didn't really know about dance at that time.

SS He had been at ballet school and had just come from Rambert to start out on his own.

DH I had just seen him dance **Dutiful Ducks**. It was on the television, and we were like, What! That is amazing! We didn't have any background in dance and we all went off to do ballet classes because we were so inspired.

SS That was our sort of circle. There were lots of people that were either up-and-coming or already pop stars, like Boy George, or film directors like John Maybury. Michael was this rising dance star and we were all friends.

DH We all lived in a kind of commune, because we used to squat originally. Steven Jones lived downstairs from me. John Maybury and Cerith Wyn Evans were in the room next door to mine, and Christine Binnie was doing this Neo Naturist thing. It was a household of never-ending creativity, from the moment you got up in the morning until the end of the day. We were always dressing up or getting ready to go out for some occasion, or Boy George would come around and do something. There was always something going on. Although Stevie didn't live there, she was always there because we were at college together; we were always in my room making costumes. Michael got wind of us from this time.

SS And because music is so influential for Michael as well, the club scene with its fashion and music was his world.

DH The other connection was Jeffrey Hinton, who used to do music for our Bodymap shows. Michael used to collaborate with Jeffrey for the music for his shows.

SS And Jeffrey used to film them.

DH He was quite obsessed with Michael as a person. Not many people had video cameras in those days but Jeffrey did, and he'd film everything, rehearsals and all kinds of things.

Was Michael's classical training apparent to you?

DH We weren't really aware of that at the time. Whether it was contemporary or classical, Michael was an amazing and extremely charismatic dancer, and you could tell what he did came straight from the heart.

SS I remember he worked with Gaby Agis, and she was more contemporary. Like I said, we were brought up with Michael and he educated us in a way, because he worked with other dancers, and that's how we got to know about contemporary dance.

DH We all got interested in dance at that time.

SS I remember we used to go with Michael to see classical dance all the time.

How did you work together?

SS He must have seen the **Cat in the Hat** collection and decided to do something. I remember us wanting to do the holes with ribs – that was our signature with that particular collection, and it lent itself well to dance because it exposed parts of the body. We asked Michael which parts of the body he'd like to have exposed. At other times, we'd do questionnaires for the dancers.

DH Dancers are quite fussy about their costumes, so we thought the best way around it was to ask questions first.

SS The costumes were very much linked to our collection, but after that we made costumes specially for Michael's work. We'd take prints from our ideas and develop them into costumes because we'd already have the fabric. I remember when we did **Do you me? I Did**, Michael wanted rubber chaps – grey latex chaps, and that zigzag mesh that we became famous for. We ended up hand-painting that on. I don't think they lasted very long, so it wasn't one of our most successful dance costumes. Michael has to be able to see the body in a certain way. Some of Leigh's costumes distorted the body, but Michael always seems to like a very long line.

DH Our costumes were all about that line, whereas Leigh's were more about taking it away and redistributing the proportions. That's why we worked together well – we were more body-conscious, whereas Leigh was more about distorting it.

SS There was a healthy competition between us, and we laughed at the fact that we were all really

talented and skilled in different ways. We'd talk about pattern-cutting and craft.

DH Although Leigh went to college, he wasn't particularly knowledgeable about cutting, so he was always after information, especially as Stevie is such a brilliant pattern-cutter. As we were used to working more industrially, we had all kinds of different techniques and things that he could use, especially as he was generally working alone out of his house.

What was the process when you and Leigh were designing costumes together for a production?

DH Usually Michael would come to us with the idea and we would sketch and interpret from his first thoughts into our own ideas. Then we would present our designs to him.

SS That's right, we'd show him drawings first, then we would have to try out in the actual fabric, as each stretch fabric behaves differently and some were more suitable than others.

DH The choreography was already set, with specific characters and music, so you had to work with what was already formed. So yes, we were working to specific briefs.

SS The music would play an important part and also give us our brief. Michael had various characters that he needed to be costumed. That was specific to the choreography. When he did **not H.AIR** – was that **our caca phoney H.**? – Michael asked us to do patchwork leather costumes, and a leather biker jacket with a fringe that was like long hair; we put hair in the armpits for Matthew Hawkins and a horsetail with dinosaur trousers – origami trousers with dinosaur legs.

DH Initially it was more our Bodymap styles taken into dance. Later it was a dialogue between the three of us and the music, and then it became more specific to what he wanted, so then we worked together more as a group.

When it became more of a working relationship, did that involve Charles Atlas and the people who were designing the sets?

DH Charlie wouldn't usually come until later, because he did the lighting by the colours, so at that point we didn't actually liaise with him. He would wait for the later ideas, and then he'd come in and have a meeting with Michael and the dancers would be wearing the costumes.

It seems to have been a remarkable time of artistic collaboration. It makes me think of productions for Diaghilev's Ballets Russes.

SS Michael is a perfectionist, that's why.

DH He made sure that it all ran according to how he wanted it, from costumes to lighting. Everyone has their input, but it's down to Michael's vision for the work. That's why it seems so seamless.

SS The graphics, the typeface, everything.

DH And contemplation, a lot of contemplation.

Will it be possible for Michael's work to be translated as powerfully as it is in the present in the future?

DH Because Michael is still here and oversees everything, the optimal performance level is down to him. When I first met Michael, I was astounded by the notation he kept. He's an artist, he can draw, he kept all kinds of notes, not just about the dance. So hopefully those chronicles will still be available.

SS And if the Michael Clark Company is still going, hopefully whoever is in that company will be able to continue his high standards.

But inevitably it becomes an interpretation.

DH We are very lucky that Michael is still here, and the more work he does that we see while he's still around, the more privileged we are.

SS I remember the first time we did the white costumes, the kinetic ones, and everyone ascended from below the stage. Even though I'd done loads of collections and fashion shows with David, at that moment my spine tingled! It was amazing to see our designs on those dancers and involved in that world.

DH I used to see the performance and I was often caught with a tear coming out of my eye. It was so incredible to watch. **Because We Must** was a phenomenal piece of work. The show had phenomenal dancers in it as well. It was the imagery and the dance, an overload of sensory perfection, if you like, and Michael was the person who co-ordinated it all. Everyone that came to see that show was blown away. Charlie made a film based on that piece.

It was obviously a fertile moment when you all met. You were kind of underground but, at the same time, **Vogue** *was doing features on you and on Michael; there were television programmes about him…*

SS We did underground in the evenings!

DH Initially it was underground, we had an underground sort of basis if you like.

SS We were coming from a club culture, from Taboo and that sort of thing.

DH In those days it wasn't about money, it was about our art and our creativity…

SS And making a difference. It was completely about drive and passion.

DH That's where we all connected, because a lot of the people alongside us had drive.

SS It was also one of the first times when young

people were allowed to have their own businesses and be creative at the same time, and there was a push for that.

DH The generation before didn't have that sort of thing. Punk helped push it forward.

SS We grew up with the punks, so we were being anarchic and rebelling against the establishment, and as Michael was doing that as well, that's how we all got on. The whole economic climate was just grey and black, like you were waiting for something to happen.

DH Like now, actually. And when you think about fashion in the 1980s, it was so awful and dry, that kind of Dallas thing – nothing to talk of. But then there was us with these completely odd shapes, prints, colours. It was totally not to do with the 1980s. It was like we were in a weird futuristic bubble.

SS I can remember feeling rebellious.

Bodymap ended in the early 1990s, but then, Stevie, you continued to work with Michael subsequently.

SS Michael asked me back to do his first **O** – at Brixton Academy.

What about Michael's use of non-dancers in his productions?

DH I think the main reason I was in the company was that I was going out with Michael at the time. I didn't have any specific talent for dancing. I could sing, so I did a couple of singing numbers – I'd get up in drag and do a few Billie Holiday numbers. Because we went on tour, I wouldn't have seen Michael for two and a half years, except for in-and-out periods. The reason I was there, basically, was that Michael wanted me to be there, so he gave me a part.

Did you have specific movements to perform?

DH Well I had been to ballet class, so I had a little bit of knowledge – they used to do ballet class in the morning, a Cunningham class or another class, and I would join in to the level that I could and then drop out. So we were given choreographed parts, yes. Leigh could play the piano and I did a bit of singing. So Michael pulled on the talents we had and it became part of the texture of the show. I did a choreographed cooking piece: miso soup, different things. All this stuff was also related to Michael as well, to what was going on in his life.

His mother, Bessie, was in his pieces as well.

DH She kind of took over from me! Bessie came in as the love interest! And then Stephen Petronio came in for **Heterospective**. And then Michael and Leigh became very ensconced.

SS That was when Leigh did the costumes for the first **Mmm...**, based on Stravinksky's **Rite of Spring**.

DH Leigh and I spent a lot of time together, because the dancers had a lot more work to do than we did. We spent a lot of time backstage, crocheting or knitting or bouncing ideas off each other – even make-up ideas, because Leigh and I did the make-up for the show – but it was always to do with Michael, it was all Michael's world.

SS I had to remake Leigh's costumes for Michael, even though Leigh was still alive then, as they weren't working together anymore. I remember asking Leigh if that was all right and he said: 'If anyone is going to do it, you're going to do it.'

What about your work on costumes for **Stravinsky Project**?

SS They were completely new costumes. That was when Michael and I fused our ideas. There are a lot of people on stage at the same time, there's a lot of different types of movement – floor work, in the air, lots of flight, traversing, crossing over and other interaction, almost like the plaiting in a Russian doll's hair in the original **Rite of Spring**. Michael wanted to be able to see the bodies, so we decided on a unitard because it relates back to Nijinsky. We were both interested in things crossing over. Michael would want to have one ballet shoe with ribbons and that would then inspire me to make criss-cross cuttings up the body. He did want to try things like elongated jockstraps and G-strings, which we tried; some things worked and some things didn't. Then, because **Les Noces** is about the wedding, one of the ideas was to have formal attire, like waistcoats and jackets. I interpreted that by cutting waistcoats into the unitard, or the outline of a jacket, and they just became ribbons. Probably if you didn't know that information, you wouldn't see it there. There was quite a lot of linear cutting – some of the patterns had 65 pieces in them, so it's not laid on, it's actually all seamed in. They are labours of love, that's for sure.

I've always been fascinated by the sexual ambiguity that's played up in the costumes. It relates to what you were saying about the dancer and the non-dancer, the clean line and the distortion of the body.

DH Michael cut through boundaries a lot, even in the beginning, and that comes through in all his work. He plays with it.

SS There's always an edge, a play on words, the idea become physical. He's very sharp and very witty. In conversation he'll use wordplay, which carries through to his inspiration. He also aims for uniformity in the designs, which plays on the sexual ambiguity.

It strikes me that through the language of dance,

Michael Clark in a publicity shot for **Pure Pre-Scenes**, 1987, with costume design by Bodymap. P: Dee Conway.

and what that can be as performance or spectacle, his performances speak of things that are societal. They are about now, and the time we live in.

DH Ambiguities stretched to endless bounds.

Do you think that was one of the reasons he was attracted to you, as he was attracted to people like Leigh – because you were also looking to articulate something of your moment, and its complexity?

SS We turned fashion on its head. We had the fashion, and Leigh had the performance art, and so of course Michael was attracted to that.

DH And in the same way that he was working with musicians who were pushing boundaries in music, like Mark E. Smith.

Do you think there are comparable projects now?

DH It's all so bland and generic these days. Everything is referenced, so it's quite hard to pick.

SS Michael worked with Sarah Lucas, which was amazing, and he's involved with other artists as well. They are part of the foundation of his company now. So he's very much involved with the art world. So with artists I'd say yes, that is comparable now.

DH He's an important part of the art world himself. He's a choreographer/artist.

SS Michael's work is always developing, it is never finished.

DH: Back in the days when I saw all the shows, every show was different – there was always some development. It was brilliant, so good to see.

SS The work has become purer, but to arrive at the point there is more complexity.

DH The frills and the dildos are gone.

I think that complexity of being an artist comes through in the work. As someone in the audience, it absolutely transports you.

DH Michael is avant-garde. That's the point, that's where he comes from, that's what he is.

Interview by Suzanne Cotter,
16 November 2008

David Holah and Stevie Stewart studied fashion design at Middlesex Polytechnic before forming the label Bodymap in 1982. Throughout the 1980s, Bodymap showcased their pioneering collections in London and New York and sold them internationally. They first worked with Michael Clark in 1984, designing costumes for **New Puritans** and **Do you me? I Did**. In 1986 they collaborated with Leigh Bowery on costumes for **No Fire Escape in Hell**, which was awarded a New York 'Bessie' award. Holah performed in several of Clark's works, including **Because We Must** (1987) and **I Am Curious, Orange** (1988). He is a practising artist, graduating in 2006 with an MA in Fine Art from Camberwell College of Arts (UAL).

Stevie Stewart has continued to collaborate with Michael Clark, originating designs for **Before and After: The Fall** (2001), **OH MY GODDESS** (2003), **Stravinsky Project** (2005–7) and **come, been and gone** (2009). Stewart now works with top creative names in fashion, music and advertising as a costume, set and production designer and fashion stylist on photographic shoots, music promos, commercials and films. She is also a consultant for some of Europe's fashion houses. Recent projects include costume design for Baillie Walsh's film **Flashback of a Fool**, costume and production design for Jan Dunn's **The Calling**, and costumes for Kylie Minogue and Britney Spears tours.

Jeffrey Hinton

When I first met Michael, he was just leaving the Royal Ballet, at the beginning of the 1980s. He's the kind of person you fall in love with straight away. He was a beautiful piece of energy in pure form. I remember taking him to a club called Heaven. I just grabbed him and spun him around in my arms for ages, as I would do with some people. He would always credit me for having dragged him into that nutty world and hasn't forgotten the blur of being whizzed around the dancefloor under a sky of disco lights.

I got to know him better as he was starting his own projects and company to get away from the frustrations of the ballet world. The environment I was in, although a little cliquey, was a world of 1980s fashion designers, film-makers and artists, mixed in with a few 1970s hedonists and a bit of punk mentality. Everyone seemed to be doing something; it was a very individualistic time. Michael was a natural fit, and was so inspirational in what he wanted to do. It really fitted into what I was doing: photographing and filming with video, editing and specialising in sound effects and music cut-ups, plus working in clubs and social events. I would love to add the texture of sound and visuals to whatever the event might be.

A lot of us were living in squats and on the dole at the time. It made a huge difference, because we didn't have to worry about things like rent and bills, or loads of debt. It was very connective: you were with these people all the time, where now people interface with each other via electronic media. We actually did live on top of each other and that brought these creative connections together, much more so than sitting around and having a meeting. I don't ever remember having a meeting with Michael. We would just be together and talk, and from that he would trust me to come up with music for him. All the people we were with were into their respective media, so there was a rich forest of inspiration to turn into dance. Michael is like a bright light – you are drawn to him. I always would go and film the rehearsals. It was great watching how people worked, a beautiful experience. Being a part of it was a wonderful thing and musically inspiring. Michael is a great artistic catalyst because he naturally understands what he wants from people around him and how it can work together organically. His shows had a bit of the naughty child about them, running around the world and carrying on. It was an unusual situation – even though we were taking it seriously, we really got away with murder. (We made sure we got our play time.) Michael likes living on the edge of a creative buzz, and we were all celebrating that to the hilt. The performances were an artistic reflection of that. People had strong reactions: some would embrace it; others would say that we were not taking dance seriously, but they completely missed the point. It was a refinement of a lot of different and specific styles, energies and directions – sometimes even directionless directions – but things that were reflective of our lives.

Because these were people that I was emotionally involved with on so many levels, it was quite a personal experience. I loved to watch all these different people that surrounded Michael, a very anarchic whirlwind of creativity. To be able to draw all these people together was great. I don't see that kind of thing happening so much now, that freeflow-osmosis type of creativity. Dancers and artists now are very structured in what they have to do and whom they have to know. That is reflected in their work to a degree. I do see some good signs – the current recession has shaken the status quo, which is always good, creativity-wise. I see some cracks appearing and interesting stuff starting to slip through. So I'm optimistic.

Michael's work captured a sort of abandonment and things coming from a lot of different angles. It isn't an easy place to be because you're so vulnerable, but collectively we gave each other enough support to draw on all these things. We were always adding things in and finishing things at the last minute. There's always a bit of chaos in creativity.

Interview by Suzanne Cotter,
6 February 2009

Jeffrey Hinton was born in west London. In the late 1970s, aged 18, he travelled to New York where he met William Burroughs, Andy Warhol and John Waters and immersed himself in the gay disco scene. In London in the early 1980s he became friends with designer David Holah, film-maker John Maybury, make-up artist Lesley Chilks and DJ Princess Julia, at what was known as the 'Warren Street squat', and with Boy George and Marilyn. Other friends included Jeremy Healy and Annie La Paz, who set up the club Circus, where he worked with dubbed and looped music and video. Hinton went on to make music for the gay/punk/fashion club Cha Cha, which was part of Heaven. He produced music for Clark on **Morag's Wedding** (1984) for English Dance Theatre; **not H.AIR** (1985), **our caca phoney H.our caca phoney H.**, (1985); **Drop Your Pearls and Hog It, Girl** (1986); **No Fire Escape in Hell** (1986), and for Charles Atlas's film **Hail the New Puritan** (1986).

Michael Clark in a publicity shot for **our caca phoney H.our caca phoney H.**, with costume design by Bodymap. P: Richard Haughton.

Steven Scott

I think I first met Michael when we were setting up **Soda Lake** with a sculpture by Nigel Hall, and with choreography by Richard Alston on **Dutiful Ducks** at Riverside Studios. He was a kind of prince of dancers in a way, coming out of the Royal Ballet School. I had previously worked with the Royal Ballet, so I knew a lot of people that were at school with Michael. Michael had a very clear classical style in movement – it is hard to describe, it was so accurate, almost clinical in its precision, and such a perfect line.

I had just left Riverside Studios when **New Puritans** was produced, so I watched from the audience. It was spectacular and refreshing. Later, I worked with Michael when he was choreographing and he brought the same perfection to his concepts about productions, both from a visual and a choreographic point of view. During my time at Riverside I had worked alongside Erica Bolton and Jane Quinn, who managed Michael and his new company. In about 1986, Jane Quinn called me and asked me to help put together Michael's next production, **No Fire Escape in Hell**, which premiered at the Royal Northern College of Music in Manchester. Michael chose to collaborate with Laibach, heavy-duty punk musicians from Slovenia, who were performing live in the piece. Most importantly, Michael described how he wanted the stage to be visually, which I found incredibly mature. Michael was very young then, but he was transferring his gift as a dancer into his choreography and stage direction. To have such a sense of space and three-dimensional forms was quite refreshing, and mature beyond his years.

This was followed by **I Am Curious, Orange**, which premiered at the Holland Festival. **Curious, Orange** was quite a big production, even in comparison to **No Fire Escape in Hell**, and the fact that it was premiering abroad provided new challenges. Again it featured Michael's favourite band, The Fall, live on stage. Michael was rehearsing in Amsterdam and I was building the production in London – including gigantic McDonald's hamburgers – and shipping them over with french fries that were the size of you and me. It was inspiring. One of the prop-makers decided to put tomato sauce in the hamburger, and Michael said there wasn't any tomato sauce in Big Macs! That's Michael's attention to detail – it was all part of the Riverside/Royal Ballet education, and very much a part of Michael. Looking at himself in front of a mirror every day as a dancer to achieve that level of perfection takes an eye and a judgement every split second. It was ingrained in Michael.

I Am Curious, Orange came together on stage in Amsterdam with a design process that included fragments of information like Michael giving me a postcard of the Houses of Parliament and images of Hampden Park or the Celtic football kit. Michael designed his own productions in this fragmented manner and I would come along and make sure that the scale of things was right and take care of the things that Michael didn't have time to deal with. It was a massive task to make a production in the way that he did it. In those first productions, he was on stage nearly the whole time so he needed the support of a full design production team – led by Charlie Atlas. The production desk was really where Charlie sat, and I would sit behind and make decisions to move things along. Michael would then view the recordings.

It was amazing, the way he got productions on. There was never enough money, and everyone was paid next to nothing. There were all these heroic collaborators that Michael inspired, people in rooms sewing on twenty thousand sequins. Certainly, when one recognises that kind of vision and talent, most people go with it. It felt as if Michael had a mini DVD player in the back of his mind; even though he was in the middle of the stage most of the time, he was aware of the way it looked from the front. That is a very special talent. When we produced **Apollo** as **O** in 2005-7, Michael's strong visual sense and visual judgement came across clearly.

After **I Am Curious, Orange**, there was **Because We Must**, which was even more complicated. It was at Sadler's Wells and we somehow got permission to paint the back wall of the theatre, which is normally black, bright yellow. This was the first part of the design process. There was a very positive relationship between Sadler's Wells and Michael at the time: we could basically do what we wanted, with full support from the SW team. **Because We Must** was a great piece; we filmed it and took it to Japan. It's a great film – Charlie directed it. We used some of the live footage of Sadler's Wells with the real sets, and then we made other sets in the studio. There's an incredible section with Leigh Bowery and Michael dancing to 'Venus in Furs' – it was just right at that time, absolutely beautiful work.

Michael also embraces the space at each venue, making adjustments that responds to the dimensions

to ensure a maximum impact for each piece. At the Brixton Academy, which is one of the very cool atmospheric auditoriums, the ceiling is like a night sky – Michael was always touched by that. He would do things at Kings Cross, a train depot, so there was always this cutting-edge, punk side of Michael. Much of what happens on a big stage doesn't fit with what he does. He doesn't fit into the matrix of the repertory system, and he requires a dedication from dancers that is not normally embraced in a classical ballet company.

Nevertheless, Michael is capable of creating works for big companies, and he's done that too – **Swamp** was fantastic at Rambert in the 1980s. At the Deutsche Oper in Berlin, I commissioned him to create a new work – it evolved out of **Swamp** and was called **Bog 3.0**, with new music, new costumes and set. We also did another piece together when I was at English National Ballet. Michael was commissioned to do a small one-act work for the second company, ENB2, touring to mid-scale theatres; much more the scale Michael was performing with his own company. He created a piece called **Drop Your Pearls and Hog It, Girl**, which was a play on **Swan Lake** – chauvinism, and the leading male as opposed to the leading female. Michael took on interesting viewpoints in terms of classical ballet. Again it was very visual. It was a Bodymap costume piece, with Charlie Atlas lighting and Michael creating dream images of a swan with wings – it really was like swan wings, not a frock, but like an organ attached to someone's body.

Drop Your Pearls was an enormous success. Whenever it played on tour, the house was full, and that was the great thing about Michael – the fashion, the music, the new dance. He broke down the barriers as a modern artist does. A number of artists have been borderless, but in the 1970s and 1980s, and certainly in British theatre, you were either in dance or in opera or in theatre or in ballet.

In 1989, we invited Michael to create **Rite of Spring** at the Coliseum with the English National Ballet, which would have played in June 1990. Just around that time there was a big change at the ENB – the director, Peter Schaufuss, left and went to Berlin and I joined him there, so the commissioning of **Rite of Spring** got as far as me speaking to Vivienne Westwood and Richard Long to design the production. They were Michael's choices and they had got to conversation stage, the first step towards his Modern Masterpiece concept.

There is definitely a legacy, in that Modern-Masterpiece sense and in the Diaghilev sense Michael has that spirit, although Diaghilev was not a choreographer, and works within that tradition. He has been the choreographer and impresario, supported by a whole realm of other people. Michael's legacy is his desire to work with the most contemporary and sometimes the most difficult music and having the performers live on stage – the merging of contemporary dance with that kind of music was one thing, but there was always that connection to the classical, which he came out of. When you look at **mmm...** and **O**, it is the classical meeting the contemporary in a rather poetic way. Michael's concept of the birth of Apollo was one of those special moments in theatre.

There's no doubt that having someone like Leigh in the picture, you'd always get something that you'd never thought of. Michael cultivated a flat management structure where everyone could contribute. I must say in my way, even though it is much less in comparison with Leigh or Charlie, I felt that he trusted me. That trust led to my ideas for **Apollo** and he went for it – we never had the money to realise it as fully as we could have, but we did it. Sometimes with the very best ideas you don't have to have things underlined in red. The audience will complete it themselves, and that's the best theatre. To leave it open is a strength that Michael has. The legacy is about the way he's made his theatre, the way he invited fashion on to his stage, the fact that he worked with film-makers, painters, punk musicians and other artists.

I think it's wonderful that Michael arrives at the Modern Masterpiece in the spirit of that time. Re-energising. Without a doubt this is not a look back, this is a look forward – that's how I see Michael's work.

Interview by Suzanne Cotter,
19 January 2009

Steven Scott was born in London in 1955. He lives and works in Copenhagen, following periods in Berlin and Amsterdam. From 1978 to 1984, he worked at Riverside Studios under Peter Gill and David Gothard, embarking on a career that has moved between fine art, theatre and architecture. Scott has worked with the British film-maker Peter Greenaway, designing **Rosa: A Horse Drama** for the Netherlands Opera. He received a commendation at the Benois de la Danse in Paris in 1997 and in 2002 the Danish Reumert Prize for the best stage design. Scott designed **Requiem** for the Royal Danish Theatre in 2006 and **Hamlet** for Copenhagen's European City of Culture festival in 1996. Since then, he has exhibited his light installations internationally. Scott's works are held in distinguished public collections in Austria, Germany, the Netherlands and Denmark.

Michael Clark, Nico Holah-O'Neill and Ellen van Schuylenburch
(reflected in mirror) during rehearsals for **No Fire Escape in Hell**, 1986.
P: Richard Haughton.

NOT
HH.AIRR

These pages and page 65: Michael Clark, Matthew Hawkins, Julie Hood and Ellen van Schuylenburch in publicity shots for **not H.AIR**, 1985. P: Richard Haughton.

67

Leslie Bryant, Michael Clark, Matthew Hawkins,
Julie Hood and Ellen van Schuylenburch performing **not H.AIR**
for the film **Hail the New Puritan** by Charles Atlas, 1986.
P: Chris Harris.

OUR
CACA
PHONEY
H.OUR
CACA
PHONEY
H.

Page 71 and above: Leslie Bryant, Michael Clark, Matthew Hawkins, Julie Hood and Ellen van Schuylenburch in publicity shots for **our caca phoney H.our caca phoney H.**, 1985. P: David LaChapelle.

Michael Clark in **our caca phoney H.our caca phoney H.**, Riverside Studios, London, 1985. P: Dee Conway (opposite) and Chris Harris (this page).

Opposite: video stills of Leslie Bryant, Michael Clark, Matthew Hawkins, Julie Hood and Ellen van Schuylenburch performing **our caca phoney H.our caca phoney H.**, 1985, Royal Lyceum Theatre, Edinburgh. P: BBC Motion Gallery.

This page: Leslie Bryant, Michael Clark and Julie Hood performing **our caca phoney H.our caca phoney H.**, 1985, Royal Lyceum Theatre, Edinburgh. P: Brendan Beirne/Rex Features.

HAIL THE NEW PURITAN

A FILM BY CHARLES ATLAS

82

Page 81: Leslie Bryant, Michael Clark and Ellen van Schuylenburch during the filming of **Hail the New Puritan** by Charles Atlas, 1986. P: Richard Haughton.

Pages 82–89: Gaby Agis, Rachel Auburn, Christine Binnie, Jennifer Binnie, Wilma Binnie, Erica Bolton, Leigh Bowery, Leslie Bryant, Michael Clark, Matthew Hawkins, Julie Hood, Grayson Perry, Ellen van Schuylenburch, Brix Smith, Mark E. Smith, Sue Tilley, Trojan, Dick Witts and Cerith Wyn Evans during the filming of **Hail the New Puritan** by Charles Atlas, 1986. P: Richard Haughton (pp. 82–85, 87–89); Alex James (p. 86).

84

87

Michael Bracewell
*An Evening of Fun in the Metropolis of Your Dreams:**
Michael Clark, London and the Art of Subcultural Lifestyle, 1975–90
*Wire, 'On Returning', 1979

Although the photograph is monochrome, the viewer can tell exactly what kind of day it depicts. The weather is cold and dry, the low winter sun attempting to push through a fine white haze. Everywhere looks derelict and abandoned: the desolate street; the block of flats beside an expanse of tyre-scarred wasteland. A length of corrugated-iron fence has been ripped from its posts and left to hang, pulled down by its own weight across the pavement. A few leafless trees stand forlorn in the freezing stillness.

The subject of this image is a semi-residential street in west London, between the purlieus of Notting Hill and the concrete expanse of the Westway. The photograph is one of a series taken by the writer Jon Savage, in January, 1977, titled **Uninhabited London**. A little over 30 years later, these photographs show a city that seems as remote in time as that depicted in Nigel Henderson's studies of East End life, taken during the 1940s. Savage shows London in deep recession, its dynamism slackened and its atmosphere stagnant. These are the ruins of the Peace; the exhausted terrain of the consumer boom of the late 1950s, which had seen the first supermarkets, high-rise housing, multi-storey car parks, airy electricity showrooms and dark, thrilling boutiques. The landscape of British punk and post-punk, between 1976 and 1980, was that of modernity reaching critical mass, and fitfully imploding.

It was during this time – between 1978 and 1979 – that Michael Clark, a young dancer from Aberdeen, was nearing the end of his studies at the Royal Ballet School. The seismic waves of punk had already reverberated through the terrain of the broader culture, their impact felt internationally, and, it would transpire, often most strongly in remote places. For Clark, the influence of punk – as an entire subcultural lifestyle, driven by innovation in music and fashion – would be profound.

To intentionally collide opposing qualities had already proved sensationally successful within the history of rock and pop music. Most notable, with regard to the development of punk and post-punk, was perhaps the Velvet Underground's formidable and intoxicating fusion of pop sweetness and aggressively avant-garde improvisations, held in place by relentless repetitions. The Velvet Underground's co-founder and viola player, John Cale – himself, like Clark, a former protégé within a classical artistic training – would subsequently liken this aspect of the group's method to La Monte Young's composition from 1960, **Composition 1960 no. 10 (to Bob Morris)**.[1] Such an approach would become significant within Clark's pioneering confluence of music and dance. (La Monte Young's mentor John Cage would be a teacher at the Merce Cunningham summer school that Clark subsequently attended, and where he met Karole Armitage.)

In 1985, watching the recently formed Michael Clark company perform **our caca phoney H.our caca phoney H.** at the Riverside Studios in Hammersmith, west London, the bravura impact of Clark's fusion of his personal tastes in music and stylised image with the discipline

and formal ceremony of 'classical' dance was immediate and seamlessly honed. The soundtrack resembled an iconographic collage of musical samples, in which the slick pop eroticism of Marc Bolan and T. Rex was dominant. Set against, yet in perfect synchronicity with the rigour of Clark's choreography, the effect was extravagant and exuberant, allowing the work to transcend the conventions and language of both 'pop' and 'high' culture, and achieve its own artistic newness. In an interview from this period, Clark would state: 'My inspiration comes from my real life. I bring my life and work together. Going out to watch a punk rock band at night and doing classical dance during the day just didn't work. Now they fit.'[2]

In their time – the latter half of the 1960s – the Velvet Underground had been largely obscure, but with a reputation for drugs, depravity, audio-sonic assault and sexual outrage that was backed by the 'producer' of their first album, Andy Warhol. Their music – steeped, in fact, in ideas and inspirations from the worlds of fine art, film, serious literature and avant-garde composition – was considered the product of, and soundtrack to, a volatile and sinister group of outsiders and freaks whose volatility was matched only by its decadence. Clark would likewise embrace this heady combination of punk 'shock' and high artistic rigour. Clark's **Heterospective** performance at the Anthony d'Offay Gallery, London, held in October 1989, would both refine and extend his signature conflation of 'high' and 'low' cultural language.

To an audience seated on exquisite gilt chairs (of the sort used for formal receptions and couture fashion shows) within the highly intimate space of the gallery, Clark devoted the latter half of the 50-minute performance to what appeared to be a dance masterclass, in which repeated exercises were carried out to a soundtrack of the opening bars of the Velvet

Uninhabited London, 1977. P: Jon Savage.

Two sides of a poster depicting Trojan, created by John Maybury for the Anti (Art) Fair, Camden, London, 1986.

Underground's 'Sweet Jane'. The use of repetition, in both music and performance, created an effect at once mesmeric and transcendent – effectively relating the pop and rock avant-garde to the compositional experiments of John Cage and La Monte Young, which in turn had been an influence on the highly sophisticated artistic thinking of the Velvet Underground.

Violence and nihilism had been the paradoxical signage of punk's revolt into creativity. Punk 'star' Debbie Jubilee, for example, was photographed standing beside the enlarged photograph of the bombed ruins of Dresden, which decorated the back wall of Vivienne Westwood and Malcolm McLaren's shop, Seditionaries, on the King's Road. But to those attracted by the centrifugal force of the movement, punk also offered a mirror. For some it was merely a rock'n'roll beer fight; for others a fashion, or militant Class War, or the occasion to retaliate against perceived social injustice. For a few, however – of whom Clark would be a highly significant representative – punk resembled in part a science fictional reclamation of the Zurich Dada or Diaghilev's Ballets Russes. This response, as made so eloquently by Clark's early work, derived from punk's delight in the conflation of opposites and extremes – of playing clever, insolent games with historical and stylistic quotation; and in the sudden opening up, within a network of mutually aware and occasionally intercollaborating insiders, of creative opportunities.

Mark Sinker, in an essay titled 'Concrete, so as to self-destruct: the etiquette of punk, its habits, rules, values and dilemmas' sets the rules of the game. It was all to do with mutual recognition: 'For my secret double injunction was just one among a thousand ways to formulate the axioms of punk life. And since what you do tells who you are – since public rituals define the tribe – there had also emerged, over the years, a series of speed-read surface pointers to deep identity. Visible-invisible shortcuts to recognition, the same as any other band of outsiders flip into in tricky times: the keychain codes of the year-zero autonome.'[3]

For Michael Clark and his collaborators, the notion of an 'art beyond the gallery' (to borrow Richard Cork's description of Vorticist applied arts) would be integral to their concept of creativity, personal image, sexual identity, appearance and outlook. Such an attitude was catalysed by the liberations and ideas provoked by punk, but had in fact been set in place – in terms of a metropolitan cult devoted to self-recreation – some years earlier. Between 1973 and 1976, during the period immediately preceding punk's scattershot emergence in London, there had been a *demi-monde* devoted to art-directed lifestyle, the intention of which was an exclusive-minded assertion of *la vie deluxe*. The common denominator between these art fashion aesthetes of the mid-1970s and the circle of artists, designers and underground club-world celebrities which would form around Michael Clark was a belief that the most interesting contemporary creativity was taking place as a consequence of subcultural lifestyle. This would be a defining trait of punk, many of whose originating participants had strong connections to the London art schools. Punk's dedication to amateurism, DIY aesthetics, collage and cultural archaeology was matched by its fixation with self re-creation. There are now copious accounts from witnesses and participants within the punk movement[4] of being inspired to re-create one's cultural identity overnight. This led to extensive renaming by punks of themselves: a practice which at its most sophisticated (writer Bertie Marshall's re-creation of himself in 1976 as simply 'Berlin', for example) achieved in itself the poise and creative insight of an artistic act. Derived from the art-school end of pop and rock music (notably David Bowie's and Roxy Music's extrapolations of the Velvet Underground), and the heightened styling of that music and those artists, this was a small but influential grouping of designers, personalities and artists whose dedication to style was based on heightened re-interpretations of Art Nouveau, Art Deco and Pop Art – these reclamations given their own gloss and twist, the effect of which (as defined by Peter York, in his essay of 1976, 'Them') added various enlivening layers of camp.[5]

'Them' would comprise the metropolitan cast of a generational network whose sensibility, attitudes and style code would be adapted and re-invented by the younger – mostly gay – milieu of metropolitan artist–bohemians who were growing up through punk. Some of these would be part of the volatile, self-destructive and intensely creative subcultural group that would form during the early 1980s around Clark, and include his close friends and collaborators, the auto-fact and underground celebrity Leigh Bowery, artist/clubber Trojan (Guy Barnes), the artist Cerith Wyn Evans, the designers David Holah and Stevie Stewart (Bodymap) and the film-maker John Maybury. While the pre-punk London style scene is seldom assigned its correct degree of importance in the more heavily researched

and documented years that followed, London's first wave of punk – although officially hostile towards much of the immediately preceding London scene – and the vast diversification of post-punk creativity, of which Michael Clark would become an avatar of lasting international significance, had a significant portion of their root structure within the cult of extreme style identified by York.[6]

In true 'Them'/post-punk style, Leigh Bowery had begun by selling clothes on a stall in Kensington Market, thus establishing himself – and his extreme personal style – as an underground celebrity. This celebrity granted him agency to originate and navigate within the social and creative landscape of a small metropolitan scene (most famously the Leicester Square-based club night Taboo), meeting Michael Clark in 1983, and beginning a series of now well-documented collaborations which would last until the end of the decade. Establishing his role as a nihilistic eccentric of the postmodern period, whose very denial of art, meaning or content served wholly to heighten his assertion of highly constructed personal style, Bowery would also possess a childlike delight in shock, excess and misbehaviour. As such, he could at times resemble both mascot and muse to the gay underground milieu.

During the first half of the 1980s, Clark, Bowery, Trojan et al., had comprised a tiny clique which stood on the furthest fringes – if not entirely outside – the better known subcultural groupings of punk and post-punk. Certainly, their extremism, games with identity, sexuality, appearance and creative attitudes placed them in an entirely different and unique category to the more heterosexual and conventionally style conscious network of New Romanticism. Through his early performances at the Riverside Studios, as Clark began to take his place as a dancer and choreographer of clearly historic importance, it seemed as though his work and presence related the violence and controversy which had attended the premiere of Stravinsky's **The Rite of Spring**, in Paris in 1913, to that which had surrounded the Sex Pistols during 1977. Conflating strands of cultural and subcultural influence, he created a dazzling, brilliantly coloured, fervid collage of intensely felt effects and mythic quotation – the patterning and composition of which were simultaneously entrancing, absurd and aggressively modern. His work thus linked modernist rigour to the wit and audacity of postmodern aesthetics; this combination was held in place and catalysed by the ethos of underground bohemianism – extreme subcultural lifestyles – within which he and many of his friends and collaborators had always maintained.

A sale-catalogue entry for the poster created by John Maybury, for the Anti (Art) Fair held in Camden in 1986 does much to describe and define the personnel and aesthetic of this particular milieu: 'Maybury (John) "even to spark out now would be no pain – Trojan. An Anti (Art) Fair." Original exhibition poster. 65.5 × 94 cm. A montage portrait of the artist Trojan in five colours and oversized Benday dots on white stock. A vivid image; the level of colour saturation is astonishing. Trojan is depicted as a semi-mustachioed, one-and-a-half eared aesthete in an oversized jacket. A skull floats directly above his tousled hair.'[7]

The extent to which self-re-creation and art-directed image was a major aspect of Michael Clark's productions can be gauged from the fact that the make-up and styling for his performances in the mid-1980s were created by Leigh Bowery but based almost entirely on

Michael Clark, c. 1990. P: courtesy Sophie Fiennes.

those worn by Bowery and Trojan as social plumage. This, coupled with the heightened sexual nature of some of Bodymap's costumes (famously, those which impudently but delightedly exposed the dancers' buttocks) contributed to Clark's signature style. (As noted by Matthew Hawkins, this would create an interesting historical echo: 'At a performance of Giselle in St Petersburg, Nijinsky scandalised all present by discarding the regulation knickers in favour of a design that better revealed his legendary contours. This prototype explicit glimpse of buttocks and things was a call to physical integrity but also an infringement that effectively terminated Nijinsky's contract at the Imperial Theatre and forced his full-time commitment to the Paris-based initiatives of Sergei Diaghilev – to seismic dance-historical effect.'[8])

The aesthetics, style, creativity and temper of extreme subcultural lifestyle would thus become a vital aspect of Clark's work as a dancer and choreographer. Absurdist, confrontational, richly aesthetic and provocative – a **Through-the-Looking-Glass** sensibility, in which vulgarity, covert intellectualism, deliberate obscurantism and an uncompromising rigour were commingled – this was a sensibility which was both shared by, and would enjoy a subsequently volatile partnership with, Mark E. Smith's Salford-based rock group The Fall. Clark's first collaboration with The Fall took place in 1986, again at the Riverside Studios. **Hey, Luciani! – The Times, Life and Codex of Albino Luciani**, a play with music, written by Mark E. Smith, also featured Leigh Bowery and resembled a Dadaist charade, in which the lines between character and performer were continually blurred. The temper of the piece was both amateurish and febrile – as though a group of progressively avant-garde and surly pranksters had created a bizarre entertainment within a village hall.

At the same time, there was a clear seriousness and high aesthetic directive to the play, in which elements from Smith's highly refined literary and imagistic style, coupled with his long held interest in history, were perfectly combined with Clark's postmodern style and modernist intent. Rock music (The Fall's musical style combined robust, guitar-driven rock with a formula of repetition, prompting Smith's remark: 'The Three Rs – repetition, repetition, repetition'), performance, pantomime, dance, film and dialogue melded amateur and professional, cartoon and tableaux, faux-horror and comic melodrama, into a masterpiece of super-stylised conspiracy theory. Within such a mix, Clark appeared like an attendant spirit, at once insolent, ethereal, detached and intent. Bowery's cameo role, also, delivered the effect of a mythic creature making an appearance within the quotidian world: his costume and personality so much extensions of one another that his presence was that of a comic and grotesque monster, delighting in his own grotesque splendour and mutant corporeality.

In order to assess the motive and extent of the post-punk interest in art deriving from subcultural scenes and lifestyles – and thus the radicalism and impact of Clark and his collaborators – it is worth considering that the 'institutional' worlds of fine art, opera and ballet, and in particular that of the private galleries, were throughout the late 1970s and greater part of the 1980s a largely remote, insular, academic and deeply self-referential society. The visual artists then prominent – with the notable exception of Gilbert & George – were abstractionist painters and sculptors, pursuing highly refined ideas related solely to the debates and concerns of the specialist art world. Artists such as Anthony Caro,

Tony Cragg, Richard Deacon, Howard Hodgkin, Bridget Riley and Alison Wilding comprised the establishment of contemporary British art, and were commercially represented, by and large, by a few major galleries along Cork Street in London's West End.

In addition to the chasm of differing sensibility and outlook which existed between radical, visually aware younger artists and this prevailing artistic establishment, there was also a recession adding further despondency and sluggishness to contemporary cultural activity. For younger artists, the aggressive energy of punk provided an entirely new creative circuitry: a language and set of attitudes which fused audacity with invention, deriving its power from a philosophy of confrontation which took as many individual forms as there were enquiring protagonists of newness and modernity. Shops such as Westwood and McLaren's SEX at World's End, or PX in Covent Garden, or ACME Attractions, and the proliferating network of independent young designers, journalists, stylists, musicians, clubbers, dandies, eccentrics, misfits, victims and would-be impresarios (all linked by the style code), became embassies of new attitudes, and new approaches to creativity and cultural production. This, vitally, was the underground arts scene in London as it existed (isolated, radical, unorganised, disorganised and largely unmediated, save by the outposts of its own style codes) prior to the **Freeze** group exhibition curated by Damien Hirst at the Port of London Authority building in 1988, in step with a changing economic ideology, and due to completely re-chart the broader cultural topography.

By the time of the subsequent and more ambitious collaboration with The Fall, **I Am Curious, Orange** in 1988, Clark, Bowery and The Fall were being taken up by the cultural establishment. While Mark E. Smith's career-long contrariness and fiercely held independence would lead him to subsequently refer to the performances as events attended by fanatical fans of The Fall, in which the group shocked a conservative (and by extension 'middle-class') contemporary-dance audience, the work appeared more to represent a period of Clark's artistic development reaching its ultimate fruition. This might be summarised as the zenith of what one could term Clark's 'colour' period: the phase of extravagant, vivid, absurd youthfulness, in which spectacle and provocation were matched by Clark's evident genius and originality as a dancer and choreographer. By the time of **Heterospective** in 1989, the beginnings of a new sensibility – an austerity and sadness, perhaps – were beginning to be apparent in Clark's work: a response, perhaps, to the destructiveness of the decade's bohemian excesses and wildness.

The London streets which Jon Savage photographed in the early new year of 1977 showed a city in depression. This urban landscape had been the venue throughout the late 1970s and 1980s for a remarkable flowering (although the adverb is perhaps too delicate) of loosely networked individualism – fed on the traditional subcultural diet of drugs, flamboyance, sex, boredom and intense emotional drama. As such, the early milieu out of which Michael Clark developed his artistic vision can now be regarded as the historical (and historic) witness to the end of an age – the late 20th-century equivalent, perhaps, to the *Weimardämmerung* which Stephen Spender had observed in German culture and youthful society during the late 1920s.

Michael Clark, 1998. P: Wolfgang Tillmans.

And there was perhaps a political allegory at work in Clark's vision, and in the roles played by his friends and collaborators in realising his aesthetic. As Thatcherism began to peak, and head towards further economic and social unrest, and as the extent of AIDS began to be felt, there was a sense in which Bowery and Trojan (both doomed to early deaths) and the entire aesthetic of vivid, febrile, absurd, loud, extravagant subcultural pantomime was describing a sickly and bulimic society heading for collapse: the Jungian shadow of the enterprise economy. Michael Clark and friends had created their lurid, psychosexual, disquieting, seductive and dazzlingly coloured dream world against an urban metropolitan landscape about to undergo vast change.

Ahead lay the mono-environment of advanced consumerism and digital media, in which everywhere would look like everywhere else, all would be 'other', and everything would be mainstream. Clark, pursuing his lifelong passion for modernist innovation, would go on to interpret Stravinsky, and work to the music of Bowie and Iggy Pop – the great architects of poised, super-cool expressionist rock. There had been a coincidental chemistry, perhaps, between Clark's early vision, his times and his adopted city, the processes of which would be impossible to repeat. The formula however, remains timeless.

1. John Cale in conversation with Michael Bracewell, New York, April 1993.

2. **Bath and West Evening Chronicle**, 31 January 1986.

3. Mark Sinker: 'Concrete, so as to self destruct: the etiquette of punk, its habits, rules, values and dilemmas.' See pp. 120–39 in **Punk Rock: So What? The Cultural Legacy of Punk**, ed. Roger Sabin. Routledge, 1999.

4. See John Robb's **Punk Rock: An Oral History**, Ebury Press, 2006; and more recently **The England's Dreaming Tapes**, Jon Savage, Faber & Faber, 2009.

5. Peter York's classic essay 'Them' was originally published in **Harpers & Queen** magazine, October 1976, and subsequently reprinted in **Style Wars**, Sidgwick & Jackson, 1980. For a further account of the metropolitan pop styling of the early to mid-1970s, see my **Re-make/Re-model: Art, Pop, Fashion and the Making of Roxy Music**, Faber & Faber 2006. This particularly London-based cult of style was concerned with turning one's lifestyle into a knowing pose – 'the keychain codes' (to use Sinker's term) of which comprised a constellation of references to iconic artifice, from the cult of Andy Warhol to the domestic pottery of Clarice Cliff. Pop glamour, Hollywood elegance and the retro-chic of Pop art and rock'n'roll Americana of the 1950s all played their part. But what this pre-punk movement demanded above all was fluency on the part of its would-be participants in the language of style codes on which it was based. The 'stars' of this movement would include singer Bryan Ferry, fashion designers Antony Price and Zandra Rhodes, jewellery designer Andrew Logan, artist and socialite Duggie Fields, club hostess and singer Little Nell, journalist Janet Street-Porter, photographer Eric Boman and hair stylist Keith Wainwright. Their milieu – a social grouping which links the Ladbroke Grove of the David Hockney set of the early 1970s to the opening of the Roxy Club in Covent Garden – would be documented by Derek Jarman, whose film of Logan's 'Alternative Miss World' fashion show is perhaps the definitive record of this particular coterie.

6. In terms of metropolitan geography, too, punk would follow the trade routes of the previous generation both east and west: to Earl's Court and the Fulham end of the King's Road (Vivienne Westwood, Malcolm McLaren, Duggie Fields, Keith Wainwright), and to Shad Thames, Bermondsey, Hackney and Rotherhithe (Derek Jarman, Genesis P Orridge and Throbbing Gristle, and later Clark's close friends and collaborators Trojan and Leigh Bowery).

7. Item #1426 in **Million-Thousand Light Volt Rave** catalogue, Maggs Bros Booksellers Ltd, Berkeley Square, London, 2009.

8. Matthew Hawkins, correspondence with Robert Violette, July 2009.

Charles Atlas

I remember meeting Michael in the small gallery at Riverside Studios. I was in London with Karole Armitage and Rhys Chatham for the performances of our collaborative work, **Drastic-Classicism**. I can't remember how I had heard about him, but he already had a reputation as an extraordinary dancer. Without ever having seen him dance, Karole decided that Michael would be right for a lead role in a new piece she was planning called **Paradise**. He came to New York to work on it, and to replace Joseph Lennon in **Drastic-Classicism** for a limited tour. He left before **Paradise** was completed; he did the work-in-progress version, but never performed the final one.

At that time the usual trajectory, if you were going to be a choreographer, was to dance with a company and then – at about age 30, or a little after – leave and make your own work. Michael was 20, and he already knew that he had a strong feeling to make his own work. It's not that he didn't want to dance, but his real desire was to choreograph. I thought the early choreography wasn't as strong as his dancing, but given that his dancing presence was stellar, that wasn't surprising. The dance world seemed to be saying the same thing that Merce Cunningham used to get at the beginning of his career – 'Oh, he's such a great dancer, it's too bad he's being wasted.'

I remember talking to Michael in a café in Paris when he was performing in a duet with Karole called **The Last Gone Dance**. I had at that time been doing costumes, lights and stuff for Karole and other people, as well as my film work, and Michael asked me to do lighting for him. The first piece I lit was **New Puritans**, a duet for him and Ellen van Schuylenburch. I had had the film idea earlier, so I must have been in touch with him before then.

I've always been independent, but I was never a subscriber to the chance method of doing things. Even when I worked with Merce Cunningham, I lit the dancers and the dance rather than having the lighting be like the weather in which the pieces existed. I continued that approach when I began with Michael. From the beginning he has trusted me to do what I do without much discussion. I normally tell him what I'm thinking – sometimes it interrupts the piece, in the spirit of the work. He has always valued my opinions and instincts, that's why I have continued to work with him – and because he's family, really.

Since I was a film-maker working with dancers, one of my methods in the early days was to get to know

Michael Clark with Charles Atlas during the 1985 filming of **Hail the New Puritan**. P: Richard Haughton.

a work by doing the lighting for it; then I could be confident about what was right when the time came to do the film. That was my motivation in working with Karole and Michael and Douglas Dunn. I had been making films for television in America, and did a workshop for choreographers and directors in London at Riverside Studios that was sponsored by the Gulbenkian Foundation. At some point my producer from WGBH in Boston, Susan Dowling, had said she had a little bit of money to do something in England and asked what I would like to do. I said that I'd do anything if I could do it with Michael Clark.

I had already met Michael and seen him, so I came up with a proposal for a half-hour programme based on Narcissus and Echo – the basis of one of the ballets he had choreographed, **Flippin' eck oh thweet mythtery of life**. He wasn't that well-known then, and I had a hard time getting the film off the ground. Channel 4 had just begun, so I talked to Michael Kustow, its commissioning editor for the arts, and said 'You have this dancer here who is world-class.' Eventually I got a budget to do an hour-long documentary about Michael – but I didn't want to do that, so I made **Hail the New Puritan** instead. I thought I was making

an anti-documentary. The title I really wanted to give it was **Not Michael Clark**, but I was discouraged. At that time there wasn't really a company and Michael wasn't a big star. By the time the film was released, he was.

The whole piece was make-believe and exaggeration. The studio he wakes up in and supposedly lives in is the dance studio at Chisenhale in east London. Everything in the film is constructed reality, and I chose pieces out of the repertory that Michael had choreographed – there was a piece from **Parts I-IV** with Glenn Branca music; the one with Lulu singing 'Shout' was from the piece that he did with Mika Borghese's company; **Morag's Wedding** was from a ballet for English Dance Theatre. I just put it all together in a mix and tried to make 'A Hard Day's Night' but with dancing. I kept the Narcissus and Echo theme, even though that wasn't the basis for it anymore. I made two films with Michael – **Hail the New Puritan** in 1986, and **Because We Must**, which came out in 1989. It starts out at Sadler's Wells. It was supposed to be a dance film with a strong narrative but a third of the budget fell out as I was flying to London to start working on it, so I had to make it shorter and drop the story.

When I think about my attitude toward filming dance, I think back to the pre-videotape days. Before 1973, if you were a dancer that was what you subscribed to, the evanescence and the ephemerality, and the live performance was just for that moment. There's this idea now that everything needs to be documented. It's going to be a tough job for librarians of the future. I've always felt that my job as a director of films of dancing was to make what is essentially a 3-D medium vivid in two dimensions, and to translate to the screen the kinaesthetic experience you get from watching live dance.

Michael Clark with Charles Atlas during the 1985 filming of **Hail the New Puritan**. P: Richard Haughton.

I was always slightly more than a lighting designer – Michael has consulted me about other elements of the production. The lighting sometimes accentuates the structure of the piece and controls the pace of transitions. I did this intuitively, from having worked with Michael over so many years. Often Michael would ask me what colours I was thinking of for the lighting. They would come first – hot pink or green or red – or how to dress the stage, even though it's not a set. I like to show what's on stage and never try to compensate for what's not there or to hide things. I love his work and I want people to see it so it tends to be brighter than a lot of dance lighting. Up until very recently, my only rule was that I never used blue, because it is a dance-lighting cliché. It's such a cheap gimmick – ballet blue. So I didn't use it until **Satie Stud**, where I needed the whole spectrum. In the early days I didn't use any colour at all, just white light.

At the beginning I used to describe Michael's work as 'dance plus'. Even then I could see the interesting steps, the personal inflection of classical dance language, and his feel for dancing. And I loved his bad-boy spirit – it was fun, interesting and extreme. Of course, the great pleasure was to watch Michael as a dancer. A lot of modern-dance people have said that it's really ballet rather than modern dance. Michael's work requires ballet training. He uses the legs in ways that few people except ballet dancers train for anymore. A lot of dancers in New York are just trained in release, which is not what Michael does at all. The idea of bringing other things into dance came from either interpretation or misunderstanding of the project of the Judson Dance Theater, which was about using ordinary people and ordinary movement – Michael interpreted that in his own way. That was one of the fun things about the early work: there was all this stupid stuff in it, stuff that was in complete contrast to high-art performance. It was a way of putting his life on stage, really.

Michael's work has always addressed sexuality in an explicit way. He came of age when there was a more open attitude about being gay. It was something to have fun with, and Michael used that. He knew sexuality was taboo. I put a sex scene in **Hail the New Puritan**, and it was a lot raunchier than I was allowed in the finished film. The commissioning editor insisted on calling it a love scene. I thought that was very funny. But because it was Michael's work, it was inevitable that there would be something sexy.

Because of Michael's early success and his notoriety, the Arts Council felt he could support himself. There

were always people in officialdom who were put off by the racy, taboo-breaking stuff that he did. That, combined with the fact that he had a big audience, meant he didn't get the official acknowledgement he deserved. A lot of the young and progressive dance scene rejected Michael because of his connection with ballet. He wasn't the leader of the avant-garde in that sense, so he's had a funny position. At a certain period, he was an international darling. The first performance he did in New York (at Brooklyn Academy of Music, in 1987) was fantastic, but he received a bad review. The audience totally got it, but the official New York dance world didn't. Maybe it was so hyped that they were waiting to take him down a peg; it was too English, and unfortunately it wasn't presented in the right context. It really needed a proscenium. After that, Michael didn't play again in New York for 20 years.

Personally, I love Michael's work. That's why I keep working with him, so I can keep seeing his work. I treasure my whole history with Michael, aesthetically and in every way. I wish there was a way to convey my memories in some way, so that people could see the whole range.

Interview by Suzanne Cotter,
10 February 2009

Charles Atlas has been producing film and video works since the mid-1970s, many in collaboration with choreographers (including Karole Armitage, Michael Clark, Merce Cunningham, Philippe Decouflé and Douglas Dunn) and performers (including Marina Abramović, Leigh Bowery, Dancenoise, Diamanda Galás and John Kelly). His film **Merce Cunningham: A Lifetime of Dance** won a best documentary award at Dance Screen 2000 in Monaco. Recent dance-related pieces include **Rainer Variations** (2002), with choreographer/film-maker Yvonne Rainer, and **Views on Camera** (2005) and **Views on Video** (2005) with Merce Cunningham. A selection of his film and video works was screened as part of a retrospective exhibition at Tate Modern (2006).

Throughout his career, Atlas has collaborated in live performance, and has been designing lighting for Michael Clark since 1984. His multimedia performance/theatre piece, **Delusional**, for solo performer (created in collaboration with Marina Abramović) was presented in Europe in April 1994. Atlas created video sequences about the work of the Judson Dance Theater in the 1960s as part of the White Oak Dance Project's PastForward, which toured the US and Europe in 2001.

Atlas designed costumes and created live video projections for the stage production **Muscle Shoals**, a collaboration with choreographer Douglas Dunn and composer Steve Lacy, which premiered in Paris in February 2003. More recently, he created the live video component for **Turning**, a collaboration with Antony and the Johnsons which premiered in April 2004 and toured across Europe in 2006. He is currently collaborating with Austrian musician Christian Fennesz on a new live video/music improvisation piece recently performed in Paris and Berlin.

Atlas has also created several large-scale, mixed-media video installations. **The Hanged One** had as its components 15 channels of video, programmed lighting and kinetic sculptural elements, and was shown at the Whitney Museum of American Art in 1997. His 2010 gallery show, **Instant Fame!** consisted of a series of real-time video portraits of performers and artists recorded live in the gallery space.

Cerith Wyn Evans

It's important to understand Michael's emergence from the classical tradition, his background as a dancer, as well as the things that were happening in contemporary culture. Michael was always interested in popular culture. He has always somehow been torn between his great respect for the classical tradition and a very powerful, anarchic, iconoclastic drive to expose its hypocrisy. So, consequently, a lot of what were perceived as very disruptive elements opened up his work to a much younger, more radically switched-on audience in the early 1980s. The classical-dance world just wouldn't speak to them, whereas Michael's work captured them directly: there was humour, a wide variety of different entry points to his work.

Over the years, he has surfed in and out of that. I think a significant moment was when he stopped dancing, or stopped taking the lead parts for himself. In a way that must have been a difficult transition for him, because he was such an extraordinarily talented and gifted performer, so devastatingly charismatic that when he was on stage you couldn't really see anyone else. He had to take himself out of his choreography, in order to make the choreography visible. There is also his psychological life in public, and I think he has had to exorcise his demons through his work over the years. But it never fell into expressionism because its basis was so powerfully within the classical tradition.

He's been my friend since he was 18, so a long time, and with totally different manifestations of what each of us had been doing. We have collaborated in many different ways. The first thing I made with Michael was a film of one of the first pieces he ever choreographed; I have been a performer on stage, played in the band Big Bottom and introduced him to Susan Stenger. So, if only metaphorically, from the wings, I feel as if we have had a deep and sustained conversation over the years. I remember in 1988 when Anthony d'Offay held that extraordinary set of performances by Leigh Bowery, because he knew Leigh would be a way of getting hold of Michael. And then these performances continued from that; they were historic events, in a way. They were much closer to the other tradition of modern dance that Michael had such respect for, which was dance taking place in non-theatrical space. We had underground venues in New York, San Francisco, Paris and Berlin, and also the Netherlands, where the dancers were really on the verge of performance art, on the verge of sculpture. One can hardly think of a very established gallery like Anthony

Cerith Wyn Evan at Stonehenge, 1983. P: Christine Binnie.

d'Offay as alternative in any sense; they weren't used to putting on dance performances in the space. So that was another adventure of sorts.

We have had some real scrapes over the years. We have been in situations that have been nothing else than absolutely classic slapstick comedy: equipment falling off the stage and all sorts of things. Some of the early pieces we worked on together, like **Of a feather, FLOCK** and **Parts I-IV**, were intimately tied to Riverside Studios. Because he was made a resident choreographer there at a very early age, Riverside was significant in the development of Michael's work. He had something that is invaluable to someone who works in this medium: a home. So there were rehearsal studios that he didn't have to pay for, professional equipment, proper dance floors, proper studios that were warm, and the whole support structure. This was his privilege as the resident choreographer. And, of course, there was the theatre. At one time there was the exhibition space and visual-arts programme, and really it was like a family home for him as he was setting up a company.

We first met through Derek Jarman; this would have been in 1980, maybe. I can remember being at Derek's flat on Charing Cross Road, Phoenix House. Michael and a friend of his — I believe his name was Owen — they were the tearaways, the naughty boys who were undoubtedly brilliant as far as Derek was concerned. I seem to remember hitting it off

with Michael. I said I would be interested in making a film as a backdrop to his piece **Of a feather, FLOCK**. At the time, Michael was interested in a certain brand of mainstream avant-garde American poetry, like Gertrude Stein and E. E. Cummings. And not long before, he had done workshops with Merce Cunningham and John Cage, which had profoundly influenced him – he'd met dancers like Karole Armitage there, who were of an older generation and who were captivated by him. This would also have been when he met Charlie Atlas. So there was a kind of epiphany for Michael, shortly before we met, which introduced him to a whole world that he very much wanted to be part of. And it seems that world was very accepting of Michael's skills and talents. So there was fluidity to it.

I read the text **Of a feather, FLOCK**, which was to be recited, I think, but I don't remember very well because there were two things regarding birds from that time … he had also, rather famously, performed **Dutiful Ducks**. There were ducks, and birds, and aviation, generally winged things, and flocks – groups of dancers in unison. The imagery was rife with the idea of flight, and perhaps the intractable communication of birdsong also. It's kind of a level of animal communication, abstraction really, that lent itself to a certain form of non-classical dance.

It was my first year as a student at the Royal College. When I was about to go there, there had been several generations of students who had a more active role in the politics and aesthetics of fine-art cinema; it became much more conservative shortly after I entered the school, although they more or less left me to my own devices. Through a flying instructor who was a friend of someone at the Royal College, I was able to go up in a small plane, above cloud level, with a 16mm camera that I really didn't know how to use. I flew up there, sitting in the back of this little plane with 400ft of film all laced up into the camera. We stuck a tripod mount outside, focused the camera on a fixed point so I could zoom, and up we went. We were bumping around and coming through the clouds. The footage was very shaky and unprofessional-looking. The other thing I was really struggling with was what they call an anamorphic lens on the camera, and that meant we had a really wide letter-box-shaped picture. You use the same lens that's on the camera, on the projector eventually, in order to get the same format.

Now, the stage at Riverside was much wider than that of a classical theatre. And even though we weren't able to go floor-to-ceiling on the backdrop, the image was enormous. So various dances and solos took place in front of this huge, huge projection. It wasn't as I had imagined it, which was this Technicolor thing with fluffy clouds looking like Poussin or something. In fact, it was bouncing around all over the place and out of focus. At the time I remember thinking that I had really messed it up, but it was actually much more in the spirit of the piece. And it was very well-received.

I think Michael had come into the Royal College and seen the film on a Steenbeck machine there. Certainly there was no editing involved. It was very much in the tradition of Cage and Cunningham, so it was like, 'You do that bit, I do the music', and we all would come together. This was the process Michael learned in his workshops. And of course he very much ran with Cage's idea of chance operations, so Michael was never without a pair of dice somewhere. From what I can remember, he didn't interfere and tell me what to do. It's similar to various people that I collaborate with today – you set out the parameters or the boundaries at the beginning, and test them. If it looks like they are not working, you go in and tweak it. But essentially, the idea of there being two parallel activities that came together in the performance, is still to this day very attractive, to me at least.

I remember doing a show around that time at the Institute of Contemporary Arts cinema, through the generosity of Derek Jarman, with various people including the artist John Maybury. We had two screenings a night – I would have the 6.30 slot and John would have the 8.30 slot, or vice versa. And to prevent ourselves from being bored for five nights a week for a month, we'd come with a selection of cassettes and DJ live to the films from the projection box. At that time, images weren't married to a soundtrack. They continued to be this sort of parallel activity. There'd be a constellation of different soundtracks; there could be seven or eight soundtracks to any one film, depending on your mood or how many people were in the audience.

I think the elements that Michael took from the classical avant-garde tradition, which he applied to the popular culture, music, fashion and whatever else was going on with young people at the time, was leagues ahead of what was happening in New York with punk, or immediately post-punk. There was a very irreverent attitude towards establishment culture. And that became an important drive for Michael in his work, and to a certain extent has been a constant for him, even though he has actually confounded that position in recent years. The **Stravinsky Project**, and **current/SEE** before that, were a return to

Michael Clark with Stephen Goff, Cerith Wyn Evans and crew at Riverside Studios, London, 1983, during production of the film component of Clark's **Parts I–IV**. P: Chris Harris.

PARTS I - IV

A cycle in 4 15 minute parts for video, film and 2 - 6 live performers. The number of live performers will vary depending on the performance conditions.

Choreography: Michael Clark

Video and film: Cerith Wyn Evans

PART I 3 synchronized video tapes to be shown on 3 respective monitors. The video material will be a trio in an enclosed space. Gradually, during the course of the dance, the space will get smaller which will alter the movement accordingly.

PART II A video montage for 3 monitors with a live solo danced by Michael Clark. The video material will be gathered from various sources: excerpts from Cerith Wyn Evans's recent work, treated television footage, text and (shot specifically) video footage. The imagery will at times refer directly and at others will be in juxtaposition to the movement.

PART III A series of live duets with a 16mm film backdrop. The film will be shot in the countryside, providing the ideal setting for the duets which explore and redefine the traditional 'pas de deux'.

PART IV A video tape transferred to 16mm film. The relationships established in PART III will form the basis of a more familiar narrative structure for the final part of the cycle.

Music will be gathered from various sources, ranging from Vivaldi to specially commissioned scores.

Technical requirements:-

3 U-matic mains playback decks + monitors on wheels
16mm projector and large screen
basic lighting rig
reel to reel sound system
at least 1 technician

CERITH WYN EVANS

1958	Born Llanelli, Dyfed, Wales.
1976 - 1977	Dyfed School of Art, Carmarthen: Foundation Course.
1978 - 1980	St. Martin's School of Art: BA Hons in Fine Art.

Films and Exhibitions:

Spring 1978	Filmmakers' Co-op
Spring 1978	The Other Contemporaries Show, St. Martin's School of Art
July 1980	First One Man Show, London Filmmakers' Co-op
March 1981	Another One Man Show, London Filmmakers' Co-op
June 1981	One month's season at ICA Cinematheque
July 1981	Montecatini Film Festival, Italy
Dec 1981	Art and Artifice, B2 Gallery, London
Feb 1982	Excerpts on BBC 2's Riverside
July 1982	Montecatini Film Festival, Italy
July 1982	Film Season at London Filmmakers' Co-op
August 1982	One Man Show, B2 Gallery, London
Sept 1982	Turin Film Festival
Sept 1982	Final Academy with William Burroughs etc., Heaven, London

Currently working on A DREAM MACHINE with Derek Jarman, John Maybury and M. Kostiff to be premiered at the London International Film Festival, 1983. and completing the MA (Hons) course in the School of Film and Television at the Royal College of Art.

Production notes for Michael Clark's **Parts I-IV**, 1983.

neoclassicism. He's almost come full circle, in that he now shocks people by putting on something that is formally exquisite, because there's an audience who are nostalgic and are disappointed if they don't see a drag queen with a dildo on stage.

I think Michael has a highly developed intelligence in that respect. I have never seen him take anything for granted. His intelligence leads him to interrogate the text of what he's doing at a profound level, its musicality, its appearance. Timing – and the dancers being able to interpret the choreography – is absolutely everything for Michael, because he wants to remain true to its spirit. I've seen him make works on dancers because they have certain attributes, skills or qualities. So the choreography would take into account that it's made for a particular person. Michael has worked with great dancers in the company over the years, but essentially it's this intelligence, to be obsessively involved with the material at a very intimate level, that shines through. Not even drugs took precedence over that. That really was the core, and it's palpable. It's a rare gift.

Parts I–IV was medium-led. We were filming the dancers, and using electronic video for the first time. And coming out of things like the work of Yvonne Rainer and Dan Graham, we were doing live transmission. So the piece grew out of the fact that I had access to this equipment. We looked at ways in which the reproduction of movement, of the choreography, was radically dependent on things like framing and camera movement. But when you interspersed the representation with live movement itself, there became a kind of feedback loop, whereby it was possible to have a live performer with something pre-recorded, or with something that was being simultaneously transmitted from a different angle. We were really dealing with a kind of fragmentation of movement. We attenuated it right down; it was completely black-and-white, very classical, and very severe in a way. It wasn't without humour, but the humour was very subtle. The situation was like the prop itself.

I played quite an active part in that. We recorded it at Riverside and it mutated, as much of Michael's work has done, from an original idea and from an initial performance. Michael very often returns to a piece in order to rework it into version two. Over the years he has returned and returned and returned, in order to re-examine what the piece is, in order to restage it, very often in different contexts and situations.

I hate to say it grew organically because there's nothing really organic about **Parts I–IV**, but I remember that it addressed formal and spatial concerns that were not returned to until **current/SEE**, 20 or so years later. There was also this element of playback: of looking at the videos, of framing things. We employed a set that was very simple – a kind of corridor that turned into a corner. Over successive sequences in the video filming we had stagehands make them smaller and smaller. So there's one bit where a dancer was doing a handstand in the corner, but the space that the camera was pointing into was no more than a metre-and-a-half wide. That is very different from doing something on stage.

So we were able to play with scale, with spatial configurations and your perception of it. If you're shooting against a brightly-lit white wall, it's difficult to tell whether the lighting is even, whether it's a corner or a flat space. Michael was very keen on putting pressure up against these side walls and actually making choreography that was not on the floor – so he wasn't touching the floor at all, he was putting the weight against the walls, and doing these strange moments in the film where there was a complete suspension of the body.

There was an extraordinary performance of what was then an elaboration of **Parts I–IV**, which became increasingly more elaborate and baroque. It was when Michael first wore the tutu, I think. Anyway there was a dance festival in this huge theatre in the south of France with Pina Bausch and Trisha Brown and various others. They didn't have the budget to fly everyone over there, so Michael said: 'OK, you and I are going to do it together.' The European dance world had descended on it because there were such luminaries in the programme, so it was completely packed out. Dressed in white shirt and black trousers, I wheeled out this video monitor on a stand into the centre of a white stage, leads trailing behind me. I was moving it very, very slowly because I was given steps to do. As I rolled the thing slowly towards the front of the stage, Michael came on in a Vivienne Westwood T-shirt with really long sleeves and really short blond hair, a white tutu and white stockings. There were roars from the audience and he started into his solo. Meantime, I was moving this thing forward and at one point I became aware that the stage ended in about two inches, right into this deep orchestra pit. Anyway, the wheels went over the edge and the monitor went crashing into the orchestra pit with a huge bang and then a huge explosion. The audience thought this was the best thing they have ever seen, and Michael and I shrugged, thinking: 'OK, what are we going to

do now?' So I went around to the end of the stage and into the orchestra pit, which was fizzing with electricity, and I lifted the thing up, trying to get it back onto the stage, at which point there was a standing ovation. The audience were screaming and applauding.

All the lighting cues were taken from the monitor, so it was obviously a disaster for the guy in the lighting box, but the audience didn't know this. The curtains closed behind me while I was still in the orchestra pit and I just thought, I have to get out of here. So I ducked down through a door and tried to get out, whereupon Michael opened the curtains and said, 'Plus! Plus!' The curtains opened, the lights went back on, and he went into a really extreme solo, like the Stravinsky solo, just hurling himself across the stage. We got a standing ovation, and we just went behind the curtains and looked at each other, thinking: 'Shit! How are we going to pay for the monitor? They cost thousands.' Then the director of the festival came over and said, 'I had no idea it was going to be so magnificent.'

Later, in 1986, I was in Charlie Atlas's **Hail the New Puritan**. Again, that was being invited as part of the gang. We were friends with Charlie, and he had got money from Channel 4 to make this documentary about Michael, something that involved all his friends. Of course done by Charlie Atlas, it would have been playful; and the way the music and editing is organised, its Charlie's way of stuttering things, of cutting things up. It was agreed that I would have a cameo scene at one point – I'm in it several times in different guises, but one scene, which I haven't seen since then, I don't think, was a spoof on the dancer Gaby Agis. Michael would constantly be accusing Gaby of being a hippy, so she had to play Isadora Duncan in the film. We were in Kensal Green cemetery, and she was in some kind of floating dress, doing a spoof of Isadora dancing. I had to play a film director, shouting at her because I was meant to be Eisenstein or something. I also got to sing a Welsh folk song.

There was a minimal professional crew there: camera operator, assistant, sound recordist and maybe a couple of people working on props and costumes. It was very rough and ready, and improvised at the time, unless there were dance sequences that were made much more formal. They were linked by these informal episodes.

I also realise that there are so many people in it that are no longer here. That's quite a sobering thought.

Interview by Suzanne Cotter,
29 April 2009

Cerith Wyn Evans began his career as a video- and film-maker. As a young artist he was assistant to Derek Jarman. He has worked with Michael Clark since the early 1980s, collaborating on sets and as a performer, notably on **Of a feather, FLOCK** (1982), **Parts I–IV** (1983), **Hail the New Puritan** (1986) (a film by Charles Atlas) and as part of Big Bottom for the 1998 performance of **current/SEE**. His own work has been presented in exhibitions internationally, including the Venice Biennale in 1995, 2003 and, with Florian Hecker, 2009, 9th International Istanbul Biennial (2005) and Documenta 11 (2002). Recent solo exhibitions include MIT List Visual Arts Center, and Museum of Fine Arts, Boston (2004), Frankfurter Kunstverein (2004), Kunsthaus Graz (2005), Musée d'Art Moderne de la Ville de Paris (2006), MUSAC, León (2008), Inverleith House, Edinburgh (2009). His collaborative installation **A=P=P=A=R=I=T=I=O=N** with Throbbing Gristle was presented at Tramway, Glasgow, in 2009.

Video still of Michael Clark (on floor), Melissa Hetherington and Simon Williams during a one-off performance at White Cube, London, 2003, for Wyn Evans's solo exhibition **Look at that picture ... How does it appear to you now? Does it seem to be Persisting?** P: Hugo Glendinning.

CONFIDENTIAL

TO: DANCE DEPARTMENT, ARTS COUNCIL OF GREAT BRITAIN

Report on Dance or Mime

From: ███████

Please circle as applicable:
ACGB Officer Adviser (Co-option) Observer RAA

Company/Artist: Michael Clark

Title of Performance: Parts I - IV

Venue: Riverside Studios Date: 5 August 83

An evening of creative chaos this, underrehearsed and probably unfinished, but a glorious work-in-progress with flashes of genius.

The name Michael Clark alone now guarantees a sell out audience at Riverside with dozens turned away. An unusual situation for a very young choreographer struggling to find his feet and to assert his own style - especially for one so determinedly avant garde and self-sufficient as this one. His influences are highly eclectic - Richard Alston and Karole Armitage in particular - which makes Michael a very very modern third generation Cunningham offshoot. I liked the energy and aggression in this (Armitage) allied to the precise use of classical technique (Alston). I also liked the mixture of different types of dancers, whether this was intentional or whether due to force of circumstances, the highly trained Rambert members Kate Price, Hugh Craig and Ikky Maas looking poised and cool in contrast to the more casual stance and rougher movements of Gaby Agis and Steve Goff. All this was held together by Michael's intense presence, felt even when he was off stage, and his truly remarkable dancing. His solo in Part III and the one at the end of Part IV (wearing a tutu) rank among my dance events of this year.

OK there were bits when I got annoyed and bored such as when we were left looking at 3 video monitors for some time with an excrutiatingly loud noise assaulting us. But to compensate there were moments of real excitement and overall I thought it was very impressive. This young man is going places and he deserves whatever support we can give.

Christine Binnie body painted and photographed
by Wilma Johnson, Saint Martins School of Art, London, 1980.
P: Wilma Johnson/Courtesy England & Co, London.

Christine Binnie

Cerith Wyn Evans and I lived in a squat in Carburton Street, next door to each other. He lived on the corner building, the old Lewis Leathers shop, and we turned it into a café. It probably only lasted about a month or so but a couple of people, like Grayson Perry and my sister Jennifer Binnie, did performances there. We had a typewriter and people used to come and write poems. It was very popular with people like George O'Dowd [Boy George] and Marilyn. It was called the Coffee Spoon; a cup of coffee was called a Cavafy, and a cup of tea was called a T. S. Eliot.

The Neo Naturists were started by my sister Jennifer, Wilma Johnson and myself. We used to go to nightclubs and do performances wearing body paint. Sometimes the performance would be the act of painting each other, sometimes we'd have the paint on already. All the people around us were Blitz kids doing all that post-punk stuff when it was very trendy to be thin, po-faced and have perfect make-up. We could never really manage that. We were always red and shiny and smiling, and a bit too fat. So we did the opposite and painted ourselves, got messy and had fun. There is a Neo Naturist manifesto but it's only a joke. It was in the **International Times**, which was a kind of 1960s, freedom-art-counter-culture newspaper. The heyday was 1982 to 1985, but we carried on for a long time after that. The last performance was at Hastings Bonfire in October 2008.

After Carburton Street, Cerith and I moved into Warren Street. There were loads of us living there – there was a side on Warren Street and a side on Euston Road. Two separate houses, but we had a back connection between the two. All kinds of things happened there, which led visits by social services. Anyway they came along and spoke to us in about 1980, and gave us three or four council flats in Camden, so we divided ourselves up and I ended up with John Maybury, David Holah and Lesley Chilkes. There was another flat with Princess Julia and Jeffrey Hinton and someone else. David Holah started having a love affair with Michael Clark, which is how I got to know him.

We started doing things with Michael. I don't think there was ever really a discussion; we just sort of did it. We were doing our performances, Michael was doing his ballets, and it just sort of happened. The one I remember the best was the first one, a one-minute ballet. We liked doing things out of Shakespeare, reciting the sonnets and things. We did **Venus and Adonis** – Michael was Adonis, I was Venus and David Holah was the deer. We spent ages gaffer-taping his fingers to make hooves. My sister was a grassy bank. I can't remember what we did, exactly – I only remember getting ready.

I think we were in four or five things with Michael. Sometimes it was more his idea that we joined in with him; other times, it was more our idea. We just had conversations and all that – that was the fun bit, really; we'd have stupid ideas and then make them happen. We did **Sexist Crabs** a few times and it was always different. It involved sticking bits of seafood to ourselves and having a communion where we gave out seafood to the audience. Michael danced around us. In **Hail the New Puritan**, we had lederhosen-style body paint and Michael lifted me onto his shoulder. My main memory is that there was a ballet move called a bluebird or a fish-dive and Michael did it with me, which was exciting. In 1986, we were body-painted cheerleaders on stage at the Royal Opera House with Michael. Dame Peggy Ashcroft was cross with us because we got body paint on the costumes.

I felt Michael was a soulmate; he seemed to understand what we were doing straight away, so we had a rapport. And we just loved it that through Michael we had the opportunity to do these proper ballets and be part of this proper thing. It was lovely the way Michael was so open to our ideas. Some people would love our stuff and want to join in, but then we wouldn't hear from them; with Michael it would happen right away.

Funnily enough, one of my memories of doing the dance at Riverside was that it was the first time I ever heard of Ecover washing powder. I said to him, 'Oh, there must be a lot of washing involved in this, with all the changing every day', and he said, 'Oh yes, we use Ecover – it doesn't kill the fishes'. We would just get ready backstage, do our little slot and have a laugh, then all go home or off to a nightclub. I don't think we ever went out to the front and looked at the whole thing.

Interview by Suzanne Cotter,
8 June 2009

Christine Binnie is a founding member of the Neo Naturists, with her sister the artist Jennifer Binnie, painter Wilma Johnson and artist Grayson Perry. Most active during the 1980s, their work was the subject of an exhibition at England & Co., London, in 2007.

Grayson Perry

I moved to London in 1983, and the Neo Naturists were happening then. Christine had done some things with Michael Clark before I came along, but I was the boyfriend of her sister, Jennifer, so I was roped in as a male member – literally. I remember going down to Riverside Studios to do something. Michael was already this mythic figure. His sensibility chimed with the Neo Naturist ethic, which certainly pervaded my work and still does. It was a kind of anti-cool – which in itself is cool, but it's a step ahead, or behind (same thing). Michael chimed very much with Christine, being classically trained and also liking pranks and odd subjects to crop up in the work.

I first met Christine in 1979 or 1980, because I was going out with her sister at art college, and she had moved into a squat with Cerith Wyn Evans, Boy George and Marilyn. She opened a sort of café in the squat next door in Carburton Street, which has since been demolished. But then they moved into Warren Street – there was John Maybury and Stephen Jones the hatmaker and Princess Julia, I think, and a lot of other people who took too many drugs. We did a couple of pantos and put them on in Notre Dame Hall; it was kind of naff and a bit daft. I did a cooking demonstration as Fanny Cradock, and other bit parts. We liked showing off. I was bad at it, but I think that kind of qualifies me as a Neo Naturist more than anything, because there was something anti-slick and anti-professional about it.

The first time I met Michael, he was putting on rubber tights in Riverside Studios. The Neo Naturists were going to take part in a performance. We didn't do any rehearsals, we were just told to turn up. I had on a big floor-length fun-fur coat that Wilma made – I think I only had that on – and had to crawl across the floor towards them with a camera with a flash on it. They might have been my instructions for the first time. I think we were hikers as well, so we walked around the perimeter of this dance area, hiking, with lederhosen painted on, or something like that. There would be music playing and we were trotting around. I'm sure Michael thought about why, and for how long, but it was very haphazard.

Michael was so much more successful than us, that was the point. He was this touchstone for a seemingly glamorous and respected world, this *enfant terrible*. We were very poor amateurs, but enjoyed the same spirit of not taking ourselves too seriously. I still think that's absolutely essential to be a good artist.

We all lived in a house with Cerith Wyn Evans and his boyfriend, Angus Cook. I came up from Portsmouth Polytechnic, moved into a squat and very quickly filled it with our friends including Cerith, Angus and Christine. Everybody knew everybody. We were all young and ambitious – I had very low self-esteem at the time, so I sort of trundled along, but I definitely picked up the mood. Cerith and John Maybury were friends with Derek Jarman and I was an aspiring film-maker. There was David Holah from Bodymap and Andrew Logan. It was kind of New Romantic and gay, but with an ironic regard for the avant-garde. I think that kind of thing shaped my view of making art. Christine enjoyed everything that modern culture could offer, but never quite took it seriously, in case it got up itself. Cerith seemed to have more of an eye on the status of the avant-garde. We were just buggering about; if it happened, it happened.

I had no interest in contemporary dance whatsoever, but I liked what Michael did a lot. I had never been to a contemporary-dance performance, not knowingly anyway. I went to see one of his and thought it was very funny. I loved all the jokes and the in-between bits. I loved it when he pretended to break his leg, and when he had his big erection. One of the funniest moments was when they all broke into 'Knees Up Mother Brown' – that had me in fits, the way he smashed genres together. I think my favourite performance was the one at Sadler's Wells where Leigh Bowery was playing the piano [**Because We Must**]. I knew Leigh from fairly early on.

I had been a fan of The Fall before I came to London. On the one hand it was reassuring to me; I liked something that Michael Clark liked, therefore it must be OK. But it was also this trendy world co-opting a slightly grungy cult band. I remember Cerith saying that Mark E. Smith got letters from his fans saying things like: 'What are you doing hanging out with all those poofs?' Because even though The Fall were an esoteric, arty band, and Mark E. Smith a kind of poet, their fanbase was that gritty, Northern, 'I'm real, me!' thing. So as an aesthete gay, you weren't allowed to like it. It was an interesting combo, and it was very far-sighted of Mark to take up that collaboration.

I think Michael probably did the things he did and worked with the people he did because he felt like it; he was interested, and that inspired him.

Thinking about the politics of the time in retrospect, when I left college, art was this rather dour

Michael Clark, with Grayson Perry as DJ, at The Heil Mary
Club, London, c.1984. P: David Gwinnutt.

socialist activity, and your idea of a gig was getting a residency in a coal mine or an Arts Council grant. Everyone wanted grants for things, and you never thought about the market and selling your work. I never knew anyone who had sold a work of art. I came from that rare breed that went to art college because I liked making things, not because I wanted to be an artist. There were various things that operated in our favour – we got a full grant and the dole, and squatting was relatively easy. So those things helped a lot in terms of being able to live in central London for nothing. The fact that there weren't galleries hoovering up the latest artists meant you had to make your own effort. When the goldrush of Young British Art happened, too many people had success too quickly, and that's not necessarily good – although, from where I was sitting, Michael seemed to be successful fairly early on.

Michael brought new audiences to contemporary dance, certainly for people like me who wouldn't normally go and see that sort of thing. And he was instrumental in me deciding I wasn't gay, and wouldn't ever be. Not that I ever thought I was, or it was an option.

We used to go to the Black Cap up on Camden High Street and laugh at drag queens there, so I was aware of that culture. But I knew that wasn't me. At the time I wanted to pass as a realistic woman, so I dressed in Marks & Spencer clothes, and walked up and down Oxford Street as a sensible housewife. That was my version of cross-dressing, and occasionally I went to openings or other sorts of things. I think in one of Charlie Atlas's films I'm wearing a painted corset and that felt slightly odd; you know that it wasn't my natural style.

I can't really comment on Michael's dancing. I could see he was good at it, but he was the dancer of the subculture that I came out of. His sensibility chimed with a lot that was going on around me in the 1980s, so he was our dancer and we flocked to him. Then, we had David Bowie and Mrs Thatcher and unemployment, and those things shaped a certain sensibility. We wanted to be cultural but at the same time we were having fun, we were party people. We went to nightclubs and liked dressing up. Christine was really good at picking up on things that were unfashionable. I still have the same antennae for the ossifying of culture – when that happens, it's time to smash it all or move on. You know, in the contemporary-art world, what used to be hip suddenly becomes the norm. It's important to have that sensibility in the art world – the sacred cow that is ready to be slaughtered – but Michael absorbed those sensibilities and incorporated them into his world.

Interview by Suzanne Cotter,
16 June 2009

Grayson Perry is best known for his elaborate ceramic vases, whose decorative motifs serve as narratives and commentaries on aesthetic, cultural, social and political subjects. Winner of the 2003 Turner Prize, which he accepted wearing a purple satin party frock, Perry is also Britain's second-most-famous transvestite. As well as his signature ceramics, Perry, who studied sculpture between 1978 and 1982, has worked in a variety of media including embroidery, film, photography, tapestry, etching and cast metal. He has exhibited regularly and increasingly internationally for 27 years, with solo exhibitions at the Stedelijk Museum in Amsterdam; the Barbican in London; the 21st Century Museum of Contemporary Art in Kanazawa, Japan; and MUDAM in Luxembourg. The exhibition **Unpopular Culture**, selected by Perry from the Arts Council Collection, toured the UK 2008–9. He also often appears on TV, radio and in the newspapers commenting on cultural issues and has had a weekly arts column in **The Times** since 2007.

Top: Neo Naturists Wilf Rogers and Grayson Perry, **Spring Rights** cabaret, 1984. P: Wilma Johnson/ Courtesy England & Co, London.

Above: Neo Naturist cheerleader Christine Binnie with Leigh Bowery, backstage, Royal Opera House, London, 1986. P: Neo Naturist Archive.

Lorcan O'Neill

I met Michael in July 1987 at the Windmill Club in Soho. The Anthony d'Offay Gallery was hosting a party there for Gilbert & George, who that week had a show opening at the gallery, as well as a retrospective at the Hayward. I'd just moved from Boston to London a few days earlier to work at Anthony's, and although I didn't know who Michael Clark and Leigh Bowery were, everyone was excited at the possibility that they might show up. Which they did, along with David Holah, Cerith Wyn Evans and Angus Cook. Although by their standards they weren't especially spectacularly dressed (even Leigh was in 'civvies') they seemed beyond glamorous to me, and clearly also to most others at the party.

That autumn I went a few times to see Michael perform in **Because We Must**. Anthony d'Offay was a big fan and he liked the idea of asking Michael to do something at the gallery. It wasn't immediately clear what an art gallery could do with a dancer, and at that time Michael was busy with big productions (**I Am Curious, Orange**, which opened the following year, and a film with Charlie Atlas) and had little time to work on anything else. And so rather than lose enthusiasm for the idea of doing something live in the gallery, we offered the space to Leigh for a week. Instead of having a sculpture in a room, you could have Leigh in a room. His iconic other-worldly presence was already well-known in London's club-land, where he was exhibiting himself every night.

And so in October 1988, Leigh divided the upstairs Dering Street space with a long floor-to-ceiling one-way mirror: he was brightly lit on one side and could see only his reflection in the mirror; the audience was on the other side in semi-darkness, and could see him lounging on a divan, slowly posing, a *tableau vivant*, in a different outfit each day. Some people stood, some sat on the floor, and most stayed long periods in a quiet almost temple-like atmosphere that I don't think anyone had quite anticipated. A tape played low traffic noise, and bowls of tissue paper soaked in essence wafted a special smell for each day (banana-smell day was most unfavourably noted). Many people, a catholic cross-section of London came to stare at Leigh: students, journalists, friends and artists, including Lucien Freud, who later that year asked him to pose for the first of many paintings.

Michael came to see Leigh a few times and there is a nice photo of the two of them hamming it up by the divan on one of his visits. I think he saw that there was a way to do something small but impactful at the gallery. Anthony offered him a fee and he developed the idea of **Heterospective**, which opened in the same space in October 1989, exactly a year after Leigh.

Heterospective ran for a week. There were four performers: Michael, Stephen Petronio (the American dancer and choreographer, Michael's boyfriend at the time), Russell Maliphant, Leigh Bowery and the corset designer Pearl (now Mr Pearl of Paris). The audience of about 100 was seated on stepped benches in the centre of the space, and faced an open archway to a dimly-lit room beyond where a high platform bed was visible. Michael and Stephen were naked under the covers, slowly making out, and the audience settled itself once it realised that the performance had already started. The dance part started – supposedly – when either Michael or Stephen achieved orgasm. The only person back there who could confirm this was Harriet Laver, a very proper girl, just out of school, who had joined the gallery that week. Her first job was thus to crouch unseen behind the bed all through the performance, and at a certain moment to wind very fast an invisible cord attached to a wig on the floor that Leigh and Pearl would chase. Harriet is much too discreet to have ever discussed what she saw or heard from behind the bed.

Once ready, Michael and Stephen left the bed and began a duet, which I think is one of the most beautiful passages that Michael has choreographed. Both naked except for a muff held strategically at the groin, they danced slowly through the arch into the main space. They both looked exceptionally beautiful at that time, and the dance is an aching

Leigh Bowery and Michael Clark photographed at the Anthony d'Offay Gallery, London, October 1988.
P: Lorcan O'Neill.

paean to love and its complications. Michael was battling his inner demons by then, and there were many references in the show to desire, addiction, sex and violence. One wall had syringes and needles stuck into it, and later Michael danced wildly to the song 'Heroin' by the Velvet Underground in a flesh-coloured body suit from which syringes hung. On one wall were nailed 10 realistic rubber casts – jiggleable testicles included – of a famous porn-star's erect member. At one point, Leigh and Pearl, who had been squashed together in a window and hidden behind a silver-foil curtain, burst out wielding hatchets with which they chased Harriet's rapidly escaping wig along the floor. Leigh, dressed as a 'naked woman', wore one of his sparkling fringed hoods, a buxom glittering bra and had his parts tucked and taped under a dark merkin. He always seemed big, but he towered and expanded beyond petite Pearl in an almost comical way, and their bizarreness together contrasted with the ethereal beauty of Michael and Stephen. Although entirely different, Michael and Leigh were both mesmerising performers, and I think Michael, loved for his perfection, always recognised a side of himself in Leigh the outsider.

The audience reaction was strong. People were passionate about the work, and felt it was brave, personal and new. The gallery charged for tickets – all proceeds went to Michael – and they were not cheap (something like £25), done in order to discourage non-supporters and to comply with the law. At that time – as there was nudity in the show and the possibility of sex – it could not have been free to the public; it needed a reservation and a charge, and signs saying that it was not for minors. Somebody did report to the police, and the gallery had a phone call saying that a complaint had been lodged, but with only two more days to go we ignored that.

How to record dance is an issue for dancers, and Michael understood that telling a story rather than simply having a camera on stage is important to keep the dance alive after its performance. His collaborations with Charlie Atlas, one of the greatest dance cinematographers, are historic. The artist Cerith Wyn Evans filmed **Heterospective** (he'd also filmed Leigh's show the previous year) and is a close friend of Michael. The art world has always embraced Michael's work. Anthony d'Offay, Heiner Bastian and Anselm Kiefer were influential art-world supporters at that time, and that enthusiasm has expanded over the years into collaborations with, and support from, a wide section of the art world. That interest comes from a lot of things, but the most obvious is that Michael's work is very visual. From the beginning, Michael worked with people like Leigh and Trojan who created pictorial and sculptural effects that hadn't been seen on stage in England before: the giant teapots, the trees with fried eggs, the measles-spot outfits, the costumes with exposed bums, the toilet/Hitler look… Michael encouraged his collaborators to pull out all the stops. He goes way beyond what anyone would normally expect is necessary to put on a show – he clearly pushed things visually, and I would say the art world embraced him especially for that.

Michael is Hermes, the beautiful and fleet god of boarders and crossings, the teacher and harbinger of change. Experiences with him have an air of fable: in a Swiss hospital, I watched a nurse called Hortense (whom he kept calling Tensewhore) rudely insert pain-killing suppositories, which he'd extravagantly begged for but didn't, I suspect, really need; north of Aberdeen, I wore a kilt at his mother's re-marriage to her re-discovered first husband 50 years after the initial wedding; in Marseilles last year I visited Le Corbusier's Unité d'Habitation (his seminal multi-use concrete building of the late 1940s) where Michael now keeps an apartment and has given dance workshops at the rooftop gym. It seems a long way from Cairnbulg.

Among Michael's gifts is an almost monastic self-sacrifice when needed. At some time in the 1990s he went to New York to study film on a Wingate grant. It was winter, and he stayed in my apartment the night before he left – he'd been essentially homeless since leaving Shepherd's Bush – and as he prepared to leave for the airport in the morning I saw that there was a hole in the bottom of one shoe, and the sole of the other was flapping off. I gave him a pair of sneakers, but I've got size 13 feet, and so one of the most sublime movers of our time looked like a clown heading to Heathrow. I remember thinking I didn't know anyone at that age – Michael was in his thirties then – who was so ready to put such practical discomforts aside for the sake of his art and personal integrity. I always found that incredibly impressive.

Interview by Suzanne Cotter,
27 September 2009

Lorcan O'Neill is Irish and was educated in Ireland, Canada and the USA. He moved to London in 1987, and spent 13 years at the Anthony d'Offay Gallery – where he worked on Michael Clark's **Heterospective** – before opening a gallery in Rome in 2002.

Sophie Fiennes

Michael Clark as Caliban in Peter Greenaway's film
Prospero's Books, 1991. P: AllArts/Ronald Grant Archive.

I first met Michael in 1990 when I was working with Peter Greenaway on his film **Prospero's Books**, in which Michael played the part of Caliban. I had only seen his **Heterospective** at the d'Offay Gallery in 1989, because I could never get into Michael's shows. I used to be a photographic assistant on Rosebery Avenue, and there'd be this moment when there was a throng of interesting-looking people travelling up to Sadler's Wells. I remember trying to get in to **I Am Curious, Orange**, but I couldn't get a ticket. It was completely sold out. So we met through the Peter Greenaway film. It was a low-budget film and the conditions in which Michael was expected to perform were quite miserable. At one point he had to descend down a chute in cold water and then dance. There were repeated takes, and like soldiers in the trenches singing hymns, we comforted ourselves by reciting Bowie lyrics, discovering our mutual ability to recite pretty much every Bowie lyric backwards. Months later I was editing with Greenaway in Paris and Michael was in Angers starting to make his **Rite of Spring**, at that time a collaboration with Stephen Petronio. Michael enticed me down to Angers and I watched rehearsals for several days.

I have no dance background, but I did life drawing from an early age, and that develops a sharpness of observation when it comes to reading weight moving in a body. I remember he ran the Chosen Maiden's solo, where the sacrificial virgin dances herself to death. He was making it with an American dancer called Joanne Barrett, who had a gymnastic background. I was amazed; there was a beautiful kind of logic at work, to do with weight, inversion, propulsion and collapse. Michael really wanted to make his own **Rite of Spring**. I think he saw that I was ridiculously hard-working – and before I knew it, I found myself leaving Angers with a new job. I was persuaded to produce the work with him, which would be the first piece he had made since disbanding Michael Clark & Company in the 1980s.

Michael often told me he consciously became a heroin addict; that he even had to work hard to become addicted. It seemed somewhere between a creative experiment and a way to avoid the burdens of running an independent dance company, which he had done from a very early age. In **Heterospective** he had danced to Lou Reed's 'Heroin' in a flesh bodysuit with needles fixed into it. Pop music and culture is as significant an influence on Michael as his formidable classical-

Bessie Clark, holiday photo Aberdeen Beach, date unknown.

ballet training. Stacks of the **NME** accumulated under the stairs in his flat, and alongside these videotapes recorded off the TV about Balanchine or Yvonne Rainer. Such influences formed what Michael might call a 'kinky contrast' of control and release.

I feel I have learned a great deal from Michael. I have always been intrigued by the way he approaches ideas and thinking. Aside from his brilliant sense of the ridiculous, he is a very strong observer. He's very cautious, particularly in what he says; I think he approaches words as if they are movements, that have to be performed perfectly or not at all. When I was making the film **The Late Michael Clark**, I was struck by a moment in an after-show public discussion at the theatre in Blackpool. This was when he was touring **current/SEE** in 1998. I can read from the transcript:

> ...Choreographic techniques are not very useful in themselves. There are certain ways of doing things that exist and sometimes they are quite useful to see what's possible by using them. How much you place on the idea that a piece of music has to mean something or tell the audience a story? Not a great deal, but you can't deny that the body has a brain behind it or there's a mind at work, and to deny that would be kind of foolish, but then again I don't think music or movement are necessarily the best ways to communicate very literal things. I mean, I love words, and I love the complexity of words, but I guess I'm more interested in what I consider a more complex place, which is where things can't be made specific through language. More often than not, things which try to have an obvious meaning or try to communicate one thing don't really interest me...

I feel I really learned from that sophistication in Michael as I watched him, that strange meeting place where meaning is cancelled out, or allowed to happen, or just suggested. And the importance he placed on both logic and intuition — he's got the most incredible arithmetical brain, which was why he loved the challenge of working with Stravinsky's **Rite of Spring** with its changing tempos and strong rhythms. I can also recall him saying how working with music like The Fall's, with its simple 4/4 time, gave him the opportunity to construct more complex timings for his dance that could work in contrast.

Everything with Michael is a work in progress. His sense of where to go creatively has always gone beyond what most dance critics wanted to see him do. If he had done what was expected of him from the outset, he would have simply had a career as a dancer in the Royal Ballet.

I remember once going into the rehearsal room and watching Michael and the dancers endlessly repeating a movement. They held their elbows together stretched out from their torsos and clenched their fists up near to their chins. He was trying to get them to unfold their arms as if they had vertebrae in their forearms, like a spine releasing, but of course there are no articulation points between the wrist and the elbow. Michael struggles with perfection — nothing is ever perfect for him — but in this case it was the limitation of the body itself that he was trying to overcome. When you see Michael's work a lot, his movements become like songs that stay in your body, even if, like me, you can't actually dance them at all.

At the time of the London performances of **mmm...**, touring with a live work was something new for me. The fact that you could make changes — it was never fixed, like a finished film is — was exciting. Michael's **Rite of Spring** evolved in several stages and we can see now that he was always building towards the **Stravinsky Project**. He started making material in Angers with Steven Petronio, which they also showed at the Centre Pompidou. After Paris they split and worked separately on their own **Rites**. Michael came back to London and I started working with him properly. He sent me off to the Arts Council to haul in a £25,000 grant that was earmarked for him. He had performed

18 months earlier at a department store in Tokyo called Parco that has a theatre in it. The shows had been a sell-out and Parco wanted him back, so we were able to negotiate a good fee, because the money from the Arts Council didn't get us very far. We did nine nights in the Parco theatre, some dates in Osaka and Nagoya, and then came back to Tokyo for a final performance on a gargantuan stage on which this small troupe of dancers looked like pin-pricks! But it was very successful, and an appreciative Michael Clark Company returned to England to develop the show further.

It was after Japan that Michael made the section of the show to the Public Image Ltd song 'Theme'. This was a strong sequence, both austere and vulnerable. Leigh Bowery designed a striking costume with a black back, white velvet polo-neck front and flesh-coloured leggings (an unexpected detail in the crotch seam meant that when the dancers spread their legs, a black V extended into the flesh side of the costume).

The Arts Council grant was tied to a commission from the Nottingham Playhouse. Its director, Ruth Mackenzie, had had the courage to say 'I'm going to commission Michael's next piece, whatever it is'. We came back from Japan, developed the show, played in Nottingham, had another six to eight weeks of rehearsal and then set out on a gruelling UK regional tour. We were a small troupe, with Bessie (Michael's mother) and Leigh and these fantastic, very committed dancers, Barrett, Julie Hood and Matthew Hawkins. Any live piece that's devised or created, that is not a pre-existing work, takes time to grow, and grows with audiences. So by the time we came to London the show was in a really great place.

Super-8 film still of Michael Clark and his mother, Bessie, in Cairnbulg, Scotland, c.1995. P: Sophie Fiennes.

Michael always had a clear sense of what he wanted to do when we brought the show to London. He said we should contact Michael Morris from Artangel as he didn't want to show the work at Sadler's Wells, but wanted it to be site-specific. Michael Morris came on board after Nottingham and found the King's Cross space. It was a complete sell-out, but Michael would never rest on his laurels. He was always looking for where the show still needed to go. For him it was never good enough. Often it wasn't a question of adding, but of taking away. In previous productions, the company had thrilled with outlandish costumes; now he was trying to reduce the impact of costumes so you could see the dance. He wanted people to follow the logic of the choreography and its relationship to the music. This determination at one point reduced Leigh to tears. **mmm...** won the **Time Out** award. Leigh and I went to pick it up, as Michael was at that time spending several weeks in bed, recovering.

My time working with Michael was intense, but it was built on a personal friendship. He is one of the people who I really love and will always love; he inspires love from people. I was working with Michael after the whole 1980s period when he was managed by Bolton & Quinn, and there was perhaps more professional infrastructure then. Here, it was pretty much just Michael and me. Me trying to understand what he wanted and how to help him make it happen, and believing what he wanted to do was what had to happen. It wasn't a question of what the Arts Council thought should happen, or what dance critics wanted to see. I did devote my life at the time to this project with Michael.

When he was living with Bessie in Scotland in the mid-1990s, I would go and visit. The Super-8 footage that starts **The Late Michael Clark** was shot at this time. When we first met, we had discussed the idea of making a film together. Michael said: 'The only way we are going to make the film is if we make the work.' So that was also how I ended up producing **Michael Clark's Modern Masterpiece**; it was always with this idea of making a film. Not necessarily a documentary. We had wanted to make a film of **The Rite of Spring**.

On finally leaving Scotland, Michael did a short-film course in New York. I had been spending time in Los Angeles, and met up with him on my way home. Michael was also preparing to make a new live work, which became **current/SEE**, and he told me to find a way to be involved. I said I'd like to make a film. One of the things that frustrated me was that we had no real document of **mmm...** – I shot the performance

with a handycam for reference, but there is no good record of it. I have a drive to document things and I felt the loss of that piece. I know there's a school of thought that says it's meant to be ephemeral, it can't be captured; you have to see it live, it has to pass into myth. 'Don't die wondering!' as Michael wrote on the advertising flyer, but you will die wondering because there is no document of it. No history. With **The Late Michael Clark**, I really wanted to make a document of Michael at that particular moment. That was the idea for the film.

T. S. Eliot's essay on 'difficult poetry' makes me think of Michael, in terms of his career, although I don't think having a career is necessarily what Michael is about:

The difficulty of poetry (and modern poetry is supposed to be difficult) may be due to one of several reasons. First, there may be personal causes which make it impossible for a poet to express himself in any way but an obscure way; while this may be regrettable, we should be glad, I think, that the man has been able to express himself at all.

There are aspects to Michael's work that make him relevant beyond the dance world. That was always the exciting thing. He had his own audience. Aside from his many gifts, Michael was born with this incredible ballet body, and when the balletomanes see a perfect ballet body, they think they own it and that it is your duty to give it over to the ballet repertoire. The fact that Michael takes a route that embraces visual art and contemporary music as much as dance means that he devises his own course, as bumpy as it might appear to some critics who moan on about his squandered talent. I see him as a talisman for a certain kind of British creativity that happens very occasionally. It is possible, but against the odds. The establishment rarely knows how to support it, because it doesn't understand how to take the risk with an artist. When work like Michael's happens to get made, it's really exciting – but it's an exception rather than the rule.

Interview by Suzanne Cotter and Robert Violette, 15 May 2009

Sophie Fiennes is a documentary film-maker. She managed the Michael Clark Company from 1992 to 1994 and was producer of **Michael Clark's Modern Masterpiece (mmm...)**. An assistant to Peter Greenaway, she began making her own films in 1998. She was commissioned by the BBC to make **The Late Michael Clark** (2000), which was screened in film festivals around the world. Other films include **Hoover Street Revival** (2003), **The Pervert's Guide to Cinema** (2006) and **Over Your Cities Grass Will Grow** (2010). She is currently working on a new film on Grace Jones.

Leigh Bowery, Bessie Clark, Michael Clark, Sophie Fiennes and others photographed backstage at King's Cross Depot, London, during the run of **mmm...**, July 1992.
P: courtesy Sophie Fiennes.

Sarah Lucas

SUZANNE COTTER *What is it about Michael's choreography and performances that you find most inspiring?*

SARAH LUCAS The sense of being very much of his time, which is also my time. The music, which might seem harsh or brash in terms of ballet but is lyrical and musical for all its hard edge. The sexy use of bodies and costumes. The mixture of his dancers and his friends and his mother...

Your collaboration with Michael on **Before and After: The Fall** *developed out of your friendship over a number of years. What was your working process?*

Well, we just knocked about and talked a lot and listened to music and so on. Who's to say where ideas come from, really? Sitting in the audience later on, I'd see things pop up that rang a bell – ideas that I thought hadn't registered or that I'd forgotten about. So watching a performance is like seeing Michael's thought process. And that process is a twirling, twisting, continually changing thing.

A wonderful parallel has been made between the functional, repetitive and task-based movement of masturbation and the more stripped-down movement that Michael was trying to achieve in his choreography at that time...

There was certainly talk of flesh-coloured underwear and big Y-fronts. And wanking, I suppose, is a constant.

Did you find the context of the performed work challenging, in terms of how you would normally approach your sculptural work?

The strictures of turning up a day or so beforehand at strange foreign theatres of greatly varying size and resources, I found taxing. And the wanking arm was a cumbersome travelling companion, to say the least.

Michael's choreography uses the full spatial possibilities of the stage. Did you find it a challenge, working to the spatial and temporal scale of the project?

I'm always enraptured by Michael's use of the stage as a picture plane – as if he's in every place in the audience at once. Quite a revelation. It is a limiting factor that the audience can't be on the stage and walk around the objects. I don't think I grasped this enough at the time, before we got to the stage. Fortunately, Michael did.

What about the performance by Michael and members of his company at your 2005 exhibition at the Kunstverein in Hamburg?

To have the dance going on in the midst of the exhibition – the audience following the dancers from space to space – was fantastic. At the same time, there was a more naturalistic use of the sculptures, allowing them to inform the scene without them literally having to be props. The sculptures could be themselves. And again, the mixture of professional dancers from Michael's company with friends is very co-operative. Of course, staging an exhibition takes a lot of people, too; something like this doesn't get loads of time to rehearse and so has a lot of spontaneity. It relies heavily on what Michael is able to conjure in his head – everybody else just needs to have a little faith and to show willing. It was really a very special event. More like that would be great, please!

Email interview with Suzanne Cotter,
March 2009

Sarah Lucas was born in London in 1962 and studied at Goldsmiths College. One of the leading figures in the generation of Young British Artists that emerged during the 1990s, she has gained an international reputation for provocative works that frequently employ coarse visual puns and a defiant, bawdy humour. Her works span the media of photography, collage and found objects. She lives in Suffolk and works in London.

Michael Clark with Sarah Lucas, c. 2001.
P: Sarah Lee.

Kerry Biggin, Richard Court, Lisa Dinnington, Melissa Hetherington, Victoria Insole and Lorena Randi, with sculpture by Sarah Lucas, during a performance of Clark's **Before and After: The Fall**, Sadler's Wells Theatre, London, October 2001. P: Andrea Stappert (top) and Monika Ritterhaus (above).

Michael Clark on Leigh Bowery

I remember vividly when I first met Leigh: it was a Saturday night in 1980 in the toilet at Cha Chas. He was with Trojan and a boy called David, all in a similar look. We used to call them the 'Three Kings'. Leigh often dared Trojan to do things which Trojan would do without thinking. One evening, on our way out somewhere, Trojan and Leigh were dressed up and travelling on the Tube. They were insulted – people followed them, prodded them – but they were oblivious to it all, totally unaffected. We used to end the evening at a club called the Market Tavern, which opened at six in the morning for people who had market stalls. We'd leave at around eight, ignoring the commuters, but Leigh would dare Trojan to push them off their bicycles on their way to work, to insult everyone, generally, just to see how it felt to be cruel – like a costume, trying out different personalities.

When Trojan left Farrel House to live with John Maybury, I think Leigh was genuinely annoyed that Trojan was blossoming on his own. Trojan was a muse for Leigh, and I think Leigh wanted to be Trojan. He was inspired by him. When Trojan died, Leigh couldn't see the point in dressing up and going out any more. Someone important to him, someone who could appreciate what he was trying to do, had gone. It didn't take very long for him to change his view, but that was his initial reaction. I had the same kind of feelings when Leigh disappeared.

If you saw Leigh in the beginning, or if you read his diaries from when he first came to London, as Sue Tilley did, you could see a huge but gradual transformation. In the very first costumes he designed for me, Leigh recreated what he was wearing himself, but after that it changed, gradually, like his personality. When we went to New York in 1983 for Susanne Bartsch to show Leigh's clothes, for example, we had to egg him on the stage. He eventually gained the confidence to be in one of my shows (**Because We Must**, 1987), but it took time. He was obviously present in all the work we made together before then, but his actual physical presence had an enormous impact. In retrospect, **Because We Must** was an important piece, something we had worked towards since we started together in 1980.

Because We Must was first shown in London at Sadler's Wells Theatre. It was controversial and displeased the critics. After the performance, Sadler's Wells said that in future they wanted to see my shows before we put them on because there were elements which offended them. The dance world was also offended and thought that anything that wasn't strictly dance was Leigh's bad influence. It was easy for them to blame one person. But if the critics liked something in particular, we would never do it again. We focused on the stuff that bothered them, much to their annoyance. It came to the point where critics were writing things like: 'Maybe if we encourage Michael to keep wearing dildoes then he would stop it just to spite us!'

Many people thought that we were just putting our lives on the stage – an easy way of writing the performance off. It did seem, though, as if Leigh was gradually turning his whole life into an art piece, even in the fictions he created with lies between friends. It was a very public way of growing up. Yet on one level we were disgusted by the idea of self-expression – Leigh was as shocked at his behaviour as other people. We often dared each other to do something provocative. If you saw where I come from, you would see why – that kind of repressed suburban atmosphere where you kick back. We'd say: 'Do you think we could actually get away with this?' We'd try it, laugh hysterically, egg each other on. At the same time, Leigh was becoming more and more confident going out. He wasn't always that brash, brassy character who swanned into nightclubs.

When Leigh and I first started to work together it was very 'corporate', like a proper story ballet. Leigh came during the day in his daywear, was polite, charming, and sat in the corner watching rehearsals. A good place to start, but I was much more interested in working with designers and composers who had

Leigh Bowery in a publicity shot for **Heterospective**, Anthony d'Offay Gallery, London, October 1989. P: Chris Nash.

Leigh Bowery during the filming of **Because We Must**, 1989, by Charles Atlas. P: Tony McCann.

strong ideas of their own, people who challenged me as much as I did them. This is unusual because a choreographer normally works with people who basically do what they are told. Leigh wasn't the type to do that. Yet when it came to ideas, Leigh wasn't possessive. He was open to everyone. He never wanted to keep his ideas for his own personal gain.

It seemed important to me to work with Leigh because he understood how to send messages through clothes. He wanted to make a nun's habit for me, for example, but never did. There were also costumes Leigh made which I never used. He once had some rags from Freud's studio which he made into a large mosaic portrait of Hitler, to be worn as a cape, but it didn't really work on stage. Leigh always did more than was necessary. If he had less to do in a show as a performer, he would work more on the costumes. He always wanted to be busy and constantly reworked outfits with Lee Benjamin and my mum (with whom he became great friends – she was often in the shows herself).

Leigh understood other people's insecurities because obviously he had some of his own. He wasn't at all surprised that people found him shocking. Ultimately he was shocked himself. He certainly wouldn't have done what he did if he didn't realise the effect it would create. Salvation Army family background! We often said that some of what we did wouldn't be shocking if it were in a film; it's only because it's in dance that it's shocking. We knew the kind of mentality we were coming up against within the dance establishment.

The funny thing is that Leigh, more than anyone, in rehearsals and on stage, appreciated the actual dance on its own merits. This restored my faith in making dance at all. Leigh encouraged me to see that dance could actually speak for itself. I have danced since I was four, and had begun to wonder what dance can really say to someone who isn't part of the dance world. Having Leigh around made me want to keep dancing.

Interview by Robert Violette, 1997, first published in **Leigh Bowery** (London: Violette Editions, 1998).

Leigh Bowery (1961–1994) was a performance artist, fashion designer and club icon. He is also well known for his role as nude model for some of Lucian Freud's most famous paintings. Born in Sunshine, Australia, Bowery arrived in London in 1980 and became a friend of and collaborator with Trojan, John Maybury, Cerith Wyn Evans and many other artists, including Richard Torry, with whom he formed the band Minty. In 1988 he installed himself at the Anthony d'Offay Gallery, London. Bowery designed costumes for and performed in many works by Michael Clark, including **Pure Pre-Scenes** (1987), **I Am Curious, Orange** (1988), **Heterospective** (1989) and **Mmm...** (1992).

Leigh Bowery, Joachim Chandler, Michael Clark and Ellen van Schuylenburch in a publicity shot for **Because We Must**, Sadler's Wells Theatre, London, 1987. P: Courtesy Michael Clark Company.

Peter Doig

PETER DOIG I first encountered Michael's work in the 1980s at the Riverside Studios. It was the one where Leigh Bowery made costumes with the cut-out arses, probably 1984. My then girlfriend, now wife – Bonnie Kennedy – was working for Bodymap. She was at college with Stevie and David and was a year below them. It was a little while after the time of their first show, **Querelle Meets Olive Oil** [1982]. Michael was very much present in the world of Bodymap, and the world of Bodymap, because of Bonnie, was very much part of our life. That's where our social world was and that's where excitement was, really. I met Michael at that time. I think I dressed Michael one year for the Bodymap show called **Barbie Takes a Trip Around Nature's Cosmic Curves** [1985]. I once worked as a dresser at the English National Opera and Ballet so they used to sometimes ask me to dress some of the fashion shows.

SUZANNE COTTER What is it about Michael's work that attracted you and continues to interest you?

He was someone who was using dance in a way that others weren't. He was – as far as I was concerned – connected to the contemporary very early on in an absolute contemporary sense, in terms of what people were doing, what people were listening to, what people were wearing, attitudes. There was just nothing else like it. It was so exciting. I witnessed a lot of classical dance, which is also the tradition where Michael came from. He was working in this medium, and yet just totally fighting it.

And there were the collaborations, the choice of making something not just for beauty but for what the collaborations could produce. It was challenging – and a lot more so than a lot of contemporary art happening at the time, especially in the UK. I think a lot of art – for someone of my generation – at that time in the 1980s, seemed to have nothing to do with anything other than art. Everything was incredibly formalist and all of a sudden this was something that had an element of the street, of what was happening in clubs and what people were thinking and it had an attitude, and there wasn't much art then that had attitude.

Can we telescope to the more recent past and talk about your collaboration with Michael on **come, been and gone** *(2009) and how it came about?*

Over the past five or six years, each time I would bump into Michael we would say we should do something together. It was, I suppose, because we'd known each other a long time. I never really thought about Michael necessarily in those days as following what I did. In those kind of circles I was always known as 'Peter the painter', I wasn't really known within the circle that I would socialise, but they all knew I was a painter.

What was the nature of conversation between you and Michael?

Working with Michael is very much like a work in progress. Michael would present me with a bunch of images of things he was thinking about. I think he thinks sonically – about music and sound – and I think he thinks visually. I also very much appreciate and understand the way he works. It's obviously much harder when you have a company and a group of dancers and having to choreograph, unlike myself, when you're absolutely on your own – I never work with any assistants, I do everything on my own.

Can you say something about the choice of subject matter for the paintings you made for the work?

The Le Corbusier painting was for Michael. You know Michael spends part of his time in Marseilles, and also I spent time in Briey in northeast France, where I made paintings about the 1946 Unité d'Habitation by Le Corbusier. I know that Michael also loves a photograph of Le Corbusier with those particular glasses and there is some sort of resemblance in the painting in a way. It was like an homage to Le Corbusier but also an homage to a kind of look. It was slightly absurd as well.

How different was it to be creating paintings knowing that they would be viewed as sets as opposed to being viewed simply as paintings?

That was the interesting thing – I had to make a painting that could be seen from a distance. I had the advantage of quite a comparable size stage in my studio in Trinidad, and to be able to stand at a distance from any painting.

Did Michael travel out to see the paintings in advance?

No, but I sent him images so it wasn't a total surprise. Initially he was going to start off with Nina Simone singing 'Four Women' (1966), and there would be a screen across the front of the stage with this incredible film footage of her, a huge head softly projected in black and white singing 'Four Women' There's a line in it 'They call her sweet thing' and Michael was planning to cut from that to David Bowie's 'Sweet Thing' (1974), but we couldn't get the rights to the piece of film footage so we couldn't use that. And David Bowie singing about a man meant that I wanted to have an image of a man. I was thinking a lot about Matisse's **Blue Nude** (1952) as it seems like a kind of dance, the shape of dance. I thought it was important that it was male and also that it was decorative. I actually based the painting on a drawing by the Trinidadian artist Boscoe Holder who's house I live in, in Port of Spain, and who painted a lot of male nudes.

Was this the first time you have created a body of work for a piece of choreography or for the stage?

Yes. It was daunting, looking at the audience on the first night. Because it's part of something rather than being on its own. You don't want it to be dominant and you don't want it to be insignificant. It's got to somehow feel like it's part of it. I have to say I think it was very brave of Michael to ask me; it involved an amazing amount of trust and respect. It wasn't as if we had many dress rehearsals. I don't think he knew what to expect and I didn't know what I was going to do – and that was what was so exciting about it.

I think it was the first time he's worked with a painter.

It's easy to use imagery – you can use projected imagery – which he does very well. He had some good

Opposite and above: paintings by Peter Doig for **come, been and gone** (2009) at Doig's studio in Port of Spain, Trinidad. P: courtesy the artist.

ideas, and he had a kind of irreverence too: at one point, in the piece where they used 'Ocean' (1969) by Velvet Underground, there was a painting of mine, for which Michael asked 'Would you make a copy of one of your paintings?' and I said 'Sure'. I did it in one night in my studio in London. A full-size copy of a painting that had probably taken me a year to make. Getting away from the idea of it being a precious object; it's like a prop, really. And I was really pleased with that.

Interview by Suzanne Cotter,
25 April 2011

Born in Edinburgh in 1959, Peter Doig now lives and works in Trinidad. A professor at Düsseldorf State Academy of Art since 2005, Doig has had major solo exhibitions at Tate Britain (2008, touring to Musée d'Art moderne de la Ville de Paris and Schirn Kunsthalle Frankfurt), Dallas Museum of Art (2005), Pinakothek Der Moderne, Munich (2004), Bonnenfanten Museum, Maastricht (2003) and Whitechapel Art Gallery, London (1998).

No Fire Escape in Hell

Michael Clark & Co

Page 129: publicity shot for **No Fire Escape in Hell**, 1986.
P: Richard Haughton.

These pages: Leslie Bryant, Joachim Chandler, Michael Clark, Dawn Hartley, David Holah, Amanda King, Joseph Lennon, Ellen van Schuylenburch and Carol Straker performing **No Fire Escape in Hell**, Sadler's Wells Theatre, London, September 1986.
P: Richard Haughton.

text: 'U.S. 80's-90's'

Had a run-in with Boston Immigration,
to my name they had an aversion —
nervous droplets. ~~but sleeping tablets~~
"The Cops" cuz of sleeping tablets
"Are Tops"
No: Cigarettes, Slam,
 Spikes, Gin
 Whiskey — Welcome to the 80's-90's
 Welcome to Eighties, Nineties
 (ch.)
Sure, I maybe the big-shot, original, rapper
But it's time for me to get off this
crapper
No beer, cigarettes, Spikes, Gin, Warmness
Cigarettes, beer in van, whiskey
Welcome to the U.S. 80's-90's
Welcome to the U.S. 80's-90's
Like 50's, Eighties, Nineties
Welcome to the 80's-90's.

Kentucy death keeps Pouring Down
By death stadium.
"Monroe used this dressing room"
(and my Ambition is to walk to work)
Not one chance in 3 million, Jack
Like Cones of Silence

No Beer.
Cigarettes, Slam
Spikes,
Gin, Cigarettes
Beer in van
Whiskey :
Welcome to the U.S. 80's-90's
Cast aside over-inflationary theory
of the ~~panists~~ panicisists
Welcome to the 80's-90's
Put on page nineteen
Small column, left hand side
Welcome to the 80's, 90's.

―――――――――

c/right Mark E. Smith 1986
to be released on lps
'Domesday Pay-Off.'
Oct. '86
music: Brix E. Smith.
(Minder Music Ltd.)

Video stills from a BBC Two television broadcast of
No Fire Escape in Hell, 28 March 1987. P: BBC Motion Gallery.

text: **Living Too Late.**

The crow's feet are ingrate, on my face
 an I'm living too late.
Try to wash the black offa my face
but it's ingrate - I'm living too late.
Sleepless in controlled spleen
A Grabe-A swillbilly
Stone tripod in the genes.
Immune to things. In my
Dreams:
I soar thru' the trees
Over poison river lochs
Stalk treacherous ravines
But still my heart is rock.
Fighting you thru' old parasite gate, but it's a 24-hr.
clock watch an I'm livin' too late
Sometimes life's like a ~~stale~~ new bar, plastic
seat beer below par, food with no taste music
grates - I'm livin' too late.
in the daylight:
I seek trouble in the street
Fearing catastrophe to meet
Down the Devil's boulevard
But still my heart is hard
They say a dead soul is one evil and black
but I know they're wrong, it's
Jus' one been living too long, I'm
living too late.
I'm supersad, streetsad, lineage cracked,
midget heart, frigid gone.
I'm living too long
I'm living too late.

 lyric, music, copyright.
 Mark E. Smith_1986
 (Minder Music Hs.)

Michael Clark, Leslie Bryant, Joachim Chandler, Dawn Hartley, David Holah, Amanda King, Joseph Lennon, Ellen van Schuylenburch and Carol Straker performing **No Fire Escape in Hell**, Sadler's Wells Theatre, London, September 1986. P: Richard Haughton.

Michael Clark, Leslie Bryant, Joachim Chandler, Dawn Hartley, David Holah, Amanda King, Joseph Lennon, Ellen van Schuylenburch and Carol Straker, with the band Laibach, performing **No Fire Escape in Hell**, Sadler's Wells Theatre, London, September 1986. P: Richard Haughton.

BECAUSE WE MUST

Page 139: publicity shot for **Because We Must**, 1987. P: Nick Knight.

Leigh Bowery, Leslie Bryant, Joachim Chandler, Michael Clark and David Holah performing in **Because We Must**, Sadler's Wells Theatre, London, December 1987. P: Richard Haughton.

Leigh Bowery, Leslie Bryant, Joachim Chandler, Michael Clark, Dawn Hartley, Amanda King, Ellen van Schuylenburch and pianist David Earl performing **Because We Must**, Sadlers Well's Theatre, London, December 1987. Slide projections in background by Cerith Wyn Evans. P: Richard Haughton.

143

Joachim Chandler, Ben Craft, Dawn Hartley, Matthew Hawkins, Julie Hood, Amanda King, Ellen van Schuylenburch, with Leigh Bowery and David Holah in the pantomime horse, performing **Because We Must**, Sadler's Wells Theatre, London, December 1987. P: Richard Haughton.

I AM CURIOUS, ORANGE

Page 149: Portrait of Michael Clark for **The Face** to promote **I Am Curious, Orange**, 1988. P: Julian Broad.

Leigh Bowery, Leslie Bryant, Michael Clark, Matthew Hawkins, David Holah, Julie Hood, Amanda King, Ellen van Schuylenburch and The Fall performing **I Am Curious, Orange**, Sadler's Wells Theatre, London, September 1988. P: Richard Haughton.

151

Pages 152–53: Leigh Bowery and Michael Clark performing **I Am Curious, Orange**, Sadler's Wells Theatre, London, September 1988. P: Richard Haughton.

Leslie Bryant, Matthew Hawkins and Ellen van Schuylenburch with The Fall performing **I Am Curious, Orange**, Sadler's Wells Theatre, London, September 1988. P: Richard Haughton.

These and previous pages: Michael Clark Company with The Fall performing **I Am Curious, Orange**, Sadler's Wells Theatre, London, September 1988. P: Richard Haughton.

BECAUSE WE MUST

A FILM BY
CHARLES ATLAS

Page 163 and these pages: the filming of **Because We Must**, 1989, by Charles Atlas. P: Tony McCann.

Video stills from **Because We Must**, 1989, by Charles Atlas.

Bruce Gilbert

I first met Michael in Charing Cross Road. I was staring into a musical instrument shop, looking into effects pedals – as was my wont in those days – when this lovely young man came up to me and politely said: 'Excuse me, are you Robert Gotobed?' He was the drummer in Wire, the band I was in. I said: 'No, I'm Bruce.' He said that he was thinking of using a couple of Wire tracks for something he had been asked to do by Richard Alston at Ballet Rambert, and whether I would mind. So I said: 'No, absolutely not.' I suppose we exchanged phone numbers.

Catherine Becque, Lucy Bethune, Amanda Britton and Ben Craft performing in **Swamp**, created by Michael Clark for Ballet Rambert, 17 June 1986, Sadler's Wells Theatre, London. P: A. Taylor.

A few years later, Michael and Ellen van Schuylenburch came to see me about a new piece. Michael had a few moves in mind. I had a new guitar, which I plugged into a very small recording device that they couldn't hear, just responding to the moves they were making. I would go to rehearsals, which we were doing without music at that point; and there were lots of conversations in pubs, getting a certain feeling, in a very organic way, of what Michael had in mind for that first piece, in terms of the dynamics, duets, solos, durations. That was the beginning of the process.

My girlfriend at the time, Angela Conway, had introduced me to modern dance, so I had seen some things. Cage and Cunningham had set a precedent for collaborations between electronic music and dance.

I loved the idea of the collision of those two things. But Michael worked differently, very much with the music.

His choice of music is interesting, because over the years he has also produced pieces to Eric Satie, Chopin and Stravinsky, but in parallel there has obviously been this attachment to contemporary music. The Fall have always been big for him, and a funny little group from Barnet, called Ear Trumpet, had a similar, free-form, powerful way of looking at things. He used them for certain pieces. And Wire as well.

Michael is interested in vocals and text as inspiration and starting-off points, but when he asked me to do what became **Swamp** there were not going to be any vocals, apart from some extracts from **Who's Afraid of Virginia Woolf?** He was very keen on some of those outbursts. In the original version, I tried to introduce that kind of thing, but I made three distinct parts, and Michael very sensibly discarded one of them. So there were other elements from the Virginia Woolf film that are now lost – probably a good thing.

It was quite thrilling seeing Ballet Rambert do **Swamp** four or five years ago – very strong, with a big squad of dancers, all of them very technically adept. Although it was brilliant, I missed the idiosyncrasy of the people Michael had in his original production. They were all highly individual, but still incredibly good dancers. Something about Michael's choice of dancers made things a bit more edgy. His company at the moment has that feel. It still has that edge that Michael was always looking for; they have to be technically fantastic, but not necessarily in the classic mould. And there's Charles Atlas.

His current production, **Thank U Ma'am**... [which became **come, been and gone**] I love it. The David Bowie projection is really good fun; the dancing is fantastic. There are elements of previous work in it, but it is much more direct, playful, really sharp.

I can't speak for Michael, but I think choreographers use music that is from their own culture. Why would you choose music that is a hundred years old as opposed to music from your own period, especially when you are a young person, when you are alive? I don't care how sheltered you've been or how many dance colleges you've been to, you must hear music from the period you are growing up in. The other thing is that Michael had a life as well, and clubbing of course. He was determined to use music that was happening around him.

Michael is incredibly musical. He really listens to music. He is an emotional and sensitive person, so if he likes the music he can inhabit it and knows what to do to it. There is a kind of recognition. In some of my pieces, he'll ask me where the count is, and I'll say I have no idea, but he always finds something for the dancers. Michael has this facility for finding the dynamics of the music, which fits into the way he wants to design a piece of choreography. At the same time – and this is a more technical or artistic thing – he is very keen on lyrics, and that sets him off. He is definitely interested in language. There has to be some linguistic and poetic content, which he responds to.

Michael was always a naughty boy. He has been part of the daring bits of the culture, making friends of people like Leigh Bowery. He has always been drawn to people who are proper artists. He is intense about his practice. He has a vision, but is also encouraged by the fact that other people are willing to push cultural boundaries as well. So it is in many ways inevitable that he would be a magnet for people who see the world in the same way. Sometimes it can semi-succeed, possibly half-fail, but you have to do it – there is no way around it sometimes.

When Michael was in his more outrageous period, people were expecting all sorts of things and that obviously helped make those performances more bizarre. It happened very quickly. The costumes were a bit odd, the music was not that mad, but with classic ballet steps it was different. One of Michael's biggest problems was where to go next. He is an artist; he makes things; he makes things happen. I think he is still the most important choreographer in this country, for all sorts of reasons. A lot of people were thrill-seeking with Michael in the early years, but having seen his new work, I can feel his mind ticking over. He is obsessed with making good work, but there is still that element of 'Don't expect anything'. Of course he has his style, but he has developed it incredibly. It has become more refined, and defined. It doesn't look like anybody else's. You can tell Michael's choreography a mile away. Other people's choreography is just 'stuff'. Michael's choreography is distinctly Michael's. That is why he is an artist of the highest order.

Interview by Suzanne Cotter,
11 July 2009

Bruce Gilbert was co-founder of the seminal post-punk band Wire, who released their debut album, **Pink Flag**, in 1977. During Wire's second period of production, in the late 1980s, Gilbert pursued various solo projects with an increased emphasis on minimalist electronic compositions. In 1990 he composed the ballet **Bloodlines** for Ashley Page at the Royal Ballet, and throughout the following decade was a DJ at London clubs under the name Beekeeper. Wire's music was first used by Michael Clark for the work **12XU** (1983). In 1984 Clark commissioned Gilbert to create the music for **Do you me? I Did**, which would be expanded into **Swamp** for Ballet Rambert in 1986. Other collaborations with Clark include the Rudolf Nureyev-commissioned **Angel Food** (1985), **No Fire Escape in Hell** (1986), **Because We Must** (1987) with Graham Lewis and **come, been and gone** (2009).

Michael Clark and Susan Stenger in a publicity shot for
current/SEE, 1998. P: Hugo Glendinning.

Susan Stenger

We met through Cerith Wyn Evans. I remember it was the day of Diana's big crash, whenever that was [31 August 1997]. I had settled in London a few years before and had a studio in the old stables of the Truman Brewery, where I kept all my equipment and where we rehearsed. I had formed Big Bottom earlier that summer after years of joking about it. I suppose it came from a combination of having watched the spoof rockumentary **This Is Spinal Tap** too many times – they had a song called 'Big Bottom', where they all switched to bass – and also from being exposed to the 'guitar army wars' between Rhys Chatham and Glenn Branca. I'd known them from the New York experimental music scene and had played for several years with Rhys. By then they were both writing for 100 guitars or more, and arguing about who owned the concept. I thought a band with a mass of bass guitars called Big Bottom would be the logical next step – kind of a cross between La Monte Young and Black Sabbath. In some ways, though, it ended up being more like the Spice Girls... but that's another story.

Both Angela Bulloch and Cerith had seen me play and really wanted to learn bass and be in the band. I assured them I could teach them the basics quickly; it's not that hard, and they both had a feel for music. I especially wanted the sound of someone just learning, discovering a riff and obsessively playing it over and over. My husband, Paul Smith, who was doing a monthly club night called Disobey, threw down the gauntlet and offered an opening slot on a bill with Japanese noise artist Merzbow – that left about three weeks to get it together. I invited artist Tom Gidley too, and musician Mitch Flacko, who could already play. I also asked Sarah Lucas – I really identified with her work and thought she could be the singer. She wasn't keen on singing in public, but we did hang an effigy of her behind us for inspiration – a photo of her head on a coat hanger above a T-shirt with two fried eggs pinned to it. Angela cooked the eggs right before the show. It hung in my studio for years afterwards, with two egg-shaped stains on the shirt.

The joke name was a departure point, but once I began working out the composition and arrangement it became quite rigorous and precise. Mitch and I programmed an old Roland R-8 drum machine with primal kicks and crashes. A 20-minute piece emerged – we called it 'VPL' – based on tremolos, interlocking rhythms, heavy-metal clichés and bits of famous riffs, all knitted together with massive volume and distortion. The sheer monumental power of it outweighed the sometimes shaky counting and technique.

I hadn't expected it to be more than a one-off event, but we'd been asked to contribute to a music/art compilation record, so I'd worked out a new piece, 'No. 2', and the day I met Michael we were moving our amps around the corner to an old synagogue to record it. He'd recently come back from Scotland, where he'd been living with his mother for a few years, and had run into Cerith, who'd invited him along. The sound was deafening, but through it all Michael seemed serenely asleep on a flight case. We ended up recording both pieces that would eventually make up the basis of the second half of **current/SEE**, but at the time I wasn't sure what he'd made of it. Afterwards, though, he suggested using that material and collaborating on something new and we bonded very quickly.

I had never worked with dancers before but was well-schooled in the Cunningham/Cage method of combining independent elements in the same timeframe, with no predetermined co-ordination. Although I hadn't been around for any of Michael's earlier performances, I knew his approach to music was much more personal and interactive, and was both excited and a bit apprehensive about the prospect of making a new piece together.

We began working in a studio in Greenwich, and I was immediately struck by how closely he listened to everything. Michael has an amazing ear, better than most musicians I know. I had given him a tape of ideas I'd made – they eventually evolved into the solo bass number in the first half of **current/SEE**. I was starting with a series of drones and adding harmonics and shifting the pitches very slightly. You could listen to it and just hear a monolithic sound, but Michael clearly heard all the variations. As we worked, he would sometimes remind me of certain things I'd done on the tape, really tiny gestures or accents that I'd forgotten about or was doing slightly differently in the studio. He took in every detail and we were able to communicate easily about the sounds. I really relaxed then, because I knew it was going to work between us. The only other relationship I'd had like that was with Robert Poss, writing and recording for Band of Susans. I never thought I'd find that again, especially with someone who wasn't a musician.

The interaction in the performance of that first piece was incredible. It was like he was making the sound visible and I was making the movement

Michael Clark in a publicity shot for **current/SEE**, 1998. P: Hugo Glendinning.

audible, the two were so intertwined. There was a long introductory passage with Michael flat on the floor in a rectangle of light, facing toward the sound. There was no set or props – only the bass amp in the middle of the stage, like a standing stone. He slowly came alive and started moving, at first hugging the stage but eventually getting up, sort of limping but finally bursting into his old self. It was as if he was rediscovering how to move while immersed in the sound. It felt like he was shifting the harmonic pattern somehow, almost like he was in the middle of the sound and influencing it by the way he was moving. I also felt that if I just shifted the rhythm or the harmonics slightly, it seemed to have an effect on him. Over the course of touring it seemed to get deeper and more nuanced. It was a fantastic experience to feel that close to someone in the middle of a performance. That's the piece I'm proudest of, because it was developed for him and with him, and I think it really worked.

The original production of **current/SEE** shocked people, in that it was so austere-looking. Big Bottom's Stonehenge-like semicircle of amps was the only set in the second half. The first half was even more pared down. There were no elaborate backdrops. Hussein Chalayan's costumes were very minimal, Charlie Atlas's lighting was simple and pure. People were taken aback, especially if they had been used to the Leigh Bowery era of Michael's work. Some people complained – where's all the cool stuff? I do remember that at a key moment in **VPL**, a handbag descended from the rafters into the midst of the dancers – at least that was something for the prop obsessives to grab on to!

All of the music for **current/SEE**, including Simon Pearson's drumming pieces, dealt with breaking down the classic vocabulary of rock into basic elements and constructing something new. So much of Michael's physical vocabulary was about that too: 'The tapestry of gestures'. He draws on the whole of classical ballet, but also on everyday movements that intrigue him. Also, he zeroes in on certain kinds of stylised movements, like maybe the way Patti Smith stands or moves her arms, or Iggy Pop twists his torso – he might focus on a small gesture and expand and abstract it, look at it from different angles. I've always been interested in the same thing. It's kind of what Band of Susans was about – the essence of a single moment of perfect feedback, a rhythm, a slide, a hammer-on strum. Big Bottom was also about that – zooming in on heavy-metal clichés, multiplying, layering and recontextualising them. It worked well with what Michael wanted to do at the time. The whole show seemed to be about distilling and reinventing, starting from ground zero and working back up again. I think it was an important time for him, as it was for me too. Since then he has revisited some of the music that he's worked with in the past, but with a fresh approach to it. Maybe **current/SEE** helped him find a new way into his own personal language.

Later on during the course of touring, we sometimes added new things. We once made a new piece in Edinburgh during soundcheck – a T. Rex send-up. We played it as an encore. I also did this sort of abstracted reggae piece on guitar, very spare and floaty. Michael requested one based on 'The Stripper' – my arrangement was built on a cluster of Ramones-style moves that eventually morphed into the melody. I think Michael played guitar in that one. I ended up teaching him quite a bit of bass and guitar – he was a natural. He played in several performances, including **Would, Should, Can, Did** at the Barbican and a thing I did for a Hussein Chalayan fashion show in Paris. Some of these things are lost forever. I have work tapes, but don't think there are proper recordings of them.

We did another piece based on 'My Sharona' – it started with a gradual additive process, one bass and one dancer entering on a given beat, and then the second bass and dancer, until it built up so finally all the notes appeared. Big Bottom played that one

and the parts ping-ponged across our stage set-up. The recognisable riff wasn't evident until the very end. I remember when we did it in Malvern, the dancers held 4ft-high plastic daisies Michael had swiped from an urn in the lobby. He often incorporated objects acquired on tour. A good source was the Crucible Theatre in Sheffield – they had a great collection of masks. When we played there on Hallowe'en, we each had a carved pumpkin on top of our amp as well, courtesy of Richard H. Kirk from Cabaret Voltaire. He drove Angela and me on an urgent, last-minute pumpkin-shopping trip, bombing around the back streets of Sheffield like an episode of **The Sweeney**.

I'm not aware of a choreographer who is as involved as Michael is in all the other aspects of a production – music, sets, costumes, lights, hair and make-up – but he is very open and generous in his work with other people. And all these aspects interpenetrate and resonate with the dance and with one another. The embedded jokes, symbols and messages may not be understood by everyone, but it doesn't matter. Within the **Stravinsky Project** itself, there are many references to the original steps. Not everyone will get them, but it still works. People appreciate these things on different levels. I think it's interesting that Michael is so drawn to Stravinsky, who also distilled forms and gestures from a variety of sources – irony was an important element for him, too.

Michael's one of the most intelligent people I know. He's so well read, he knows as much about Stravinsky or Satie as most scholars, but is equally passionate and informed about, say, Nina Simone or David Bowie. There's an embodiment of paradox in Michael's work that I also strongly identify with. He can analyse music down to the minutest micro-beat, but responds passionately and viscerally to it as well. I studied classical flute, spent years playing the music of John Cage, and also played in rock bands. I think we both find common elements in things that to many people might seem at opposite ends of a spectrum, and even when working in a specific area, ghosts from others find their way in.

On one hand Michael is incredibly disciplined, and on the other there's a sense of quiet chaos that surrounds him and anything he's working on. I think there's a kind of creative tension between those sides of him, the struggle to balance them. And Michael is a true perfectionist. Nothing is ever finished, but only because he is always thinking, working, refining – sometimes right up until curtain call. His collaborators have to just go with it – it's part of the process – but the experience is unique and unforgettable and always worth it.

Interview by Suzanne Cotter,
13 March 2009

Susan Stenger was born in Buffalo, New York, where as a teenager she played in rock bands and studied experimental music with Petr Kotik and Julius Eastman. After intensive classical flute studies in Prague and New York, she joined Kotik's Brooklyn-based SEM Ensemble and devoted herself to performing music of 20th-century composers, such as John Cage, Phill Niblock and Christian Wolff. She soon began making her own work for flute and electronics, as well as touring with Rhys Chatham's all-electric-guitar band. In 1986 she joined Robert Poss to found seminal guitar group Band of Susans; her role expanded from bassist to singer and songwriter as BOS went on to release nine critically acclaimed CDs during the next decade. After moving to London in 1996, Stenger formed experimental group The Brood and all-bass band Big Bottom, made up of both visual artists and musicians. She has collaborated several times with Michael Clark, most notably as a soloist and with Big Bottom in **current/SEE** (1998), toured as a bassist with John Cale, Nick Cave and Siouxsie Sioux, and composed a 96-day sound installation as part of **Soundtrack for an Exhibition**, presented at the Musée d'Art Contemporain de Lyon in 2006. She has been producing soundtrack and performance projects with London writer/film-maker Iain Sinclair since 2007.

HETEROSPECTIVE

Page 175: Michael Clark in a publicity shot for **Heterospective**, Anthony d'Offay Gallery, London, October 1989. P: Chris Nash.

Leigh Bowery (opposite) and Dawn Hartley, Russell Maliphant and Gisela Mariani (above) in publicity shots for **Heterospective** at the Anthony d'Offay Gallery, London, October 1989. P: Chris Nash.

Leigh Bowery, Michael Clark, Dawn Hartley, Russell Maliphant and Gisela Mariani performing **Heterospective**, Anthony d'Offay Gallery, London, 1989. Stills from a video by Cerith Wyn Evans.

mmm...

Page 181: Joanne Barrett in a publicity shot for mmm...,
1992. P: Chris Nash.
These pages: Michael Clark in publicity shots for mmm...,
1992. P: Hugo Glendinning (opposite) and Chris Nash (above).

Michael Clark in publicity shots for **mmm...**, 1992.
P: Hugo Glendinning (opposite) and Chris Nash (above).

Michael Clark in publicity shots for **mmm...**, 1992.
P: Pierre Rutchi (opposite) and Thomas Krygier (above).

Joanne Barrett, Leigh Bowery and Michael
Clark performing mmm..., King's Cross Depot, London,
June 1992. P: Steve White, courtesy Artangel.

Joanne Barrett, Michael Clark, Matthew Hawkins and Julie Hood performing mmm..., King's Cross Depot, London, June 1992. P: Fred Whisker.

Leigh Bowery and Michael Clark performing mmm...,
King's Cross Depot, London, June 1992. P: Fred Whisker.

194

Joanne Barrett, Leigh Bowery, Bessie Clark, Michael Clark, Dawn Matthew Hawkins and Julie Hood performing **mmm...**, King's Cross Depot, London, June 1992. Stills from a video by Charles Atlas.

o

Page 197: Michael Clark in a publicity shot for **O**, 1994.
P: Chris Nash.
Above: Michael Clark performing **O**, Brixton Academy,
London, June 1994. P: Henrietta Butler.

Pages 200–01 and opposite: Michael Clark performing
O, Brixton Academy, London, June 1994. P: Henrietta Butler.
Above: Michael Clark performing **O**, Newcastle
Playhouse, May 1994. P: Dee Conway.

Opposite: Tammy Arjona, Shelley Baker, Michael Clark
and Vivien Wood performing O, Brixton Academy, London,
June 1994. P: Henrietta Butler.
Above: Bessie Clark (on sofa) and Michael Clark
performing O, Brixton Academy, London, June 1994.
P: Darryl Williams/ArenaPAL.

I MUSTN'T FORGET MY SCOTTISH DAD.

POT NOODLE

ORIGINAL CURRY FLAVOUR

Jann Parry

As a dancer, Michael was so outstanding that he attracted immediate attention, from the ballet-lovers who had known him from the Royal Ballet School to the contemporary people who were amazed at what was happening. He was such a powerful performer that people wondered what would happen if he were no longer able to do it – if he was injured or, as we later discovered, when he succumbed to drugs. Could he transfer that ability to other people? Could he choreograph for other dancers who weren't quite as gifted as he was?

Michael needs exceptional dancers to do his work, the solos that he took on himself, because it is a demanding technique. After a while, when he had good dancers, he was choreographing in a way that people could recognise instantly as an individual voice. It wasn't somebody aping anybody else, or only doing the things that suited his own body. Then he became a choreographer to take seriously – a dance-maker as well as a dancer.

It took a while to make this distinction. Probably the late 1980s, because I remember writing a piece after he had appeared at the Edinburgh Festival – **not H.AIR** and **our caca phoney H.our caca phoney H.**, both in 1985. I started to think he was riding too much on shock value – 'I can get away with this; people will watch anything'. It had been entertaining and endearing at first, because he would do outrageous things; he was a bad boy, but he was charming and gorgeous, so you would indulge him. Then it became a cult thing for him to be outrageous – whatever would he do next? So I started to get fed up; it seemed he wasn't really thinking anything through, that he was just doing bits and pieces and shoving it together like a collage, saying that you don't need a structure. And then came the motley crew of friends who weren't dancers but amateur performers. I got quite irritated with him – I thought he wasn't being a choreographer but a showman, and getting away with it.

Then I began to see what he was doing, accepting that he needed these extraneous things. Someone remarked that it was important to remember that he was so young. On the one hand there was this wonderful talent – not just for dancing, but an ability to realise a vision of a performance that was quite different to what had been produced previously – but at the same time he was a young man having a great time, so he didn't necessarily feel that he had to take things seriously.

Expectations were high, and that was what Michael was fighting against. He was almost intimidated by his own talent; I sometimes thought he quite literally wanted to hide himself. There was a gala where he crawled under a Union Jack from one side of the stage to the other, and people were outraged that he would do this. Or a big crowd would turn up at Riverside Studios expecting to see something absolutely wonderful – all the Royal Ballet people, the administrators and dancers who knew him – and he would send on these nude Neo Naturists instead. People would be shocked and appalled and just laugh themselves silly. He was very young, and it was a way of sticking up two fingers. I think Michael was appalled to see this almost-monster that he was creating and the facility with which he could do it. It's like a very beautiful cat – whatever it does is languorous and gorgeous, and the line and aesthetic of its body is amazing to watch – but the animal inside that body is wondering what all the fuss is about.

In the early 1990s, Michael seemed to focus again on the classical tradition with Stravinsky's music. Coming from a ballet critic's background, it was tempting to heave a sigh of relief because he had stopped doing his outrageous antics and had come back to what he was supposed to be doing all along. But another part of me was saying 'Don't be too orthodox and conventional', because then he would be yet another contemporary, ballet-based dance maker and wouldn't be as special as he was. He also wouldn't fill that strange niche for people who were not interested in dance: from the club scene, from the arts. Once Michael focused on a dance with a technique, those of us who love technique were almost reproving ourselves for being so conventional.

I strongly remember going to see **mmm...** at the depot behind King's Cross, not knowing what it was going to be like. It was such a strange place. When Michael came out and performed, it was miraculous, as if he had found who he wanted to be. It was much more of a manifesto and less of that kind of jumbled, recycled collage, even though it had his mother and Leigh Bowery in it. It was a real response to the music. I left absolutely exhilarated, and outside there were these great juggernauts with their lights on and their engines roaring, because it was a huge depot behind King's Cross. It was as if it was part of the show: huge gleams of light, overwhelming in the dark, and a noise that was like a continuation of the same performance.

I often thought it was better seeing Michael's pieces in unusual places rather than on an orthodox stage. He should have performed much more in museums or galleries: it sets up different expectations, a different audience. I remember going to see **current/SEE** at the Roundhouse, queuing up to get into the strange little box office, which was a Portakabin, with the traffic roaring past and people standing around chatting. The atmosphere was very different from a theatre.

At the Brixton academy with **O**, it took forever to get going because there was some argument about the stage — I think various rock bands had wrecked it, so they were trying to get it smooth enough for the dancers not to injure themselves. So there was a really long wait: the rock audience didn't mind because they were used to it, but some of the dance critics became very tetchy about hanging around. Then the whole performance was quite short, because there was a long interval. And yet for that audience it was quite acceptable, because concerts tend to be like that. It was Michael in a mirrored box as Apollo — I felt you needed to know this, that he was finding his way out of the box to this music because it was the young Apollo being born as a demigod. Whether the people who had been hanging around and drinking actually got the performance (which was classicism, or some form of it), I was never quite sure.

When Michael was starting out in his career, he danced a lot. He danced for Richard Alston, Ian Spink, Mary Fulkerson, Jeremy Nelson — a lot of experimental, postmodern people who didn't want to perform on stage. They much preferred to see their work in galleries, where the audience was close and could walk around and choose their own perspectives.

Having been exposed to these different ideas as a young dancer and assimilating them, Michael was able to forge his own choreographic language. This language changed quite a lot — in the very early days, he used to do a lot of really fast fiddly things with his feet to challenge himself, because he didn't like doing allegro. He preferred the andante, or adagio, and so he would make himself do these. Then he moved on to very simple things, like rolling in and out of swathes of material, and working with David Holah, who couldn't dance at all. Then later on he worked out a sort of pelvic-based choreography where everything emanates from this sexual form. He worked on it with Steven Petronio, who was interested in some of the same ideas.

When they were together and both choreographing, you could see how they were influencing each other in

Michael Clark in publicity shots for **current/SEE**, 1998. In the lower picture: Michael Clark, Pauline Daly, Silk Otto-Knapp and Lorena Randi. P: Jake Walters.

this kind of movement – a lot of hip-thrusting up from the floor and strutting provocatively around, which Michael then changed back into a more classical form of moving, but still with emphasis on the pelvis. Ballet tends to be higher up.

In the history of contemporary dance over the last 30 years, nobody has been able to follow Michael and to come back in a different vein. Nobody has been able to run with it sufficiently well and to attract those kinds of audiences from very different backgrounds who will go away feeling satisfied. Nobody in dance today is reflecting the culture in the way that Michael did in the 1980s and the 1990s.

He's in a different place following his Stravinsky line. What appeals to my tastes is the combination of Apollonian and Dionysian – that he could put the two together, that he always hung onto his classical training and background while doing outrageous things. And yet there was always that core – you knew he was a classicist underneath, a person with a strong sense of form and sculpture, however much he mucked about with costumes and stuff. You didn't see that anywhere else, you wouldn't see those costumes and wigs and bare bottoms on stage then.

And it wasn't a polite mix of 'I think you should work with this fine artist and have an Anish Kapoor in the middle of the floor while you dance around it' – it was Michael's clubbing aesthetic. He has also had very long-term collaborative relationships with some very talented people. There was a sense that Michael was actually performing with friends and family – this wasn't an ensemble put together by the Arts Council, but a collection of people who were meaningful to him, lovers past or present, and dancers he respected, who were tough enough to bring their own qualities. They were not just unformed clay; they were individuals in their own right. Leigh Bowery was like the drunken uncle at a wedding that no celebration is complete without. That was what I missed when Michael disappeared – that unparalleled continuity.

There's a deliberateness about things that doesn't seem too left to chance. Although the works are sometimes shaping themselves, they are still quite amazing. There is nobody like Michael because outside a few cultish contemporary choreographers, the ballet ones who people admire, they have no visual sense at all. Yet he is elusive because he never fitted into any sort of category, and then he disappeared, and when he came back it was a different cultural context.

As a choreographer, Michael is an artist working on other people's bodies, which is an extraordinary way of creating because those bodies change constantly. Somebody wrote recently that when a dance is over it is dead, gone. It can be carefully transcribed and recorded, but it only exists really in the memory. So how do you hang on to a body of work, when the dancers get pregnant, or don't want to do it anymore, or are injured or get old? And if your mind is whirling or you're in a dreadful state, and you see all these expectant faces standing around saying 'OK, tell me what to do', how on earth do you create something? And yet there are ways of getting those people to move, then they show you something and you can change it. It's not as frightening as staring at a blank page in a typewriter.

Interview by Suzanne Cotter,
20 June 2009

A long-established dance writer, Jann Parry was a writer and producer for the BBC World Service from 1970 to 1989, covering current affairs and the arts. Dance critic for **The Observer** from 1983 to 2004, she has written for publications including **The Spectator**, **The Listener**, **About the House** (Royal Opera House magazine), **Dance Now**, **Dance Magazine** (USA) and **Dancing Times**. She is the author of **Different Drummer**, a biography of the choreographer Kenneth MacMillan, published by Faber & Faber in 2009.

Richard Glasstone

The problem in the early days was that a lot of people couldn't get beyond the music. They couldn't stand the music and the noise and the volume of it – they've got used to it over the years – and they also couldn't get past the dildos and all that. They would say: 'Here's this wonderful dancer and choreographer, why doesn't he choreograph to proper music?' It was only when Michael did **Apollo**, which I think was called **O**, that they said: 'At last! Now he's using proper music and this is wonderful.'

As he got older, I think it was very difficult for Michael to make the transition from being a dancer to being just a choreographer. It needs a very good eye for movement, which some contemporary-dance people have more than ballet people. They tend to look more at steps and effects. You can't really generalise, because I know ballet people who really love his work and contemporary people who hate it, but there are ballet people who will never be convinced, because they think it's iconoclastic and such a waste of a beautiful dancer.

A lot of contemporary dance is very boring – you know, it's barefoot and no costumes – and they think that all that carry-on with sets and costumes is not right. Michael falls in between those two; I think that's what is interesting about him. Michael is theatrical and a lot of contemporary dancers are not theatrical. When Michael arrived at the Royal Ballet School, he was 13. There were five forms at White Lodge, the Royal Ballet Lower School, and he came in the third year. He was a beautiful, sleek boy, wonderful footwork, nimble, an amazing Scottish dancer, and a perfect student. Very well-behaved, very nice, and was like that well into fourth form. Coming into the fifth form he discovered punk, and that was the beginning of the end – or the beginning of the beginning!

Michael became absolutely fascinated by this whole punk thing. We were good friends and he would go out on Saturday and buy all these things, he was into the whole fashion thing. But he was still working beautifully at his ballet. In the last term of his school year, I choreographed a ballet specially for him called **Odd One In**, music by Liszt and designs by Heather Magoon. He was a sort of outsider figure, a dreamer. The others were all very casually dressed, playing football: young kids, normal life. Gradually he gets more accepted and they all end up doing classical movement, symbolic of the influence Michael has had on other dancers.

A few weeks before the performance, several of the boys (and they were quite a difficult bunch) were caught smoking or drinking or sniffing glue. I actually found the note the headmistress wrote to me: 'Michael Clark admitted drinking some wine before and finishing it tonight; sniffing Aero Stick; and had cigarettes and matches. He said he thought it was worth it to try things out and says he likes wine, hard head. All very depressing.' There was this huge carry-on, and eventually the headmistress and the ballet head said we really couldn't have this. It was the matches they were most worried about in case there was a fire, as it was an old listed building. The solution was that Michael and another boy came to live with my wife and me for the last few weeks of term.

I sat them down and said, if you want to smoke, you can smoke here in this living room, but if I catch you smoking in bed you're out. They thought it was wonderful that they'd been allowed to smoke, but Michael still wanted desperately to dye his hair green. I told him that I would give him the money on the last day of term so that he wouldn't do it until after the performance. And on that day, his mother, Bessie, was in tears at the hairdresser. He then went home for the holidays, his grandfather died and he had to have his hair dyed black for the funeral. So that was Michael at White Lodge.

Seeing Michael's performances in the 1980s was absolutely wonderful. My wife and I were the original Merce Cunningham groupies. When Cunningham first came to London, he had a week at Sadler's Wells and then a couple for weeks at another theatre; we went to every performance. There were only about a half dozen ballet people there, coming to see Robert Rauschenberg's designs and that sort of thing. Cunningham was dancing himself, and he was a marvellous dancer. If you've only ever seen figurative or expressionist painting, and you suddenly saw an abstract painting, that was Cunningham to me. Michael was more dramatic and overtly theatrical than Cunningham.

I think he did some very good choreography, but a lot of people couldn't really see the choreography. There was a difficult period, when he was making the transition from dancer to choreographer, but he finally did it with **Les Noces**. Bronislava Nijinska's **Les Noces** was a wonderful ballet in 1926, extraordinary for its time. But Michael did it a completely different way and I thought it was very good, truly original.

THE ROYAL BALLET SCHOOL

WHITE LODGE RICHMOND PARK SURREY TW10 5HR

Summer Term 1978

NAME: Michael Clark Form: V Date of Entry: Sept. '75

	REMARKS
BARRE:	Neat, accurate work, still needing some adjustment to the basic stance as well as more control of the pelvis and hips.
PORTS DE BRAS:	Tends to over-extend the arms when raising them. Shows clarity of movement, poise and style.
ADAGIO:	Coping well with rapid growth. Elegant sense of classical line, but tends to get the weight too far back.
PIROUETTES:	Very much improved. Must learn to use the eyes to help recover his balance when necessary.
BATTERIE:	Potentially very good. Needs to practice the exercises learnt on his visit to the Paris Opera School.
ALLEGRO:	Very much improved. The arms and head should be used more to assist his movements. Elevation and 'ballon' much improved.
POINTEWORK (Girls) or TOUR EN L'AIR (Boys)	There has been some improvement, but much more consistent study is still required.
MUSICALITY:	Excellent. Responds with great sensitivity to the phrasing, rhythm and dynamics of the music.
DANCE QUALITY:	Occasionally a little negative in approach, but at his best Micahel dances with real style and elegance.
GENERAL REMARKS:	Michael has a remarkable natural facility for dancing, combined with an instinctive artistic understanding most unusual in a boy of his age. His potential is exceptional and I sincerely hope he will prove to have the self-discipline necessary to harness this potential and exploit it to the full. I will watch his future development with great interest.

Richard Glasstone
Ballet Teacher

I'm sure people who saw Michael's work in the 1980s were influenced by him. But there's a gap where he did nothing that was recorded, so there's a whole generation that don't know anything about it. People need to see some of that work in order to appreciate it and evaluate it. Michael's notation is just his own way of remembering. There isn't a system per se. So it would have to be done largely from film, and from people who have worked with him, which is the way things were always done. It's only relatively recently that notation has been used widely in dance. Traditionally, it was always handed down from master to student. Someone like Ellen van Schuylenburch could certainly pass things on. Forgetting my own personal involvement, at its time it was very important, it had a huge effect, it brought in a whole new audience – that should be recorded.

There are some very good ballet dancers who are impossible to work with because ballet has become so much to do with getting your legs up past your ear, and when you have your leg up there you can't really use your torso. Ballet has become very lacking in that range of movement. So it's no good saying to Michael, 'Oh, you can have the whole of the Royal Ballet', because a lot of them can't do his movement.

Enrico Cecchetti, whose work Michael admires, was the great teacher of the 19th century, but he belongs to a certain period and people think that's old-fashioned. But what they don't see is that there is a whole other element in Cecchetti's work because he really understood the body. He wanted to use it to make a certain stylistic statement but he also understood how the body worked. If you understand that, as I do and as Michael does, then you don't have to end up with a 19th-century look. Michael's approach to choreography is essentially an exploration of the body's physical possibilities, allied to a subtle use of rhythmic complexity. In that way he has an affinity with Cecchetti – not stylistically, but physically and musically.

Interview by Suzanne Cotter,
6 January 2009

Richard Glasstone has worked internationally as a dancer, choreographer and teacher. He was resident choreographer and principal teacher of the Turkish State Ballet from 1965 to 1969. On the invitation of Dame Ninette de Valois, he joined the staff at the Royal Ballet School, where he held the posts of senior teacher for boys and director of the dance-composition course. He taught Michael Clark from the age of 13 to 16. The author of several books on ballet, he also writes regularly for **Dancing Times** and **Dance Now**. He continues to work with the Michael Clark Company as company teacher.

Michael Clark, c. 1981. P: Chris Harris.

Richard Alston

The beginning was odd, but it's still clear. In the spring of 1979 I went to the Royal Albert Hall to see a performance of folk dance – an enormous jamboree. At one point, some very adolescent-looking boys did Scottish dances, and then a taller boy came out on his own carrying two swords – it was Michael, and he held the attention of the whole place, it was remarkable. These boys were from the Royal Ballet School, where Bob Smedley taught, but of course Michael knew these intricate sword dances from his childhood. Even then, there was something about his physical presence that was completely arresting, even in the Albert Hall.

Later, when I was invited to work with Ballet Rambert, they told me there was a new dancer coming from the Royal Ballet School called Michael Clark; I remembered seeing him and asked if he could be in my new piece, **Bell High**. The company administrator said that they weren't planning to put him on contract until Christmas, but I knew I really wanted to work with him, so they got him in early – that's why the piece opened with a solo for Michael. That's still the way I choose dancers – it's very instinctive, I just felt he had a gift. Rambert asked me to stay, and so I did, for 12 years; Michael was there for maybe two.

Over those two years I worked quite a lot with Michael – I felt he was, although much younger, a kindred spirit. We had long talks; he understood instinctively what I was on about. I found him really good to work with – he was in every piece I made before **Soda Lake** in 1981. **Soda Lake** arose because I was asked to make a piece for television, and because it was intended for the camera I wanted to have some kind of visual framework. That's why I chose the Nigel Hall sculpture from which it took its title. Earlier I'd seen a really beautiful work of his that was attached to the wall and barely moved. I became intrigued by Hall's work and when I saw **Soda Lake** at the Warwick Arts Trust, with its extraordinary tunnel of space and its overhead oval shape, I thought it would be really interesting for the television project. We started work on the programme but it didn't work out, so I ended up making the dance for Dance Umbrella.

Integrating the work of a visual artist into a dance had its roots for me in the work of Merce Cunningham and his collaborations with Robert Rauschenberg and Jasper Johns. When I was still an art student, I went to see Merce because of Rauschenberg and Duchamp and Warhol, and to see Martha Graham because of the amazing sculptural sets by Isamu Noguchi. There's an iconic piece by Graham called **Frontier**, and I've always thought that **Soda Lake** had quite a lot to do with that. **Frontier** had the simplest of sets – a small wooden frame and two big ropes. It made this huge space around the single figure of Graham: her territory, her space. That definitely influenced me, especially visualising **Soda Lake** onstage making a mark in the space, as opposed to the original idea of being a frame for the camera.

For the production of **Soda Lake**, the sculpture was upstage left, and Michael started there. He came out and looked into the space and out into the audience, then he kept going back. It became a form of punctuation. With the movement in **Soda Lake** I can remember thinking: 'How can I make something really hard for Michael to do?' Because he could do anything, and he always looked so serene. He had this incredible long torso, and a very low centre of gravity. There was something amazing about his proportions and he was very co-ordinated. And he had such beautifully trained, incredibly articulate legs and feet – through a mixture of Scottish dancing and Cecchetti technique with Richard Glasstone.

Michael made amazing lines. I remember he never wobbled, because his centre of gravity was so low. Without being too fanciful, it was something almost swan-like; it was very elegant. And that's what I was doing in **Soda Lake**. There are some phrases in it that I thought would be impossible to do, and he did them, with that serene, slightly elfin look that he had – and still has, although he's slightly craggier now.

Most of **Soda Lake** was legato, drawn-out movement, with a lot of stillnesses. **Dutiful Ducks**, which I made a year later, was at the opposite end of the spectrum, with complex rhythm and speed. Michael moved very fast and still looked very serene. The detail of what he achieved was extraordinary.

Part of my decision to stay with Rambert was to gain access to a different resource – when I arrived, most of the dancers had had quite substantial classical training. It was a different language of skills; it was interesting to see what was beautiful about it and what was, for me, redundant. That, I think, was what was mutually exciting for Michael and me: I could see his gift, and his gift was involved with his training and his understanding of the language. His body was just one; it was almost impossible for him to do anything graceless. I've always found it very exciting to work with young people when their knowledge is

Michael Clark performing Richard Alston's **Dutiful Ducks**,
Riverside Studios, London, 1982. P: Chris Harris.

off, and as a teacher, you give them information and they absorb it like blotting paper. With Michael it was an absolutely clear line of communication. You would say something to him and he'd do it. He really seemed to like the work, and I loved his dancing. Of course, it was then disappointing for me that he left as early as he did. I knew that he was impatient with the company situation. It was a repertory context with other pieces by other choreographers, and I know he didn't really like that. He was encouraged by David Gothard at Riverside – his first pieces were all performed there. The first complete programme that I remember was **New Puritans** and then **Do you me? I Did**, which I particularly liked. That seemed a big step forward for Michael. **New Puritans** had shock value, and that was the one everyone latched onto, but I remember thinking at the time that there was something amazingly pure about Michael's dancing, and I was a bit irritated that people were so into the Leigh Bowery costumes and the clubbing scene. I was rather puritan about it – Old Puritan, as opposed to New Puritan.

I remember watching it develop and seeing Michael accumulate a company. **New Puritans** was just him and Ellen van Schuylenburch – they worked together for years and there was a strong bond. **Do you me? I Did** was with Matthew Hawkins and Julie Hood. That quartet was the most coherent thing he had done. Years later, when I was running Rambert and asked Michael to come and work there, I can't remember whether I asked him to rework **Do you me? I Did** or if I asked him to do something like it, but that's what **Swamp** was. All I can remember is feeling delighted by what he had chosen to do.

I was pleased that Michael kept it so plain. When we did **Swamp** at Rambert it was fantastic, and when they revived it recently it was even more successful. I remember feeling very satisfied, very proud, that Michael had produced such a good piece of movement. Originally there were slides of Richard Burton and Elizabeth Taylor in **Who's Afraid of Virginia Woolf?**, but these disappeared very quickly. Because Michael was known as an *enfant terrible*, I thought it was wonderful that, somehow or other, he responded to me asking him to make something comparatively plain. **Swamp** was a very rigorous piece, with smart but austere costumes by Bodymap. I was excited precisely because it was so pared down. Michael never said anything to me, but it was as if he thought: 'OK, I know Richard doesn't want a dildo, so I'll just leave it out.' I never said to him: 'Please, no dildos', I just asked him to make a piece.

The recent performances of **Swamp** got very good reviews – I think it even won an Olivier Award. I'm really proud of having commissioned it; it was great to see it after all those years. And the cast included a lot of people who would have known Michael from White Lodge: Ben Craft, Matthew Hawkins, Gary Lambert, Kate Price – all people who Michael would have known either at White Lodge or at the Royal Ballet Upper School. In those days he kept connecting with those people. The tradition of modern dance is to work with a particular choreographer, and a particular kind of language and then break away. The funny thing about Michael is that he hasn't broken away, he's gone back to his roots. He's re-examined the language he learned when he was a teenager and a child, and in that sense, Richard Glasstone has been the most important influence of all on his dance vocabulary.

I saw Michael's **Rite of Spring** at King's Cross, but I didn't see **O** partly because it was at Brixton Academy – I was told that everyone was crammed into a sort of pit and it was really smoky, and that made me quite reluctant to go there. Instead I saw it at the Barbican when Michael revived it, with a beautiful string orchestra. I remember him taking it to New York:

I didn't quite know what they were going to make of it because it refers so much to Balanchine's **Apollo**, which in New York would be considered the purest of churches.

There was a time when I didn't go and see Michael's work because it seemed so involved with a scene that I didn't relate to much. When Michael was at Rambert and we were on tour, he seemed to know all the clubs all over England. When we were at Birmingham Rep, we went to a thing late one Friday called Poser Night. It was quite a nice night out except there were a lot of people who were seriously involved with themselves in the mirror, with one white glove and a hat or something – very strange. But it was part of Michael's life and part of what he found interesting. It took the work to another place, where there was a young crowd who thought it was absolutely fantastic.

In all artforms, but particularly the performing arts, there's room for, if you like, maverick or obsessive work. Michael went through such a bad time in his life and we didn't know if we'd ever see him dance again. So there's an element of extraordinary survival and revival. There are artists who are very prolific, with great facility and quick organisational skills. Michael's not like that – sometimes producing work seems to be a real struggle. It's a difficult way of being an artist but it gets there, even if it takes time!

The fuss around Michael used to irritate me because I always felt it was superficial, that it was too easy to classify him as an *enfant terrible* when things got difficult for him and his state of health was not so wonderful. The same people – the critics or the establishment – who put him in that box and praised his classical training were the ones who labelled him the *enfant terrible* when he couldn't fulfil something for them. Every time a choreographer I knew was asked to work for the Royal Ballet, I always prayed for them. Historically, it didn't have much of a support system for creativity, and I think when Michael worked at the Royal Ballet it was the dancers that supported him and who were really keen that he should achieve something. When it didn't work out, the press said 'How terrible.' I think it was quite wrong when the Arts Council said to Michael: 'You're really successful, we don't need to fund you.' Val Bourne supported him through Dance Umbrella, and there was a small circle of people who supported him.

It's really interesting that now Michale is supported so much by his friends in the visual-art world. I'm not sure that he relates his work much to other choreographers working now. Michael has made a different space for himself, with doors that open to minds that he finds more sympathetic. He has moved his work into a wider context.

There's certain music, like The Fall, which conjures up a certain era in Michael's work, the guitar-laden, heavy gut-wrenching volume. He was working with that even just a short while ago with Big Bottom and Susan Stenger. I think of that as part of Michael's world, but against that music he continues to explore a pure series of *tendus*. It's fascinating that Michael puts these things together in his work. I don't always understand why they are together, but I understand that he wants them that way.

Interview by Suzanne Cotter,
6 July 2009

Richard Alston is a British choreographer and artistic director of the Richard Alston Dance Company. He has been resident choreographer and artistic director for the Ballet Rambert and is also artistic director at The Place in London. He trained at the London School of Contemporary Dance, choreographing for the London Contemporary Dance Theatre before forming the UK's first independent dance company, Strider, in 1972. In 1975, he traveled to New York where he studied at the Merce Cunningham Dance Studio. In 1980 he was appointed resident choreographer with Ballet Rambert, serving as the company's artistic director from 1986 to 1992. During that time he created 25 works for Rambert as well as the Royal Danish Ballet (1982), the Royal Ballet (1983) and a number of solo works for Michael Clark, including **Soda Lake** and **Dutiful Ducks**. He was awarded a CBE in 2001.

Above and opposite: Michael Clark rehearsing with Richard Alston, Riverside Studios, London, 1981.
P: Chris Harris/Victoria and Albert Museum, London.

Karole Armitage

During the Dance Umbrella festival in 1980 or 1981, I was performing **Drastic-Classicism** – a piece for seven dancers, with music by Rhys Chatham for four electric guitars and drums – at Riverside Studios. Michael came to see the performance, and I shook his hand and thought: 'This person has a special aura.' I must have got his phone number, because six months later I called him and asked if he wanted to come to New York to dance with me. I had never seen him dance, but I could feel that he was very gifted. I knew from other people that he was an excellent dancer, so it wasn't that I had no information, but I had very little to go on in a concrete way. There was something in that smile and the shaking of the hands that expressed a deep sensuality and sense of freedom, which made me think that it was a good idea. He got on a plane and came, and I met him at the airport, I think.

The first piece that Michael performed with me was a revival of **Drastic-Classicism**, which we toured all over Europe. I particularly remember the performance in Rome where the neighbours cut off the electricity, due to the loud volume of the guitars. We were unable to rehearse all day; the electricity was restored just in time for the show. Only in Italy.

The music to **Drastic-Classicism** is played twice. The first time we wore straight dance clothes and followed specific choreography that I had devised. For the repeat we improvised on the original material, wearing more flamboyant costumes, and sought to do something site-specific. Michael dragged a huge red velvet curtain around the Roman stage and threw it into the audience. He performed **Drastic** with the gleeful delirium of a newly released inmate enjoying the thrill of destruction.

I had quit Cunningham Company by the time I asked Michael to come and dance with me. He and I were partners for a couple of years. What was extraordinary about him was that he was an absolutely perfect classical dancer with the most refined, understated and beautiful technique imaginable. He was supposed to have been the new Anthony Dowell, the prince of the Royal Ballet. He definitely had that level of a gift. After **Drastic**, I created a duet for us called **The Last Gone Dance**, which we performed at the Théâtre du Châtelet in Paris with the Paris Opera Ballet, who were performing another dance of mine on the same programme. I think he was still taking class, because he was probably interested in doing Cunningham classes. While he was with me he was in great technical shape. He was this charismatic, delightful creature, a gifted being filled with polymorphous sensuality and delight, but he was so very young, a kid discovering the world. New York was a wonderful playground for him. Seeing me decide to go on my own gave him an idea of what he could do in his life. I had broken off from the mainstream and was doing my own thing, which was appreciated by enough people that one could survive. I'm convinced that the reason he decided to go back to London and start his own company was because of the examples he had seen in me and other people like me in New York.

I was in one of his first pieces of choreography at Riverside. He had done most of it before I got there, because I was still touring, and I somehow landed in London and had a day or two of rehearsal. I am fairly sure it was **Of a feather, FLOCK**. I remember that he could do everyone's roles better than they could. I am from the Balanchine tradition, which is very physical and rhythmically driven, and more knife-edged, whereas English ballet is softer in style and rhythmically much less volatile. Michael's choreography had those English roots, so I remember it being fairly gentle and having a lot of things where you need a very loose back – like big arches or lying on the floor putting your head to your foot – which for him was very easy; for me, not so easy. It was calm and quiet and very gentle, not punk in spirit. He had been doing that with me, so I think he wanted to do something different.

I think Michael was always on a suicide mission, and always in a dark place somewhere inside, though he was also very joyous. In the early days I went out every night with Leigh Bowery and other friends of Michael's. We were a kind of gang; we had a wonderful time going to the newest, hippest clubs, but gradually I got busier and busier with my company and its responsibilities, and Michael's impulse to be taken away from the day and into the night became stronger. Living on opposite sides of the Atlantic, we wound up not seeing each other as regularly as we had in the early days.

Michael shifted the audience spectrum for dance, through rock music and his spirit of freedom, which included extremely flamboyant costumes that were openly gay – one good example was the pants that exposed the dancer's bottom to the audience. I think he gave the London audience an absolute sense of liberation by doing something unique to his generation, tied to the club movement of the time,

Above and right: Karol Armitage performing with Michael Clark in **Of a feather, FLOCK**, Riverside Studios, London, August 1982. P: Chris Harris.

with its expression of counter-culture fashion, music and ways of living. That spirit of freedom was probably the most important thing for the audience response to his work. He did an extraordinary thing for dance, which was to make it a popular art form for a huge range of people.

I like his more personal – and what today are considered to be less conventional or marketable – works. I think presenters like the Stravinsky works because it reassures them that the audience will understand what they are seeing. It's seen as more serious than rock 'n' roll. Personally, I think these are just cultural prejudices. It's not superior just because it has music by Stravinsky.

I wish today's world were less conventional and could acknowledge the greatness of these other pieces by Michael. Those works take you into an experience of altered consciousness that is unique to him. They are really exceptional. I love the choreography, the use of costume, the theatricality and the sense of time, which is unlike anyone else's as it comes from a mind in an altered state. Michael is one of the single greatest dancers that I have ever seen. He is a unique force of nature that we have been lucky enough to witness and to enjoy for many years.

Interview by Suzanne Cotter,
31 May 2009

Karole Armitage is director of the New York-based Armitage Gone! Dance Company. After dancing in George Balanchine's Geneva Ballet (1973–75) and with the Merce Cunningham Dance Company (1976–81), she developed a unique choreographic style, which combines contemporary movement with classical ballet and modern dance to create a virtuoso, poetic style. Christened a 'punk ballerina' by **Vanity Fair** in 1984, she began choreography with **Ne** in 1978 and **Drastic-Classicism** in 1980. In Italy, Armitage served as director of the 45-member Ballet of Florence (1996–2000) and the Venice Biennale of Contemporary Dance (2001), and worked as resident choreographer for the Ballet de Lorraine in France (2000–5). She has contributed to the repertoires of major dance companies throughout Europe and North America, including Alvin Ailey American Dance Theater, American Ballet Theatre, The Kansas City Ballet, Rambert Dance Company, The Paris Opera Ballet and the Ballet Nacional de Cuba, as well as the ballets of Berlin, Bern, Lyons, Monte Carlo, Munich and Naples. Armitage also directs opera, has worked for Madonna and Michael Jackson, and frequently collaborates with artists from other fields such as James Ivory, Jeff Koons, Christian Lacroix, Lukas Ligeti, Brice Marden, David Salle and Philip Taaffe. She was recently nominated for a Tony award for choreography for the Broadway production of **Hair** and was awarded France's most prestigious award, Commandeur dans l'Ordre des Arts et des Lettres.

Michael Clark and Mikhail Baryshnikov in **nevertheless, caviar**, Barbican Theatre, London, February 2004. P: Nigel Norrington/Camerapress.

Mikhail Baryshnikov

SUZANNE COTTER When did you first encounter the work of Michael Clark?
MIKHAIL BARYSHNIKOV In the early 1980s, I think. In London.

What was it about his work that interested you?
His originality. His nuttiness and naughtiness. I had never, nor have I since, encountered anyone quite like him – especially as a dancer. His body articulation is phenomenal and his presence arresting, almost faun-like. Whether he's dancing or choreographing, he always takes a very bold and sensuous approach.

What prompted you to invite Michael to choreograph **Rattle Your Jewellery** *(2003) and* **nevertheless, caviar** *(2004)?*
I never thought he would say yes. At the time, I followed him as much as I could – in England, and here in New York. I was a great admirer, so of course I was very glad when he agreed.

What distinguished these works from other choreography with which you have worked previously?
He's one of those choreographers who danced with you. He had such a different body than mine – beautiful long arms, and he moved in a balletic way, but with an obvious Cunningham influence. I probably looked ridiculous trying to imitate him, but it challenged me as a dancer. In the end, I was always just trying to catch up with him. Michael's process is very smart – he begins to conceptualise before he even starts to choreograph. And it's not just about the movement, he considers every element: the socio-political aspect, the music. It's all part of what makes his work so rich.

Could you say something about the process of working with Michael?
He never compromises his craft. He is incredibly demanding and introspective, always questioning and improving upon what he did the night before.

Did your collaboration influence the way you think about choreography and its possibilities?
I am not a dance critic. I just love his work. I'm never bored with him or his dancers – I had a wonderful time dancing with them.

How would you position Michael within the history of contemporary dance?
Top shelf, for sure.

Email interview by Suzanne Cotter,
21 January 2011

During his illustrious ballet career, Mikhail Baryshnikov danced more than 100 different works, from the classics **Giselle** and **Don Quixote** to Twyla Tharp's **Push Comes to Shove** and George Balanchine's **Apollo**, and he was a leading guest artist on the world's greatest stages. From 1990 to 2002, Baryshnikov was director and dancer with White Oak Dance Project, which he co-founded with choreographer Mark Morris. White Oak was born of Baryshnikov's desire 'to be a driving force in the production of art', and, indeed, it expanded the repertoire and visibility of American modern dance. In 2003 and 2004, he toured a programme of solo works by noted American and European choreographers to benefit the Baryshnikov Art Center (BAC) in New York, which opened its doors in 2005.

CURRENT
/
SEE

Page 223: Kate Coyne and Michael Clark, with Tom Gidley and Cerith Wyn Evans of Big Bottom, in a publicity shot for **current/SEE**, 1998. P: Alan Titmuss.

Opposite: Michael Clark in rehearsal for **current/SEE**, 1998. P: Gautier Deblonde.

This page: Michael Clark performing **current/SEE**, Birmingham Rep, October 1998. P: Dee Conway (top) and Laurie Lewis/Lebrecht (above).

Before and After: The Fall

Page 227: Publicity shot for **Before and After: The Fall**, 2001. P: Jake Walters.

This page: Melissa Hetherington in a publicity shot for **Before and After: The Fall**, 2001. P: Jake Walters.

Opposite: Melissa Hetherington performing in **Before and After: The Fall**, Sadler's Wells Theatre, London, October 2001. P: Laurie Lewis/Lebrecht.

Lorena Randi performing **Before and After: The Fall**, with fist sculpture by Sarah Lucas, Hebbel-Theater, Berlin, August 2001. P: Andrea Stappert.

OH
MMY
GODDESS

Page 235: Lorena Randi and Kimball Wong in a publicity shot for **OH MY GODDESS**, 2003. P: Jake Walters.

These pages: Kerry Biggin, Michael Clark, Melissa Hetherington, Lorena Randi, Tom Sapsford and Simon Williams performing **OH MY GODDESS**, Sadler's Wells Theatre, London, September 2003. P: Laurie Lewis/Lebrecht.

Mick is a window cleaner and a murderer.

Amy Hollingsworth in a publicity shot for **mmm...**,
2006. P: Hugo Glendinning.

Stephanie Jordan
Michael Clark: **Stravinsky Project**
(**O**, **Mmm…** *and* **I Do**)

For Michael Clark admirers, it was an important moment: the completion of his Stravinsky trilogy (2 November 2007 at the Barbican Theatre, London) after several years in preparation, everything finally in place. Yet it was at this culminating moment that the singular nature of the enterprise became apparent, the deft sidestepping of the notorious images of the choreographer that spill over from his past.

It was a performance shorn of virtually everything but dance content: movement to be looked at for its own sake, and unadorned. Any references onstage to Clark's life offstage were subdued. The rude costumes and stage paraphernalia for which he remains famous were largely absent, long gone the loud allusions to club culture and renegade fashion via the iconic walking work of art Leigh Bowery and designer duo Bodymap. And, for the first time ever, all the music on the programme came from the classical tradition. Clark is much better known for ferocious rock music (The Fall most regularly, also Wire, the Sex Pistols, T. Rex and Susan Stenger) or for appropriating snatches of popular music, such as Stephen Sondheim or Nina Simone. You can count on a few fingers his use hitherto of anything classical: most notably, perhaps, his choice of Chopin **Preludes** in **Because We Must** (1987), a tongue-in-cheek reference to the regular association of Chopin with conventional ballet class and choreography. Clark has always enjoyed using music that carries associations that he can 'play with', including the most familiar or celebrated music:

> *It's the ambitiousness for my own work … daring myself to do that. It's a way of upping the ante … having the audacity to tackle these sacred cows.*

The Stravinsky scores forming the trilogy are seminal, designated masterpieces written for Diaghilev's Ballets Russes: **Apollo** (famously choreographed by George Balanchine in 1928, here reworked and retitled **O** by Clark); **The Rite of Spring** as centrepiece (**Michael Clark's Modern Masterpiece**, later titled **Mmm…**, first set in 1913, notoriously, by Vaslav Nijinsky); and finally **Les Noces** (Clark's **I Do**, premiered in 1923 with Bronislava Nijinska's choreography). But this could be the first time that they have appeared in this order. And a kind of cyclical story might be read from the order, about the facts of life in their plainest, least sentimental form: birth and the ritual of marriage as preparation for further procreation.

At first curtain rise, on a gloomy stage, we see a grey figure caught in a hard oblong of light, flat to the floor. Pencil-straight, taut through to the toes and lean to bone and muscle outlined by the unitard, the figure's exaggerated flatness reduces human qualities, although there is a suggestion of female contour: is this strange creature a corpse in a coffin (earth to earth) or a woman lying on a bedsheet? From the orchestra pit, we hear the caress of warm strings. Soon, straining into movement, we discover that she is a woman giving birth, parallel to Apollo's mother, Leto, giving birth during the prologue of Stravinsky's score. She hoists up her pelvis and opens her legs (angled flexions at knees and ankles) in a kind of jagged scream,

and soon a man rolls into place between her thighs as if the newborn infant. She is Kate Coyne, Clark's most commanding and inspirational dancer of today.

At the end of the same evening, we see Coyne again, now as the bride in **Noces**, standing bolt upright *en pointe* and statuesque, but again barely human, almost wholly immobilised, enclosed and tied up with bows in a giant-knitted white dress. But here, she is definitely not alone. She is a tall woman, made taller still by her headdress and, not only does she dwarf absurdly the groom at her side in his brown unitard, she also towers over the whole proceedings, upstage centre, the end of a corridor flanked by a chorus of singers on risers and 10 prone dancers laid out before them. The only movement left is the clanging of percussive pianos, antique cymbals and bells, which too gradually reduce to nothing. Of course, you could read the wedding dress (apparently after a 1965 Yves Saint Laurent original) differently; as the critic Sanjoy Roy suggested, 'like a cross between a tacky toilet roll cover and a knitted condom' – after all, this is a Michael Clark evening – but you would only think like this if you were familiar with Clark's deeper past.

In 2004, management at the Barbican Theatre had discussed the possibility of staging Clark's dream trilogy as a three-year project, one work annually, and then appointed him artistic associate, offering him and his company an administrative base. Clark was attracted by the guarantee of live musical accompaniment on a large scale, a string orchestra for **Apollo** (originally, in 2005, the Aurora Orchestra conducted by the young rising star Robin Ticciati; in 2007, the Britten Sinfonia conducted by Jurjen Hempel), two pianos for **Rite** (played by Andrew West and Philip Moore – funds could not stretch to the original 100-plus orchestra version) and the wonderful – impossible demands of **Noces**: four pianos, percussion, four solo singers and large chorus. Never before had Clark enjoyed such musical resources.

But, there is a longer history behind the trilogy. Clark first began to think about **Rite** when he was a tribe member in Richard Alston's 1981 setting for Ballet Rambert. Towards the end of the 1980s, Peter Schaufuss suggested that he set it on a cast of 40 dancers for his company English National Ballet. In 1991, Stephen Petronio and Clark worked on a version called **Wrong-Wrong**, together taking on the role of a double-headed Sage, with Joanne Barrett as the Chosen Maiden. She remained his choice in the role for his own full **Rite** premiere in the UK in 1992. Two years later, Clark turned his attention to **Apollo**. The same year, the Royal Ballet gave him a commission: he badly wanted to set **Noces** but was dissuaded, hardly surprisingly because of the firm position of the Nijinska version in the Royal repertory. The idea of the trilogy was beginning to emerge. After all, it is not hard to find thematic links across these particular scores and Clark's new conceptions of them: stories of birth, sex, sacrifice and Chosen Ones. And, as the critic Jann Parry has observed, there is a link between **Rite** and **Apollo** in the history of ballet, via Louis XIV (who promoted the codification of ballet movements), to the sun god of **Rite**, recipient of the sacrifice that ensures the return of spring. Meanwhile, Clark listened voraciously to other Stravinsky music, and recently, there have been further tentative ideas for choreography to his music: a **Firebird** for the Kirov Ballet mooted in 2005, and, for Clark's own company, T. S. Eliot's **Four Quartets**, an extract from which Stravinsky set as **Anthem** ('The dove descending breaks the air', 1962). Yet, for more than a

decade, Clark held on to the notion of reworking, and in his terms, finishing the two 1992 and 1994 works. **Stravinsky Project** has asserted itself regularly – he was still reworking details up to its last performances – weaving in and out of his other work, his periods of inactivity and activity, his comebacks and disappearances.

In 1986, Clark said that he found complex, classical music dictated too much to him:
I enjoy the simplicity of … The Fall because it gives me a sort of broader canvas to make whatever I want to on.

His choreography indicates that the regular pounding beats gave him freedom: sometimes to follow them, sometimes to work within the gaps between them. When it came to Stravinsky, the **Rite** attracted him because:
The music is incredible, some of the best dance music I've ever heard.

With the score and original ballet cited regularly as prime examples of artistic radicalism and bad behaviour, **Rite** well suited a theme of revolution:
Not just in the political sense, but also in the sense of cycles between all opposites – like life and death, good and bad, and ugliness and beauty.

Furthermore, there was the primal urge within it:
Sex and dance were made for each other.

And Clark was drawn to the fact that:
One of the themes of the piece is the idea that winter can't turn to spring without dance taking place. That's quite foreign to us, the idea that dance might be necessary.

The sacrificial act itself, the crucial, final stage in making the spring happen, Clark has seen in both positive and negative terms – resonating with the life choice of professional dancers, with the conventional fate of women and domestic expectations of them, most recently with suicide bombings (not an issue in the early 1990s). But he also saw it as a potentially positive and powerful decision. The 1992 press release referred to his **mmm…** as 'a fundamental, brutal and highly physical affirmation of life and death – primal, modern, necessary.' By 2006, the allusion to death had been expunged. Clark also found the equally radical construction of the score appealing:
Stravinsky wanted to strip dance down to just its rhythmic element … He was breaking all the rules … I wanted to underline that to try and strip away the melody from the work and make it more rhythmic and primal.

But Clark's next Stravinsky undertaking, to the score of **Apollo** (written in 1928) – by which time the composer had long since relinquished any revolutionary ambitions – emerged for quite different reasons. Here, Clark found a parallel with Stravinsky at a personal level, identifying with the Janus-faced, transformative characteristics within the composer's life:
*I often talk about myself in the past as if I was a different person, because it does feel like that … The person who wrote **Apollo** seems completely different to the person who wrote **The Rite of Spring**. I was attracted to **Apollo**, because in the past my work has been Dionysian rather than Apollonian. It has been about embracing chaos rather than order.*

The reference here is to the Dionysian/Apollonian opposition, borrowing from the concept so frequently associated with Stravinsky's progress. For the composer, **Apollo**, with its sublime

lyricism and fundamental serenity, can be seen as a metaphor for the reconciliation of the various tensions in his private life and also as a signal of his renewed religious faith. It was an important stage too within his move through neoclassicism, 15 years after the rampant physical blast of **Rite** (the pinnacle of his expression of chaos and primitive oblivion). Famously, and betraying his by-then-conservative stance, he admitted that it was classical ballet that helped him see his way through the eternal conflict in art between the Apollonian and Dionysian principles. The latter assumes ecstasy to be the final goal – that is to say, the losing of oneself – whereas art demands above all the full consciousness of the artist. There can, therefore, be no doubt as to my choice between the two. And if I appreciate so highly the value of classical ballet, it is not simply a matter of taste on my part, but because I see exactly in it the perfect expression of the Apollonian principle.

Clark had already experienced the schizophrenic juxtaposition of the immaculate cool of ballet-school classicism and the riotous, colourful subculture that formed his daily life. Oppositions were already characteristic of his work too – 'ugliness and beauty' – but now he needed the Apollonian Stravinsky as an additional regulatory force. Quite as important, Clark, with all three works of his trilogy, situated himself within the major dance tradition that has grown around Stravinsky's scores. He joined a mass of choreographers who have been inspired to create new commentaries on his music, like them too moved by the celebrated Stravinsky dance premieres, especially those from the Diaghilev period:

I'd like to think I'd made a piece that Stravinsky and Nijinsky would make now.

A database chronology currently lists over 700 Stravinsky choreographers and more than 1,200 dances to his scores, and Clark's is not the first trilogy: Balanchine provided the most celebrated precedent with the strictly neoclassical series, **Apollo**, **Orpheus** and **Agon**. Clark's three chosen scores represent some of the most choreographed of all, **Rite** especially, with several hundreds of settings. Acknowledging the authority of the past, most of the 30 or so recorded settings of **Apollo** have referred back to Balanchine's 'perfect' ballet of 1928. Likewise, most **Noces** choreographers (about 70 settings recorded) have applied themselves to the tradition stemming from the original Nijinska. **Rite**, which Clark likens to 'a sort of royal family [or]…your mum and dad', is a different case. The choreography was lost after eight public performances until reconstructed in 1987 by Millicent Hodson for the Joffrey Ballet. But the memories of its scandalous premiere and of the terrifying, turned-in and twisted choreography have always been strong. **Rite** became both 20th-century icon and monster.

Clark did not balk at referring to his new **Rite** of 1992 as **Michael Clark's Modern Masterpiece** in the first instance, which was a signal, if partly ironic, of taking his place as myth-maker alongside the great works and movements of past and present. But it was also a memory of Alston's 1980 **Rainbow Ripples**, another work that Clark danced during his time with Ballet Rambert. Here, the sound-score by Charles Amirkhanian incorporated a lecture by the musicologist Nicolas Slonimsky on how perceptions of an iconic piece of music, like **Rite**, change over the years:

A modernistic monstrosity in 20 years becomes a sophisticated curiosity and in another 20 years becomes a modern masterpiece.

Like a jackdaw, Clark added the rebuttals of popular culture into his 1992 mix. So Stravinsky and Leonardo meet their match – an image of the **Mona Lisa** morphs into one of Andy Warhol's **Liz Taylor**, while we listen to 'Send in the Clowns' from Stephen Sondheim's **A Little Night Music**. Meanwhile, adding a touch of self-irony, Clark performed a gorgeously sensual solo wearing nothing but a fur muff covering his crotch (nought covering his backside), which became the literal centre of his dance. Clark's art–life world was fully present: his friend Bowery, the costume designer and a protagonist on stage, and the **Rite** score topped and tailed by various rock preludes and postludes – PiL, T. Rex, The Velvet Underground and the Sex Pistols. Originally, Clark says, he wanted the freedom to break into Stravinsky's score with interpolations of this kind of music and indeed to give the composer a touch of electronic treatment. (According to the terms of the Stravinsky estate, Boosey & Hawkes could allow none of this.)

Here in **mmm...**, there was even the startling debut of Clark's own bare-breasted mother Bessie, one of her jobs being to perform a re-enactment of giving birth to her own son (in the muff) during one of the preludes, with the enormous, padded, blubbery Bowery operating as the midwife who hauls him out from between her legs. This was high-definition Clark of the period, both funny and chilling in its remorseless bad behaviour, alongside images of Bowery turning into a cowering creature on all fours, to be walked upon, kicked and led like a dog, or appearing during the **Rite** score as pregnant Earth-Mother-cum-Mr-Blobby; then the toilet-collar costumes in the second half of **Rite**, with lids as haloes screaming horror about their association with human waste; and finally the Hitler moustache worn by the Chosen Maiden. The writer David Hughes explained it in the terms of contemporary postmodern and post-structural thought, Clark being a product not of a moment of history, but of histories, then, conflated in a moment. This is the condition of the work itself, a compacting of references and a series of images which run into each other through their connecting elements.

At the same time, Hughes questioned the value of such 'glamorised and fetishised autobiography'. Yet a strength of the work was its highly ambiguous nature, that it registered a breakdown of civility as both disturbing and entertaining. Clark had enough theatrical know-how to tread this dangerous borderline in such a way that we were made to feel uncomfortable, forced to question our reactions to such outrage, and to note its double-edged comment on the virtuoso violence of today's media.

In fact, **mmm...** turned out to be a transitional work – with much less than expected in the way of props, theatrical paraphernalia and Clarkian life references to disturb our view of the real dancers, especially in the **Rite** section. Clark said in a 1998 interview:

I had already started to draw the line between my private life and my work.

Even the original narrative was kept to a minimum, with little notion of a specific place where ritual happens, or of a tribe, or separate bands of men and women – costumes by Bowery and Stevie Stewart were unisex and strange enough to be objectifying (like the rubber kilts lightly referencing Clark's Scottish background and worn together with yarmulkes). There was a Chosen Maiden and a Sage, in 1992, his mother, regularly described in interviews as 'the wisest person I know'. But, typically of all Clark's Stravinsky works in all versions, the programme

named no characters. The performers seemed to have stepped off another planet, earnest of energy, facially withdrawn, often literally turned upside-down. In 2006, if anything, this was even more the case, with the performers increased from six to 12 – we felt that we had got to know them all personally in 1992 (Barrett, Bowery, Bessie Clark, Clark himself, Matthew Hawkins, Julie Hood) – with the formality and clarity of doubling up in unisons, and the guests from life all gone. The stage was now brighter and whiter (and there were new colourful flower-print leotards in Part 2 of **Rite**), the movement lighter, and Nijinsky's presence diminished. But there was one especially significant new twist: Clark now as the Sage (sinister in toilet collar and black dress), wielding two black sticks, a disturbing, poignant reflection upon the passing of time, and – now he was no longer 'dancing' – upon Clark's difference in age from the rest of his cast.

Back in 1992, press releases reported a new movement focus, that Clark had 'developed a technique where movement is initiated from and centred around the pelvis. Complex and technically demanding, this expresses the life force – libido – that is the essential source of dance.' The performers swung their pelvises vigorously in circles and wave-like undulations. They also imprinted their new identity with a memorable slow, slow processional to PiL, entering one by one in their light-front, dark-back unitards, hips forward, chins to the chest, evoking the idea, says Clark, of *'your brains being between your legs.'* You can glimpse this move in his later Apollo setting. There have always been many links across the three Stravinsky pieces, both images and movement sequences, binding them together, so we read a continuity between them. However, in 2007, with **mmm...** placed second in the full Stravinsky trilogy, we spotted the references between it and **O** backwards, in reverse order.

The dance writer Rachel Duerden has written of the parallel, or turned-in stance – or other oppositional movement – acting in a 'chromatic', dissonant way against Clark's background in *danse d'école*. To push the musical parallel further, the chromaticism may escalate but tonality never completely dissolves. Notably, the opening of Part 2 of **Rite**, despite the toilet costumes, brings back Apollonian crossed-leg (ballet) fifth positions as a signal of calm. Otherwise, **mmm...** (especially the 1992 version) stretches as far away from stable, consonant 'tonality' as any piece that Clark ever made, frequently removing clean body lines in its frenzied scribbles of motion, base squats and (reminiscent of the Nijinsky choreography) helpless knock-knees. (In 1992, it seemed that Clark 'turned into' Nijinsky just before Stravinsky's score begins.) The Chosen Maiden's solo Sacrificial Dance is an extreme account of Clark's new style and of various striking floor moves now propelled to find their resolution in triumphant standing and aerial celebration. In 1992, after ambivalence with regard to the rest of the piece, Hughes welcomed this solo as a potential re-writing of the score:

> *Here there is no sacrifice or martyrdom to the demanding dance... She gives herself to us and keeps herself all to herself. We almost dare not look, we are dared to look, we are looked at very directly, causing us to reflect on our gaze. Here is not the seduction of the melting image and the compliant body, but the body refigured in stone.*

Yet the final image is two-faced, typical of Clark: the Chosen Maiden wears a Hitler moustache, she is evil, frightening, perhaps a touch comical, as much as inspiring.

This most famous solo is balanced by another representing sexual awakening in Part 1 of **Rite**, to the section of the music called **Spring Rounds**. Significantly, this solo was also scored for a woman (initially Julie Hood, more recently Melissa Hetherington). She wears a purple satin unitard with a leg and arm stripped out to reveal the full connection of hip, shoulder and crotch. A moment in the solo surely primed Ajay Close's observation that women find **mmm...** powerfully erotic:

Sex from the inside, tracing the twisting route of desire and arousal, the elaborate, insistent pattern...
The woman places a hand inside her groin, then closes her thigh and turns her back on us. This onanistic action is soon adopted by others (including Clark in the original **O**), but the primary sexual empowerment of woman is crucial, set off in the 1992 work by the rude 'trash', in 2006 by a more well-behaved and pristine neoclassicism. It is not long before the same woman expresses herself in utterly abandoned positions, buttocks skywards or legs split apart. She too is incompliant, 'keeps herself all to herself', and invites us to ask questions of ourselves as onlookers.

The 'purple' solo is also an example of Clark's special adagio choreography – the speed that suited him best during schooling, and that remains a special choreographic strength – sustained single-tempo arcs and circles that stop in striking sculpted positions. He went further with this in **O**, dividing the work into just two speeds more broadly than Stravinsky suggests – or, indeed, Balanchine, to whose masterpiece he turned for inspiration. The first piece reworked for the Barbican, **O** represents Clark's need to take stock and find order, and the next step in jettisoning quotations from his life. Even if its titled prelude, **OO**, incorporated some of the noisy punk material that accompanied Stravinsky's **Rite** in **mmm...** there was a major commitment to purity when it came to the string score, a redefinition of classicism. Crucially, Balanchine and Stravinsky had themselves spoken of the work as an exercise in elimination, gestures selected according to 'family relations'.

Programme notes suggest that Clark went for the image of an infinity of nothingness that contained everything:

O is the hole in the whole... [Clark] abstracts Stravinsky's rhythms and distils from his music the most elevated pronunciation of all: an inexorable, single syllable.

In 2005, this was modified and updated, to include the statement that the work was his 'ground zero' and further oppositional concepts:

[Clark] takes ideas of fullness becoming empty, the hole becoming whole, negative space becoming positive.

Clark chooses not to mention the obvious resonances with the vaginal 'o' or the 'o' of orgasm. The **O**s of 1994 and 2005 led to the formalisation of **mmm...** in 2006, though both pieces, Clark maintained, were always tightly linked as two sides of the same coin. It's that thing of opposites confirming one another:

*[In **Rite**] I wanted a quality there of the phrase doing a dancer, rather than the dancer doing a phrase. In contrast, Apollo is the Sun God. He's in control, he divides day from night, a god of clarity. Apollo moves to make the only possible choice from one reason to the next.*

In **O**, there was the same broad outline of prologue, apotheosis and solos and a couple

Melissa Hetherington performing **Mmm...**, Barbican Theatre, London, October 2006. P: Hugo Glendinning.

of group dances in between, as in Stravinsky's score and Balanchine's setting of it. But in 1994 there were two men in white – both Apollos (though no one has ever been formally named as such)? Daniel Squires wriggled out from under a duvet – Clark's mother giving birth again – and there was Clark himself, rapidly recognised by critics as their Apollo (another Chosen One) if there was one at all. Balanchine's three women in white were featured (he referred to them as Muses), but there was no sense in Clark's piece of one being a favourite (Terpsichore), and the duet that once emphasised male-female union as a symbol of artistic idealism rapidly became a quintet. Since 2005, in further pursuit of reduction and classical clarity, there has been just one possible Apollo, a real duet (though for no narrative reason), and no reference to Clark's life history whatsoever. The piece develops as a kind of glassy meditation on the past. The women now wear pelvis-covering tunics for the central Muse section, just as they did for Balanchine. In 1994, they wore pelvis-revealing unitards.

In the meantime, Clark had undertaken detailed video analysis of the Balanchine. Classical-academic steps and positions – but absolutely no *pointe* work – replaced some of the earlier dance material. Still, there was pelvic-led movement, in 'family relations' with his **Rite** setting, also free-curving torsos and a code of angular arm gestures, all of which counterpointed academicism. There were actual quotations from Balanchine in both versions, the Michelangelo image of the hand of God giving life to Adam being a shared motif of the early duet/quintet – in 2005 this was reduced to the pair pointing to each other across the space. But there were a number of other more subtle and fleeting recollections and allusions, often appearing during the same passages of music as in Balanchine's choreography.

The adagio material remained relatively intact across the decade, like the early solo for Clark himself in a see-through mirrored box, stretching, exploring, walking the walls with his feet, and self-contemplating like Narcissus before he opens the door on to the world. The end of **O**, with a touch of aqua lighting, evokes slow-rolling through water. In the current version, Coyne completes a brisk little solo with a hard arabesque arm pointing the way, whereupon the apotheosis begins and the dancers relinquish upright classical poise and surge to the floor in a sort of primeval return to the deep. There is one especially memorable moment: the three women lift their pelvises, swing their legs around each other into a knot, knees to the left, toes to the right reaching like needle points to the ground. So there is none of the idealism of Parnassus – originally Apollo led his Muses up a stairway. Rather,

Clark's Apollo touches the floor in a final *penché*, one leg raised in the air behind him, the direction of attention bluntly downwards, which cannot but be read against the original.

In 1994, I remember how many of us enthused about the new 'seriousness' of the **O** enterprise and Clark's unforgettable beauty and vulnerability as Apollo, deliciously languid, supremely poised, and claiming a seemingly inevitable rightness, in both refinement and awkwardness. But impressive too was the fierce commitment of his super-strong women, firmly rooted with powerful leg extensions and abandoned head circlings initiated from churning, plunging pelvises. In the 2005 revision, the performers looked uncertain, even bland. By 2007, the new material, more rehearsed and legible, revealed the strength of its own personality and the 'truth' of enriched movement material, a huge development in Clark's negotiation with Stravinsky.

I Do followed the trend set by the revised **O** and **mmm...**, even more highly choreographed, even more formal than its precedents. There were new challenges with regard to complexity, a Russian text assembled by the composer from folk sources – if you understand the language, a wild, sometimes bawdy, Joycean collage of nonsense prattle that led semantically in multiple directions – and fresh rhythmic complications in a score that often does not look as it sounds.

Yet Clark still wanted to make a generalised critique of regulation and the problematic aspects of social conventions, which remain with us today (a theme from his own creative history). He explains what the libretto meant to him:

It's full of anguish about getting married; in the piece the woman's dreading it. This is what's going on. Different conversations are heard in the music, different perspectives on marriage... And it's all to do with control. She doesn't want to leave her family and the freedom...

Like many other choreographers following Nijinska, whose work he studied carefully and remembered well from his days at the Royal Ballet School, Clark did not go for the composer's much more upbeat conception of a 'divertissement of the masquerade type', even had he known Stravinsky's intentions. Yet, as in some other stagings (most notably that of Jerome Robbins in the US in 1965), he did share the composer's idea that the music should be a visible part of the action. Stravinsky wanted to see the pianos and percussion on stage. In Clark's work, we see the 40-strong choir on risers, divided in two by a corridor, with the upper bodies of the four solo singers visible in the pit. The effect is highly theatrical: oppressive, almost as if ambushing the 12 dancers, but also adding to their numbers, symbolic of a much larger wedding crowd.

In 1923, Nijinska's **Noces** was already innovative for its time, an early example of neoclassicism, with stripped-down narrative, giving pride of place to movement concerns. In accordance with his other Stravinsky practice, Clark went for an even more stripped-down account. So there were no parents, or specific entourages, no Tableaux 1, 2 and 3 designated as taking place in the home of the bride or groom or showing the journey to church, though perhaps finally (equivalent to the score's Tableau 4), there was a kind of party with all the dancers on stage together for the first time. The bride is seen in a state of undress at the start, emerging from a huge matryoshka doll, then fully ready at the very end. During the centre of the piece, she sometimes dances as just one of the community, sometimes emerges as the

figure we recognise with an identity. At the halfway point, she is lifted up flat like a table and deposited on the floor, where she goes through the opening section of her Leto solo from **O**. It could be seen as a dream of impending motherhood.

Again, the community seems distant, both prehistoric and ungendered post-human in their beige/brown leotards and tight caps. Nijinska had hers in brown and white peasant uniform: shirts, pinafores and leggings. When wearing leotards, dancers already seem less human, more unreal, but here, in Clark's **I Do**, we read them through Nijinska as people who have lost something of their original identity. Yet crisscross peasant garters are painted onto their unitards; colour variations and detail of decoration confirm that they are six couples as much as 12 people, as much as a whole community. Nijinska's broad division of men and women is transplanted here on to the choir, men and women on each side of the corridor.

From Nijinska's model, Clark absorbed key principles that he could use in his own way – like geometry, closed-up lines and walls of dancers, square and horizontal pyramid formations, and interweaving trellis sequences reflecting the braiding image within the text (symbol of sexual violence and the interpenetration of two families). She proposed a strictly reduced range of movement ideas. Clark followed suit, building on his previous Stravinsky vocabulary: ballet steps and arms, with Nijinska's half-fists blunting line, torso curves and twists (Merce Cunningham's style was a distant base), and gestural hieroglyphs. Clark pressed his ideas into short, repeating units, or let them unfold into longer accumulations or chains of motion. Nijinska favoured moments of frieze, with the piling of body upon body; his multi-body sculptures tend to be more entangled, three-dimensional and slow-moving. She responded to the counterpoint and textures in the music while adding her own chords, polyphonic strands and isolated solo utterances; so, in a different way, did he. Always, pattern is of the essence. And rhythm. It is impossible to overestimate the importance of rhythm in establishing the main tenor of the piece and of the image of mechanisation constituted by rhythm. Even if he wrote gaily about masquerades and divertissements, Stravinsky's music has often evoked the image of the machine, read as both thrilling and terrible. Listen to what T. S. Eliot wrote in 1921 about **Rite**, which seemed to him to transform the rhythm of the steppes into the scream of the motor-horn, the rattle of machinery, the grind of wheels, the beating of iron and steel, the roar of the underground railway, and the other barbaric noises of modern life.

One central component of Stravinsky rhythm is its motor. Charging just about all his work, this is exceptionally pronounced in **Noces** by virtue of its extreme percussive orchestration. Here too, images of mechanisation extend further, across Nijinska's choreography as well as the music: the processes of new cinema, the semblance of puppets in motion, the factory at work, the noise of metal upon metal.

The music critic Émile Vuillermoz wrote in 1923:
The only thing [Stravinsky] needs, in order to create his special pathos, is a solid machine with which to forge lovely accents, a machine to hit, a machine to lash, a machine to fabricate automatic resonances. His genius resides in the organisation of the rhythmic panting of this sonorous factory … On the stage – without decors, and transformed into a vast cinematographic screen – moves a

Artists of the Ballets Russes in Nicholas Roerich's costumes for Nijinsky's **Le Sacre du Printemps**, Paris, c.1913. P: Top Foto.

Vaslav Nijinsky and Bronislava Nijinska in Nijinsky's **L'Après-midi d'un Faune**, c.1912. P: akg-images.

The Ballets Russes performing Bronislava Nijinska's **Les Noces**, c.1923. P: Lebrecht Music.

The Chosen Maiden solo in Millicent Hodson's reconstruction of Nijinsky's **Le Sacre du Printemps**, performed by The Joffrey Ballet, 1987. P: Colette Masson/Roger-Viollet/ArenaPAL.

simplified humanity, black and white, as if it came from a projector ... these synthetic marionettes ... One remains forever troubled by the strange accent of humanity possessed by the laments, laughs, and yells that escape from the forge where one sees the great blacksmith Ansermet brandish his menacing fists in order to bend all of his workers on their anvils!

Vuillermoz had already read Nijinska's ballet as a statement about us, a metaphor for 'the mechanisation and automatism of society'. He went on to ask: 'In the games of social and religious ritual, are we anything other than obedient marionettes?'

Clark takes the machine metaphor just one stage further, renewed for our own times, with his further level of dance abstraction: people are negligible, like emotionless androids. It might also have encouraged him to explore the opposite, confirming the motor through contrast. In **Noces**, Stravinsky provided the clues for contrast with his more or less rhythmless sung laments interpolated between dominant, urgent, chug-chug sections. Clark expresses these laments through his slow-moving multi-body sculptures.

There are times when Clark shows beat very plainly and clearly, especially in **mmm...**, for instance, in the quick limping step motif that permeates the early, regular sections of Stravinsky's score. But the dizzy riffs that used to break out of his pumping earlier dances to rock music do not work with the more complex, dense rhythms of classical music, and he has found other tactics. One thing is for sure: drawing from the American Cunningham and postmodern dance traditions, he celebrates dance autonomy, the power of movement to act as a separate voice or layer, interdependent with the music, touching it lightly, as it were, with occasional shared exclamations. He is vigorously anti 'Mickey Mousing' or 'Keystone Kops'. One tactic is to make blocks of movement material for their own sake and then to try them out to music, looking at how a change of music can make the dance speak in a new way. Nonetheless, Clark is led by his ear. Noting that Stravinsky's **Noces** rhythms read quite differently on paper from how they sound – even different metres suggested – Clark had no hesitation in choosing a closer relationship with the aural experience.

When Clark's tactic is smooth adagio, we comprehend the broad span of a musical passage. But whether we hear the detail of music less keenly or more so when there are so few points of contact with the dance is moot: probably both according to context. What is certain, however, is that we hear music differently when we see it choreographed differently, and our musical perceptions are refreshed. Consider the powerful effect of highlighting a key structural moment in the score. Without warning, adding to the sound blast, the crouching 'purple' soloist in **mmm...** throws a leg and arm as far away from her as she can, like taking an enormous, straining stride at floor level. Or the prone Leto suddenly arrives in a sitting position, articulating a hiatus in Stravinsky's **Apollo** prologue.

It is revealing to compare two of the Muse Variations from **O** with their counterparts in Balanchine's **Apollo**, the dances for Calliope and Terpsichore. Clark is much less literal in terms of following musical structure than Balanchine, who favours short movement units that often repeat with their music: our perceptions are probably ready for more challenge these days. Neither does Clark staple an obvious ABA form to each of Stravinsky's dances: his continuity reaches ahead for longer time-spans. Now that a strong or regular

dance pulse is rare, the short-long repeating patterns in the music seem less prominent. So do the pizzicato upper strings accompanying the cello melody in the centre of Calliope's variation. Whereas Balanchine's dancer steps consistently on each pizzicato pluck, Clark's tips at them on and off with arm or step detail and our ears are drawn to the cello in between times. The same variation also alludes to Leto's slow floorwork, but with the anguish removed, and Clark allows this sequence to roll on freely over the musical seams. As for accents and punctuating points, there are four startling thuds (deep D-minor pizzicato chords) where Balanchine's Calliope contracts her torso and clutches her heart four times, a violent emotional reaction and an eccentric touch, classicism suddenly abandoned. Clark uses just two of these, one for a plunge to the floor, the other for an airy ballet *changement* (a jump, with changing foot in front) – the other two you barely hear, covered over by dance phrases. Terpsichore's variation is famously punctuated by 'four huge sustained attitudes', when she crosses one leg over the other, one arm up, the other pressing down, thrilling to her personal power. Coyne's halts to the same music are all different. Two of them are precarious balances on one leg, in attitude and in *à la seconde* (the other leg bent behind or extended to the side); another is a reflection of Balanchine's position; all of them are suddenly laid bare, held longer and with less activity between them than in **Apollo**. Some of us cannot help but read them through the famous precedent.

Perhaps Clark's 1992 setting of the Sacrificial Dance, fundamentally unchanged ever since, represents his most sophisticated negotiations with musical time. It is harder to read than the **O** solos, but that is absolutely appropriate given that it is a metaphor for extreme struggle. Choosing Joanne Barrett for it in 1992 was a brilliant decision, and she remains unmatched in the part. She is a gymnast dancer, with the kind of arm and fist power that can initiate whole-body action and that dance training does not provide. Yet the gymnast in her is disguised in this solo, through her total immersion in what she has to say. She is clad only in knickers (and the Hitler moustache) so that her muscle power is fully exposed and operates in a constant state of resistance, working against the urge to move on. But that urge is all-powerful. The concept of more and still more encapsulates the solo, more turned in, more split asunder and more thrust upward to counteract the pull of gravity. Even as she falls with increasing frequency in the final stages, Barrett picks herself up to be strong again.

Compare Pina Bausch's formidable Sacrificial Dance in her 1975 **Rite**, which is a crazy assemblage of movement recollections, much reduced, sketched, barely there, ending in collapse. In Clark's account, the body never loses high tension, and movement memories are displayed in the spirit of triumph, of will to overcome their bitter resonances. Leto's image of giving birth, the jagged scream, becomes an enlarged scream of revolt, driven by quick tempo and crazed impatience. Compare the Hodson/Nijinsky Sacrificial Dance. Clark found it disappointing:

> ...surprisingly static for someone who is dancing herself to death...I wanted to make it a dance where someone really could die, with some really full-on dancing...[and yet] to fight it, to not die.

Hodson's reconstruction matches the pattern repetitions in the music schematically. Clark does the opposite. The gulping signature music comes back again and again, and once

Eryck Brahmania, Stefano Rosato, Alexander Whitley and Simon Williams performing **O**, Lincoln Center, New York, June 2005. P: Stephanie Berger.

as a false start. Clark teases us with a Nijinskian leitmotif, the two-dimensional *tendu* opening position (pointed foot extended forwards), and just once he repeats the whole first section, forging into new spatial directions. Otherwise there is no return. Rather he goes for the significant changes in energy and drama in the music: the repeat of the opening down a notch, then ratchet up in pitch, adding tension and renewing energy, a sharpened inflection rather than mere restatement. And he paces his progression by etching stillnesses and visual accents into the memory. At the start of an early Interlude with irregularly spaced, repeating, stuttering chords, Barrett huddles over, arms (as at the end of **O**) wrapped tightly around her, and waits… Later, to a brass outburst, she propels herself flat on to her front, legs flung wide, and waits… The Interlude ends with her suspended on her forearms, her legs rearing up behind her in an excruciating tail curve. Later she runs up the stage diagonal – a strong pathway – and throws herself flat on her back, body and arms at alarming full stretch. These are all moments of frozen terror or violence, the foil to, but no release from, her furious rush of thoughts. Both procedures together build energy, and together with the score, they create the big storm. At the end of the dance, there is the final salute (a gesture from Clark's Stravinsky collection in a new guise), one right-angled arm slung over the head, vicious and triumphant. All three of Clark's Stravinsky pieces have terrific endings, but I can think of no finer Sacrificial Dance.

When, in 2007, the full trilogy went public, Clark had clear reasons behind the order of its parts. He wanted to increase the sense of integration between music and dance across the three works, with a growth in the physical, onstage presence of the music. He also

wanted to demonstrate a move from convention as the evening progressed – from **Apollo**'s classicism and setting with the orchestra in the pit to the radical sound and staging of **Noces**. He then suggested how the trilogy could be read:

> *… the marriage in* **I Do** *might mean that after going through those earlier stages, one could unite with another person, or it could simply be a celebration of community. But I'm never literal.*

My reading is different, of a cycle from birth, **O**, to a kind of living death, with an important challenge to the scheme, **mmm…**, in the centre. I suggest the idea of living death because the form of resignation at the end of **I Do** is wholly uneasy, with all serenity left far behind. The extreme immobility and confinement of the Bride is like an annihilation, magnified by the accompanying dancing group strewn defeated and exhausted at her feet. It is a hugely bleak outcome.

But a sense of loss, of severance, also hangs over the entire trilogy. Clark gets rid of so much of his past: the fun; the angry choreographic preludes stemming from a long creative history; the intimate clutch of friends whom we felt we knew given way to a larger, more anonymous company; his own dancing history – we have seen him progress from Nijinsky and Apollo to the Sage once played by his mother, and now, in brief stage appearances, he is older, wiser, distanced through age.

After the shock of severance, we begin to look at all three pieces anew. Now they seem to reference other histories more strongly, the bigger histories of dance, and the history of the composer. We see them as a single entity with internal dialogues leaping between them, about the power of women performers embodying the meta-story (most spectacularly Coyne and Hetherington), about the movement vocabulary that twists and turns in its meanings as it binds fast the three pieces. The entity becomes more object-like and modernist, I feel its solidity, its thereness, the more I write and think about it. And Stravinsky, icon of modernist purity, has the last laugh, looming godlike over it all – even appearing in person on an old film conducting **Firebird** (screened just before **I Do**).

Yet, will we ever see the trilogy in its pure form again, with or without live music? Since the series of performances at the Barbican, it has never again been shown like this. At Lincoln Center, for instance, it was split into two programmes, the first of which began with a rock prelude. The Barbican was a moment, a frozen statement about life, beautiful, full-on physical, and also removed, life with the disruptions of the life force finally unable to penetrate it. But it could be one of the key staging posts in Clark's career.

Author's note: I am grateful to the Michael Clark Company for providing recordings of the Stravinsky works: **mmm…** (Glasgow, Tramway, c. 1992); another close-up recording of Joanne Barrett in the Sacrificial Dance from **mmm…** (c. 1992); excerpts from **O** (c. 1994); **O** and **OO** (Barbican, London, 2005, and Lincoln Center, New York, 2008); **mmm…** (Barbican, 2006); the full trilogy (Barbican, 2007).

Michael Clark in rehearsal for **mmm...**, Barbican Theatre, London, October 2006. P: Hugo Glendinning.

STRAVINSKY PROJECT PART I: O

Page 257: George Balanchine and Mourka jumping, 1964.
P: Courtesy Martha Swope.
　　Melissa Hetherington in publicity shots for **O**, 2005.
P: Jake Walters.

Ashley Chen performing O, Barbican Theatre,
London, November 2005. P: Hugo Glendinning.

Adam Linder, solo (right) and with Kate Coyne, Melissa Hetherington and Alina Lagoas in publicity shots for Stravinsky Project [0], 2007. P: Ravi Deepres.

Kate Coyne performing **O**, Barbican Theatre, London,
November 2005. P: Hugo Glendinning.

STRAVINSKY PROJECT PART II: mmm...

Page 267: Igor Stravinsky (1882–1971), Berlin, 1930, from the book **Igor and Vera Stravinsky: A Photograph Album, 1921–1971** (London: Thames and Hudson, 1982).

These pages: Joanne Barrett, Ashley Chen, Kate Coyne, Fred Gehrig, Melissa Hetherington, Amy Hollingsworth, Alina Lagoas, Adam Linder, Tom Sapsford, Daniel Squire and Simon Williams performing **mmm...**, Barbican Theatre, London, October 2006. P: Hugo Glendinning.

Kate Coyne and Melissa Hetherington (opposite), and Joanne Barrett, Ashley Chen, Kate Coyne, Fred Gehrig, Melissa Hetherington, Amy Hollingsworth, Alina Lagoas, Adam Linder, Tom Sapsford, Daniel Squire and Simon Williams performing **mmm...**, Barbican Theatre, London, October 2006.
P: Hugo Glendinning.

These and pages 274-75: Michael Clark, Kate Coyne, Melissa Hetherington, Amy Hollingsworth and Adam Linder performing Clark's mmm..., Barbican Theatre, London, October 2006. P: Hugo Glendinning.

273

Above: Melissa Hetherington performing **mmm...**, Barbican Theatre, London, October 2006. P: Hugo Glendinning.

Opposite, top: Ashley Chen and Amy Hollingsworth performing **mmm...**, Barbican Theatre, London, October 2006. P: Hugo Glendinning.

Opposite, bottom: Melissa Hetherington, Amy Hollingsworth (centre) and Adam Linder performing **mmm...**, Barbican Theatre, London, October 2006. P: Hugo Glendinning.

Amy Hollingsworth as The Chosen Maiden in mmm...,
Barbican Theatre, London, October 2006. P: Hugo Glendinning.

STRAVINSKY PROJECT PART III: I DO

Page 281: Leni Riefenstahl with a members of the Kau Nuba, Sudan, 1975. P: Ó/Leni Riefenstahl-Produktion.
Publicity shots for **I Do**, 2009, with Kate Coyne (above). P: Ravi Deepres.

Kate Coyne, Melissa Hetherington, Stefano Rosato, Hannah Rudd and Simon Williams in publicity shots for **I Do**, 2009. P: Ravi Deepres.

Kate Coyne, Melissa Hetherington, Fiona Jopp, James Loffler, Stefano Rosato, Hannah Rudd and Simon Williams in publicity shots for **I Do**, 2009. P: Ravi Deepres.

Kate Coyne, Melissa Hetherington, Fiona Jopp, James Loffler, Stefano Rosato, Hannah Rudd, Andrea Santato and Simon Williams in a publicity shot for **I Do**, 2009.
P: Ravi Deepres.

Opposite: Kate Coyne and Andrea Santato in a publicity shot for **I Do**, 2009. P: Ravi Deepres.

Stefano Rosato (opposite top and middle); Ashley Chen, Samuel Guy, Stefano Rosato, Andrea Santato, Simon Williams and Kimball Wong (opposite bottom); and Stefano Rosato and Melissa Hetherington (above) performing **I Do**, Barbican Theatre, London, November 2007. P: Hugo Glendinning.

A

Judith Mackrell

The first time I saw Michael was at the Museum of Modern Art in Oxford. It was interesting – what was considered orthodox radical in those days was very much the stuff that was coming out of Dartington College and the early generations of The Place graduates, rather soft, release-based work. The real great exponents were Julian Hamilton and Kirsty Simps and some of the pieces by Second Stride. It was not flashy technique, and there was still this bitter rift between ballet and modern dance. So it wasn't about beautiful bodies, hardcore technique, or flashing yourself. It was about going inwards, which frankly I found incredibly tedious at times.

It was a shock to see people like Michael and Ellen van Schuylenburch, partly because they were classically trained dancers and they were stretching their technique to the limit. They weren't there with baggy sweatpants, they were clonking around in platform shoes, addressing fashion rather than pretending to be above it. It was comparable to the first time I saw Mark Morris. It was so flamboyant. It was really against that minimalist and rather drab sensibility. At that time in England we were still catching up, in dance terms, with what other people were doing elsewhere. We just had Martha Graham in the 1950s and 60s, and then we got Merce Cunningham and Trisha Brown, and we were still dealing with that.

It was only 10 or 15 years ago that there had been any modern dance training of any kind in the country. People were very influenced by what was being imported from America and from Europe, but also they were making it up as they went along. We threw up some pretty genius people in that generation along with Michael – there was Laurie Booth, the Cholmondeleys. Lloyd Newson didn't really flourish until he came to Britain, so everybody was ready for it all to explode, but up until then it was just such early days. The easiest kind of alternative dance was this rather loose minimalism. The kind of dancers I see now weren't around then, which I think was partly dictated by the fact that there were a lot of not very good dancers. But then you had the Laban Centre producing good graduates, The Place was expanding and there were more classically trained dancers beginning to have the confidence to shift over into modern dance. People talked about Michael being so crucial to that.

There had been this thing with ballet that you crossed into modern dance if you weren't very good. And amongst modern dancers, there was the attitude that if you had been a ballet dancer you had been infantilised, where all you knew was to repeat what other people had shown you. So for Michael to be such a talented classical dancer, but to make the decision to come over to the other side – and to do it so well and be so flamboyantly individual – was quite huge in terms of influence.

It is interesting to talk about the audiences Michael, Ellen and the company attracted – a lot of crossover from the club, rock, punk and art worlds. Apart from the stellar ballet celebrities, nobody knew the names of any modern dancers or choreographers then. It was such an overlooked little world, so to begin with people were a bit bemused and quite flattered that finally there was all this attention. I think magazine and newspaper editors were pleased that there was this dancer that people could talk about. And there was a hell of a lot of laziness in the coverage of Michael, a lot of recycling of the same stories. There was a feeling amongst the people that cared about Michael and his talent that it was, if not toxic, then potentially destabilising, because he was so young. I felt ambivalent about the whole relationship between the choreography, the pure dance stuff – which right from the beginning, once I had got over my shock, I thought was just extraordinary – and all the other antics.

Going to a Michael Clark performance in the 1980s was huge. They were always sold out. Certainly the audience was part of it – everyone dressed up as if they were going for a big night out. I remember for the premiere of the first **Rite of Spring**, we were all given earplugs; I think that was at the King's Cross venue. Everything always started late, like a rock gig. At that point I was one of the youngest of the critics, so I always had a bit of a swagger – even if I didn't particularly like every aspect of the punk stuff, I could deal with it – whereas some older critics were snorting and squealing with outrage. I enjoyed all of that. Audiences were actually quiet while they were dancing, partly because you couldn't have heard anything, but there was a definite sense of people looking at each other as well as what was on stage. They were there to be excited. I think my ambivalence to the whole camp thing on stage was some kind of irritation to that part of the audience who didn't know what they were seeing and then were being distracted by it. But that was part of the fun of it, too.

One of the extraordinary things Michael does, that no one else does, is almost a Bauhaus thing with costumes and props, which gives his productions a different quality. It is intensely physical and object-based. Michael's dance hasn't entered the digital age, as far as I'm aware; I don't think he even knows how to use a computer. With other people's work, you definitely feel the influence of computer technology one way or another, because they use programs to choreograph with, or they use it visually in terms of speed and layering and fracturing.

What Michael did, he did very intensely. There are two things there: firstly, that sense of actually bringing the past with him. That is partly to do with his ballet training – obviously ballet dancers are not just learning a language that has been handed down over generations, but it's natural to them to inhabit past work. Weirdly, although Michael came kicking and bashing into this whole new style because of his training, that was what was interesting about him as a dancer: he had more of a tradition than any of his equivalents in pure modern dance would have had. I think it's in his bones. Obviously dance survives in different ways to any other art form, and it will depend in part what there is of him on video or DVD, but I would never say that anything he is doing is any kind of cul-de-sac. It's an incredibly rich style that he created. It was a lot to do with his facility in both classical and modern styles, and all those contradictions he managed to carry within himself. I just love the fact that he'd be taking classes in the morning with Richard Glasstone, who is obsessively correct, and then going out clubbing in the evening. Somehow his head and his body were able to combine those things. The fact alone that he was the interface between those two cultures, at a certain watershed in dance history, makes him significant. Even now when I look at **Swamp**, it is so perfectly formed, so hair-raisingly frightening and exhilarating in its energy.

There is tremendous crispness and precision in his work. There's nothing lazy in it. In a way, one of Michael's demons is his perfectionism. Maybe it's because he had such facility as a dancer, so he could embody such a level of detail as he worked. But, equally, coming from his classical background is the fact that, however abstract individual ballets may be in repertory, at the Royal you're brought up dancing characters. Michael is trying always to make the perfect movement, so that tension is there, and on top of that it is natural to him to think of people dancing, as opposed to bodies.

So even **Swamp** has a psychological tension, and what's so amazing is that it is refracted in the formal structure. I don't know how he does it. It is not just about those slicing gestures and advancing lines – there's something about the way he organises the dancers on stage.

Apollo was a really bold thing to do, because everyone does **The Rite of Spring** and **Les Noces**; they've almost become the two rites of passage for choreographers. But to deal with **Apollo** and that whole Balanchine–Stravinsky sacred pairing was amazingly brave. I remember feeling so excited, because it was the first of the works where you felt that everything else was so calming…the rest of the noise was quietening down and you could see this dance coming up. That was very exciting. Michael must have believed in himself to be able to do that, so symbolically **Apollo** was the most important for me.

It's interesting to know how universally acknowledged Michael's sensibility can be, because there is something so very British about it; it's like British fashion – for some people it's just too chaotic, neurotic and subversive. I'm sure, however, if something like **I Am Curious, Orange** was revived just at the moment it could be a cult hit, with all the 1980s fashion coming back!

I couldn't imagine British dance without Michael Clark, and that is the critical thing: he is completely a British product – the Royal Ballet and punk. The Royal Ballet is an incredibly eclectic company and has one of the widest repertories, and punk, although it originated in New York, was really British in the way it developed as a street/art/music/dance thing. Scottish dancing is huge for Michael as well, that phenomenally detailed footwork and crazy sense of rhythm, that sense of disciplined wildness. And in New York there is so little state funding that he would have floundered. In a way he has been our genius underdog, and we've loved him for it.

Interview by Suzanne Cotter,
5 February 2009

Judith Mackrell is dance critic for **The Guardian**. She has broadcast on dance and the arts on television and radio and has written several books including **Reading Dance**, published by Michael Joseph; **Bloomsbury Ballerina**, the biography of Lydia Lopokova, published by Weidenfeld & Nicolson; and **The Oxford Dictionary of Dance** with Debra Craine.

Matthew Hawkins
Member of the Thinking

Michael Clark, Matthew Hawkins and Ellen van Schuylenburch rehearsing **Do you me? I Did** at Danceworks, London, July 1984. P: Darryl Williams/ArenaPAL.

Choreographers of a certain status often have a crack at Stravinsky's **The Rite of Spring**. One version I remember seeing (at Sadler's Wells) was set by Angelin Preljocaj. Before the music started (and we could all hum it, couldn't we?) there was a vignette in silence. The chosen reached up under her minidress and slowly fished out her knickers. As she stepped out of the leg-holes and scooped up said room-temperature undies, she managed to maintain a sort of resentful eye contact with the fellow who ceremoniously took them in hand, now tightly bundled. Then (gasp!) he popped them in his pocket. I felt so short-changed. I mean, pop them on your head, dear, at least! Go all the way; give us profanity. In **The Observer** the reviewer (Luke Jennings) described the vignette and made this pithy observation vis-à-vis its tone of restraint: 'but he did not put them over his head as a Michael Clark dancer would have done'. Wasn't this spot on? I had not been a Michael Clark dancer for many a season, but I was evidently still a member of his distinct thinking.

The Michael Clark Company is now 25 years old. I was involved for the first eight years – closely, it seems. And we go back further. Strange that I did not encounter Michael sooner than I actually did. True, I went through the Royal Ballet School two or three years before he did. And he did not start at the beginning nor stay to the end of what could amount to an eight-year course. I know that he worked hard.

Like me, he was one of Richard Glasstone's protegés. As befits the owner of such a name, Mr Glasstone was rigorous about clarity. One applied oneself or else suffered a degree of dispatch. There was ample to inspire and motivate in his teaching – it could seem simple, a matter of carefully juggled basics with mandatory variations in speed and tone. Then he would quietly ask for (and get) some feat of control or virtuosity; achieved to a degree that established new levels on which one would then build. It was a shared achievement and a delight. One would struggle to regain that kind of singular aplomb in later life.

White Lodge (the Royal Ballet's lower school) was tatty, congenial and full of honest aspiration. The art room was open all hours. The music room came to house a stereo, for ecstatic collective listening. It was not some histrionic forcing-bag. It was just more nourishing and specialised than the ambience of Aberdeenshire (Michael) or Balham (myself). Michael later told me that there were opportunities to continue practices that had taken hold prior. Into the surrounding wilderness of Richmond Park, one could slip unnoticed over the perimeter fence, a tube of Bostik and crisp packet in hand... This was not on everybody's curriculum. A person could get expelled. Such a shoe almost fell on Michael Clark. But Richard Glasstone stepped in, offering the miscreant a probationary haven off-campus amid his own family. By then I was already in the Upper School, but a bunch of us visited White Lodge on some errand (I can't remember now quite what) and this was

my first sighting. There he stood, in humble mufti, nothing but grace, sporting Marc Bolan curls. He had been working, so there was both a sweatiness and innate resourceful glow, touched perhaps by the Glasstone influence. There was honest humility, too, in the soft brogue of his greeting, his open palms and the hang of his arms.

Hemmed in by rackety train lines on the one side and six lanes of the Great West Road on the other, the Upper School was a waking nightmare. All growth and study disappeared in favour of an intense beefing-up, ballet-wise. Range and clarity deferred to a vernacular of pretended butch moves. New muscles could get contentious. The only real interest lay in mastering the situation, getting competitive, getting it over with. At this stage in my life I was a high achiever and the institution presented me for graduation in key roles in performance on Covent Garden's boards. In the rigorous guise of Prince Jean de Brienne (the leading man in Nureyev's bravura production of Petipa's **Raymonda**, Act 3) I took a noble stab at ruling, with my advanced batterie and multiple mid-air turns, while in the junior section Master Clark intrinsically knew what to do in performance of a traditional Scottish solo dance, so that he was thought the year's real find. No matter, I had held my own and successfully pitched for a contract. Hence I emerged a more or less precocious wage-earner in the Royal Ballet's corps, at the tender age of 17. But I did not get to leave the clamorous building; the Royal Ballet Company and School shared the premises.

Michael Clark famously nipped this kind of initiation in the bud. But, in the process, he made some memorable inroads. As scholars, some of us were interested in choreography (as we had been in artwork or music) and we were encouraged to try our hand. Personally, I found it all a bit sink or swim. One plotted after hours and prepared an item to be seen in competition with the tentative efforts of one's peers. There were prizes, and maybe the next John Cranko would get discovered. We might get an urbanely conspiratorial Freddy Ashton as our judge, or a logical, narrative-biased Dame Ninette. A peevish Kenneth MacMillan could be dragooned into explaining why everything failed except his choice of winner (I'll never forget those lugubrious nasal tones – I was put off choreographing for years).

Because my workload in the corps de ballet was light, I had lots of time for espionage and so I did get to witness Michael's student choreography. I saw a witty number that featured concealed music-box apparatus, a cast of four and yo-yos. Brahms's lullaby tinkled, slowed and ran aground while the intrepid dancers got entangled. Genial Norman Morrice gave the boy a gold. It was a coup. It was audacious. It seemed to have come easily. For the first time, I saw that grin of his. For some, he was unnerving. I know he was arguing to shelve study of the usual compulsory-figure type repertory in favour of innovative Ashton solos: Beliaev from **A Month in The Country**, Troyte from **Enigma Variations** (both created for Anthony Dowell's deft abilities). Temerity! Refusal only informed the young enthusiast that he'd better look elsewhere.

There were grumbles in the subterranean company canteen; a cramped affair where court could be held. Here the senior dancer, Ronald Emblen, told all. He was moving laterally into teaching, hence handling the first-year boys, and he was lamenting this particular 'talent'. So we got to hear about the boy who was so gifted but finding it all too easy; he was lamentably cocksure – turning up to class late and in no fit state. Meanwhile, other company members had clocked the student prodigy but were just delighted to see a boy with great proportion and line. Obviously this was a startling potential colleague to accommodate in the near future, even if he might leave us all standing. And then it was all pre-empted. Michael attended a summer school, where he was talent-scouted and signed up for Ballet Rambert in two shakes of a lamb's tail.

Now it really began. The choreographer Richard Alston was engaged by Ballet Rambert to begin what was to become a long association. He must have felt well blessed when he set eyes on Michael, whom he immediately featured, with great elegance. At this point, in the Rambert frame, we eclectic dance-goers

Michael Clark and Matthew Hawkins performing in **New Puritans**, Riverside Studios, London, August 1984. P: Chris Nash.

Leslie Bryant, Matthew Hawkins and Ellen van Schuylenburch performing **I Am Curious, Orange**, Sadler's Wells Theatre, London, September 1988. P: Fred Whisker.

were all struck by the poise with which this young man naturally held sway over new ensemble work. His lucidity alone was worth the price of a ticket. Let's mention the feet: they were like living creatures. The combination of the high-curved instep and relaxed articulating toes was so mesmerising. Watching the play of those metatarsals, one could feel as if one was being drawn right in. Physically he was muscled ideally and evenly head to toe, just enough to animate his will and to foster nicely contoured repose. He had been dealt a rare combination of attributes and skills; worn (at this point) just as if it was his due; just himself.

The Alston/Clark oeuvre is a matter for the archives; significant for the way in which it enabled the young man's manifestation in the most apt choreography to be had at the time. And the reputation of the choreographer flew too. Michael shone first in Alston's **Bell High** (with a shimmering Maxwell Davies score) and was spotted (unaccountably grinning amid the honest manoeuvres) in the ensemble of Alston's version of Stravinsky's **The Rite of Spring**. Richard Alston was going to get established, but Michael was on a different drift. Off out, actually. His Rambert career was little more than a season. Then he went itinerant – the status of which could still include continuity with Richard Alston (there were two divine photogenic solos yet to arrive) and much else besides.

The Riverside TV studios had just become vacated by the BBC and adapted for live performances. Directors Peter Gill and David Gothard gave entry, with David becoming the unwavering architect of much that concerns us here (especially after Gill's move to the National Theatre). They were thinking beyond text-based theatre. They were in hot pursuit of the visual. In dance terms the main emphasis would be on clearly legible abstraction in the unadorned, cavernous space. Hence Riverside Studios flung open its doors to the likes of Trisha Brown, Rosemary Butcher, Richard Alston, Steve Paxton, Lisa Nelson, David Gordon, Valda Setterfield and Ian Spink. Thence (and in fruitful partnership with the first Dance Umbrella festivals), there would be all this plus teasing glimpses of the 'Dartington School', a crop of ballet-rooted autodidacts, and a kind of maverick star-power on the scene (Honi Coles, Lynn Seymour, Karole Armitage).

It turned out that David Gothard's dance tastes (amounting to a philosophical position) had been formed via a youthful epiphany whilst watching the New York City Ballet give **Agon** (Balanchine/Stravinsky). Knowing this work, it comes as no surprise to learn that David's better-than-sex moment arose amid the realisation that the show had led him to a state where there was no longer a division between the visual and the aural. At the peak of their craft, these masters knew how to open the doors between hitherto separate chambers of perception; calculated simplicity (knowing when to be eventful and when to be spare; organising an alternation and interplay between these modes) being the key. One might say that the subsequent Cunningham/Cage investigation was about taking such doors off their hinges. We became versed in this. Michael Clark's initial choreographies had their own transparent portals and so barriers could be dissolved. None of his early choreographic writing would lodge in my muscular memory. We would be travelling light. There had to be non-definitive bits so that other information (humour, concepts, outfits) could be rhythmically and alternately foregrounded, searing the scene and making for wider audience impact. Contrast this with the alluring pearls of the justly admired Siobhan Davies (whose choreographic orbit I would also get to inhabit) and it is clear that her facility for continuous definitive movement invention (and the implied hypnotic completeness of this) would not easily provide entry for the bi-sensual thrills (nor chime with the likes of Gothard – whilst yet being something of an opiate to many others). Cue: pockets of distinction and rival camps. And heightened multimedia 'conversation' is often received as a paucity of real choreographic language. Perhaps oblivious to the fullness of things, many critics would dismiss his inclusive choices, even as Michael's name started to go up in lights on the marquee – but this would all come about later.

In autumn 1980, having rediscovered a choreographic impulse of my own, I found myself featured (non-competitively and in public) in an evening at Riverside Studios that was dedicated for young choreographers of the Royal Ballet. And I saw everything else that was on there. David Gothard made sure we had free entry and in return we formed part of the critical culture that emerged. We all shared our thoughts. In this context, I joined the coterie filing into studio two, where Michael Clark danced Alston's **Soda Lake** alone and in silence. We were looking at a purified relationship between a dancer and his task. He was riveting and fully engaged. He oozed credibility. And, by the way, here was an arena where a classical training was valued as part of the legible abstraction mode. This changed everything. Soon Michael was named choreographer-in-residence at Riverside. This assignment he took literally, dossing down on the premises (it wasn't all abstraction).

Even as the 1980s began, the dance landscape found its form, due for the most part to the opinions of established arbiters. Even now I can remember the echo of their plummy tones: gushing, earnest, grisly or just holding forth. And in my mind's eye I see them roosting together in their pale summer suits and pastel shirts – an inadvertent style tribute to Gustav von Aschenbach of **Death in Venice** fame (early or latter pages of Thomas Mann's novella, depending on how much Chianti was going down at lunchtime). Unlike the here and now, when every college graduate can get a public airing and the dance-going public casts its vote, yesteryear's arbiters provided a filter. They decided who specifically to get behind. When they moved beyond the realm of salon balletomania, they were a productive force. I'm thinking back to the carefully planned and sponsored annual phenomenon known as the International Course for Choreographers and Composers; a considered enterprise, now lost to our rudderless times.

For the summer of 1981, the course directors engaged Merce Cunningham and John Cage as leaders. I was one of the nascent choreographers selected and Michael Clark was there amid our pool of dancers. In a whole new milieu, where it was suddenly about methodologies rather than being somehow 'better' or 'more inspired' than the others, real ideas took hold. They were ideas that could sustain a lifetime of creative practice (as was evident by the example of Merce and John) and one could 'click' with one's colleagues over their daily embodiment and manifestation. Many of us are still colleagues. Each day new tasks were set, new dances made and shown, in tandem with new music. The day I was assigned the dancer Michael Clark was a revelation. Quite unfazed by any sense of pressure, he suggested fine paths for my rapidly devised material and in performance that lucidity of his came into convincing play. For the first time I could see myself as a choreographer, rather than someone who was trying to be one. Peers noticed. He was a natural and gifted enhancer, bringing credibility to all he touched.

After this course, a rumour grew that Merce Cunningham had wanted Michael to join him in New York. Here one might speculate on the degree of self-possession involved in turning down such a prospect. But he did not only want to be admired for what he did not do. Productivity ensued for the next few years, intensely so. He and I criss-crossed a lot. But first I had to leave my perch. As part of the scheme of things, the Royal Ballet were reviving Kenneth MacMillan's 1960s production of **The Rite of Spring** and I was newly cast in the chorus. Then the mature fellow I was replacing marched into the casting office and demanded his part back. To me it was worth no more than a pout and a shrug; just another moment in my stagnation. Turnover (the complete lack of it) was a problem for most of us. Eventually I was inspired to create a bit of turnover by resigning in mid-season. This was unprecedented; I was asked how I would cope with 'the void' (sic). But actually I was going into a niche vacated by another restless young soul. We all enjoyed the spookily scintillating works of Ian Spink, and Michael danced in several of these. When Ian joined forces with Siobhan Davies and Richard Alston to form Second Stride (initially a temporary enterprise), Michael opted out and I sensed my moment. Tossing my ballet tights to the four winds, I took up the place he had vacated. At a stroke, mercurial Michael had ushered in my independent practice.

The Psychedelic Furs, This Heat, The Raincoats, Bauhaus, The Fall, The Birthday Party, Gang of Four, Modern Eon, St Martins' graduates, denizens and diaspora of the Warren Street squat, Neo Naturists, nightspots (Cha Cha's, The Pink Panther) — Michael had his feet in several London camps. It was an intoxicating scene. One could get nicely embedded ... but not just yet. From across the pond, Michael was lassoed by Karole Armitage. Right time. Right place. New York, USA, fount of the dance knowledge we all sought then and source of lifetime cohorts for Michael in the form of Charles Atlas (lighting/video/film) and dancer Ellen van Schuylenburch (of whom more later). Karole Armitage had Michael dancing, more or less maniacally, and she stretched his range amid a cast as adept as he. It was an initiation into an intensely ambitious milieu; neurotic to a point; territorial; dress-coded even. Back he came, quite a bit more seasoned, with a very convincing set of lower-back muscles and a peroxided buzz-cut. Next, he pretty much stopped dancing in other people's work, changed gear and choreographed for a number of small repertory troupes. **Morag's Wedding** (starring Julie Hood at English Dance Theatre) was his first collaboration with costumier Leigh Bowery and was a finely observed wry comment on Scottish roots. **Flippin' eck oh thweet myth-tery of life** (commissioned by Micha Bergese at Mantis Dance Company) was a kind of militant vaudeville encompassing Ancient Greek tales, and it shared a bill with works by Micha and myself.

These dances, like all his output of the time, were both hallucinatory and a must-see, but it started

Michael Clark and Matthew Hawkins performing **I Am Curious, Orange**, Sadler's Wells Theatre, London, September 1988. P: Richard Haughton.

to bother him that the repertory companies might perform with less precision beyond his sights (on tours or with cast changes, etc), so he came out with his trump cards at Riverside. Somehow I missed the premiere of **Of a feather, FLOCK**, but I heard it had to be played twice through, as the show was 100 per cent over-subscribed by fans. I took to the stage (alongside Betsy Gregory) in the by-public-demand revival. Michael wanted to extend his part and spread the load. Who better to cast? The lyrical choreography unfolded in an enfilade of duets, crowned by Michael flying through the latest Alston solo. INTERVAL. Then the audience filed in to see the same thing again but much more rapid, and with the time structure whisked away (we did not await cues). This bit was subtitled **Rush** and was over in a few minutes.

I was struck by the eye-catching hordes backstage. Michael's entourage was pretty much at ease in our dressing rooms. Their intrusion was something to get used to. They were going to be part of the deal for a while, and their florid presence would do wonders for audience chemistry. These liggers could also be muses and later there would even be openings for dressed-to-the-nines *flâneurs* to take to the boards with us. Lana (now Alan) Pellay, visually and aurally something of a Tina Turner-like, would get to thunder-and-freshness around the stage whilst deconstructing her crinoline of J Cloths. Christine Binney astonished with her memorable line in 'fish-dives' and, with her cohorts (Neo Naturists Jennifer and Wilma), appeared undressed to the nines, brandishing pom-poms with synchronised cheery aggression. Michael would feature a gamut of such personages in selected 'happening' scenes much as a visual artist would deploy *objets trouvés*; or was it panto? Variety being the spice of life, this kind of function would eventually entirely fall to the person of Leigh Bowery and he rapidly became scrupulously accomplished.

The team Clark has gathered around him make up the strongest group in Britain today. Matthew Hawkins, with his craggily elongated build, makes an excellent foil to Clark's slight, sensuously rounded slipperiness. Julie Hood, warily eager and Ellen van Schuylenburch, who moves with something of Clark's aggressive daring, complete the group, making a contrasting complementary quartet of the first order.

This review in 1984 (a lone bit of sane recognition from John Percival in **The Times**) vindicates Michael's careful choice of dancers for his first signature company. We each had a gratifying history with him by now, hence were able to fully inhabit his specifications.

Enrico Cecchetti, c.1900, and as Widow Simone in **La Fille Mal Gardée**, from Olga Racster, **The Master of Russian Ballet** (London: E. P. Dutton & Co., 1923).

At the stage of announcement of this line-up, my left leg was in a plaster cast from ankle to hip, due to menisectomy and surgery of a pre-keyhole nature. Medics hoped one might walk painlessly thereafter, but Michael had faith that I would do much more. He was unwavering in his sense of ethics and choice – further proof (if this were needed) that he was impelled to shape roles for specific dancers. I was immensely buoyed up by his conviction and was allowed to work gingerly at first. These were unique auspices that also comprised a return of Richard Glasstone into my orbit. Michael had engaged Richard as our company teacher, so once again extraordinary feats would arise amid the deceptively simple training system.

In his review, Percival also noted:
Above all, he knows how to use his dancers. He still composes more imaginatively for himself than the others, but he is adroit at setting the different personalities, physiques and manners of the team against each other in every different combination of duos and trios to reveal various aspects of them.

As dancers, we were fully aware of the skills he alluded to. Maybe the players in early Orson Welles movies felt as we did. Yet the persona Michael devised for himself in **Hail the New Puritan** (part two of the inaugural performances) was once-in-a-lifetime definitive. For anyone who saw this (and I never tired, from my oblique viewing spot) this spitting, kicking, visionary, bare-bottomed *über*-tart is the quintessential image conjured when pondering Michael's dancing.

The thing certainly took off. It was a coup that looked like a punky triumph but actually required the pulling of all sorts of strings. Bolton & Quinn PR had put Riverside Studios on the map and would now get

Michael into gear. The glossies and the inkies jostled for interviews and he spoke amusingly and well. He ranged from cult new-waver to striking clothes-horse without contradiction.

True, come showtime, the psychic *toupés* of our first-generation arbiters were blown askance. One such spokesman, once dear to us, tottered backstage (in his cups) and blew us an unsolicited gale of regretful invective, and it was a turning point. We were going to have to cut loose from such avuncular forces. Other critics gave their cursory nods towards the cool abstractions they could detect, then went into rants about what were in fact fun anarchic elements; harbingers, actually, and evidence of a unique voice. The profane bits fitted like a glove. We felt powerfully gorgeous, albeit that the buttock-exposing costumes implied the tongue-in-cheek. It did no harm that establishment types were on the scene and seeming to suffer. But such echelons were in the minority. Punters were flooding in. Amid the crush it was evident that a light-fingered contingent of our fanbase could be souvenir-hungry. Soon our photo publicity had to be glassed in, under lock and key. The Chris Harris stills cosied up within a shiny new foyer cabinet. We had arrived.

For the second season, Leslie Bryant was installed in the troupe. As a dancer with a CV to die for (encompassing outings with Lindsay Kemp and Arlene Phillips), Leslie was bound to add verve and poetry to our quartet. Being something of a DJ manqué, he regularly furnished us with individual compilations that we could have booming out from Michael's boogie-box on tour. Our second season mushroomed. We planned media-friendly ensembles to wear in public (airports, clubs, that sort of thing). There were groupies and a constant soundtrack. What with two new full-length works, **not H.AIR** and **our caca phoney H.our caca phoney H.**, plus the later broadcast of the Charles Atlas film **Hail the New Puritan**, the enterprise was rapidly becoming a cult.

But there was no part for me in Michael's next work. Of this he quietly informed me well in advance; it was ethically done. And this bracing bit of news comprised an acknowledgement that my own choreographic practice should not be abandoned. The shift also meant that I could see his eventual next works, **No Fire Escape in Hell** and **Pure Pre-Scenes**, from the front. At this point his productions were going into proscenium theatres, taking the stage with serious aplomb. He also found time to see what I was doing and once even threw my troupe an opening-night party, *chez lui*. By now the Scottish Ballet, the Opéra National de Paris and English National Ballet had also commissioned new works from Michael and powers-that-be began to envisage him at the artistic helm of such a company. Perhaps with this in mind he proposed a reunion and a radically imagined 'panto/seasonal special' for which I was roped back in (as was Julie Hood). **Because We Must** went on as the Xmas show at Sadler's Wells Theatre. There was a lavishness in its avalanche of detail and wit, and the whole trod a line between earthy and ethereal entertainment – all very compatible with *le ballet*, one might have thought.

It's tempting to imagine the Scottish Ballet as the tastiest niche. The piece Michael made for them was called **Hail the Classical**. I went up to Glasgow by coach to see it. I saw rainbows on the way and in the show (Michael was, in one episode, quoting the 'rainbow scene' which was a staple of the Spice of Life Review – part of his childhood experience in Aberdeen). Equally the piece used the full forces of the ballet company and deployed all the backdrops and many of the costumes that the troupe had kept in storage. It was his mastery of this scale (and a bond with the then director Peter Darrell – who nominated him as potential successor) that lent credibility to the idea that he (and we) would take up residency. The fact that, following the show, we were lauded by massed football fans (chanting 'One Scottish Ballet'

Vaslav Nijinsky as the slave in Michel Fokine's **Le Pavillion d'Armide**, c.1909. P: Bettmann/CORBIS.

to the tune of 'Guantanamera' in a Sauchiehall Street chip shop), who recognised Michael from a local TV news broadcast, was also a positive indicator. Talk about a hot new demographic! This was an invitation to a different and perhaps more stable career, the proferring and subsequent withdrawal of which shapes aspects of the Clark story.

Next up was the commission from the Holland Festival for Michael to mount a work based on the accession of the House of Orange to the English throne. It was a tercentenary tie-in. I don't know what our official hosts were expecting, but they got a juggernaut in the form of a full-scale satirical allegory of the Enlightenment. It was called **I Am Curious, Orange**. The Fall played live – with the mercurial mind of Mark E. Smith yielding much of the stimulus for the shape of the thing. This was a marvellous place to have arrived at. It was also a watershed of sorts. Productions of this scale are usually supported by corporations or fully staffed opera houses. It took a degree of temerity to pull this kind of thing off without recourse to the backstage infrastructure available, say, in opera. Without a wardrobe department, quick-change dressers, *régisseurs*, wig-teasing maintenance and the like, the whole thing could get exhausting because we were bound to do it all ourselves.

'When queens collide, the stars will fall from the sky.' Jayne County definitely had a point with this song lyric. Michael Clark and Stephen Petronio got together and apparently were having the best time you could have without actually exploding into smithereens of pure fellow-feeling. Part of this phenomenon was their co-choreographed **The Rite of Spring** of 1991. Because I was commissioned for a premiere alongside their launch event (in a curated festival called Le Diable au Corps at the CNDC in Angers, France), I was on the scene and I saw what was being pooled and pulled off here. They had indeed grafted something complex and alluring to this abundant score but one felt it was only a question of time before each choreographer would want to extrapolate his own bits, have a good look and mount the material separately. They soon did. Michael got the chance to do this thanks to some Japanese patrons. Soon I got a call: 'Hi Matthew, do you want to go to Tokyo?'

That's all it took. Thereafter there was a natural time and place to ponder Vaslav Nijinsky: choreographer of the original **Rite**. It is simplistic yet also tempting to wallow in the myth of Nijinsky as the fatally ahead-of-his-time genius/insane protagonist/victim of *la danse*. Not a great leotard for M Clark to be wriggling into, I thought. But looking beyond the vastly different physicalities (we were never going to exchange our 1990s svelteness for Nijinsky's of-its-time workhorse frame), there were embraces. Richard Glasstone (on hand once more) had long adopted the same teaching methods as Nijinsky had experienced (at the hand of Maestro Enrico Cecchetti, the peerless ballet master, of whom most of Diaghilev's choreographers and chief dancers were protégés). We know that a profound friendship between Cecchetti and Stravinsky resulted in (among other things) Stravinsky's rudimentary knowledge of the basic positions. And, ever the thespian, Cecchetti humorously undercut memories of his youthful virtuosity (he had been the original Bluebird) with a diverse line in cameo roles, often in drag.

Matthew Hawkins and Joanne Barrett performing mmm..., King's Cross Depot, London, July 1992.
P: Fred Whisker.

A glance at Cecchetti's teaching method (and by implication that of Richard Glasstone) is salient. The class is rigorously divided into component nuts-and-bolts phases, contrasting with fully choreographed dollops: the latter having to be 'danced' and the former just 'done'. The induction into these distinct modes would well reference a dance-maker's need to alternate

eventfulness with non-definitive moments – the early output of Michael Clark being a fine example. Fuller Cecchetti immersion (and we think Nijinsky was a maniac for this) tasks the devotee with a vocabulary multiplied five-fold, as the maestro had devised complex chapters of material for every day of the week. There's no denying this intensity as one attempts to be at the top of one's game for all those dollops, and the quest is bound to foster visions; that of an ice-cold post-exertion pint of lager, perhaps, or even an inevitable gear change in favour of anti-vocabulary.

Looking at Nijinsky's notebooks, with their rebellious legacy of cursive notations and text/graphics, puts me in mind of Michael's copious notes and distinctive jottings. I'm also remembering the way our **Rite of Spring** costumes got emblazoned with key words. Hence, as we made our sequence of entrances, the audience were flashed: 'should'; 'would'; 'could'; 'can'; 'CUNT' – this latter Anglo-Saxon term etched on the cranium of Leigh Bowery as he lumbered on, dressed as Stonehenge (there was a huge kerfuffle about whether this was going too far).

Returning to Nijinsky's fitting impulse toward the physically inverse (and my positing of this as connected to grapples with Cecchetti's class of perfection), photographs and contemporary accounts of his **Rite** reveal his unhinging of classical principles (and skills) in favour of inward-turned limbs and flat-footed landings. Cracks showed: the chosen maiden gracelessly floundered and redemption quit the scene. Fast forward to a domestic episode: something has fallen behind the piano and if you perch on your knobbly knees, press your cheek to the skirting board, stifle your breath and strain to the end of your very digits (you've been putting off this uncomfortable chore for ages), you can wheedle the lost object up the wall in jerky irregular increments. Imagine an unbroken sequence of such ordeals performed at high speed and in an unpredictable sequence. Now you are getting a sense of what it was like to rehearse Michael's **Rite**. He was devising a whole new movement range. Fascinating compositions were coming through every new day. Nobody was remembering them. Nobody was deciding. Maybe it was all meant to stay elusive.

Choreographers often need their work to look spontaneous, but as their technician one is also deciphering what the new gestures consist of. As I recall, Michael's tenet with this work was to present only movements that he had not seen before. But in the context of daily rehearsals, even complex and surprising material can start to look like well-trodden ground.

There is tension between the Clark/Nijinsky pursuit of the as yet unseen and the performers' need to get on top of the text. Sometimes, in our hastily located drill-hall rehearsal venue, our team got lary of over-practising the conjured manoeuvres, as these might well get scrapped as soon as they were spotted. Amid the perverse struggle there came moments when we had to get militant about getting it together. (Opening night, anyone?) It was, in some respects, a bruising experience. We were connecting with awesome theatrical precedent and we wanted to equal the sense of urgent upheaval being summoned within the music and the original idea. It couldn't be otherwise.

The Rite of Spring is not a full-length work. Our performance comprised other scenes and went out under the title of **mmm...**. But the Stravinsky nugget did its work and the Michael Clark Company began to inhabit a new plateau. Yet here were resonances, by now, boiled down to a small cast, with each performer indispensable to the show's structure and impact. It seemed that these performances were true to Michael's initial company-forming impulses. I understood why I had been included and this closed a circle. Michael's next show was **O**. That was one I watched from the front.

> Matthew Hawkins is a freelance dance artist with a continuing international practice that spans choreography, performance, writing and teaching. He performed with Michael Clark Company for many of its early seasons, including its launch. He has also danced with the Royal Ballet, Second Stride, Rose English's Walks on Water Company, Compagnie Blanca Li (Paris), the Claire Russ Ensemble and Ann Dickie's From Here To Maturity project. As well as responding to commissions, notably from Rambert Dance Company, the South Bank Centre and the Royal Opera House, Hawkins has been presenting his own choreography internationally and independently since 1980; forming his own company soon after. He has been awarded fellowships from Arts Council England, the Jerwood Choreography Prize and the Chris de Marigny Dance Writer's Award.

Michael Clark in a publicity shot for Richard Alston's
Rainbow Ripples, 1980. P: Michael Stannard.

Leslie Bryant

I remember the first time I saw Michael Clark. I was in my final year at the Rambert School of Ballet; I went in to the office to discuss something with the secretary, who was sitting in front of an enormous poster of a figure in profile, lunging into the future. I had no idea who this person was, but I was stunned. It was a phenomenal image: ethereal, extraterrestrial, flawlessly beautiful. You must remember that this was way before Photoshop. I stood there transfixed. 'Who the hell is that?' I asked. The secretary replied 'Oh, a young dancer from the Royal Ballet called Michael Clark. He's an amazing talent.'

After I left Rambert, I frequently came across articles on Michael Clark in glossy magazines such as **Ritz**, **Vogue** and **Harper's**. He was this young, winsome punk. I was in a touring ballet company at the time and was intrigued. Around this time – the late 1970s, early 80s – I attended a performance at Jacksons Lane in which Michael was one of the dancers. It was a somewhat pedestrian piece; I left unimpressed.

Michael's name would constantly pop up in various social cliques. I was doing open classes at Pineapple Dance Centre with a lovely teacher called Marion Lane, who had been a principal ballerina with the Royal Ballet. She mentioned that Michael was looking for dancers and asked if I would be interested. I went to a rehearsal at Riverside Studios; we got on extremely well and he offered me a part in his forthcoming project. That was in 1981. There were three of us, Michael, Gaby Agis and myself. At that time there was such an abundance of dance, you could do a commercial one day, perhaps a film or a pop promo the next, even a season at Sadler's Wells – quite an eclectic offering for a freelance dancer.

One day in rehearsal, Michael performed a work-in-progress for me, a solo in a threadbare tutu, Vivienne Westwood bondage shirt and bare feet. He turned to me and said: 'This is for you, Les'. I've never to this day seen anything so breathtaking, so technically flawless, so beautiful. I was agog. I started to throw things at him and hurl abuse because I was just so moved. And that's when I could see what everyone was going on about. He was phenomenal.

The wonderful thing about working with Michael is that there is no envy or competition; he is eternally generous. Perhaps he was comfortable with his own genius. He was the first to recognise and to encourage other people's individuality and talent. I never got the sense that he felt threatened by any of his dancers.

Michael, Gaby and I went on tour with **Parts I-IV**. We toured all over the country and in Europe, staying in bed and breakfasts, with nylon bed sheets and runny egg for breakfast. We would go out incessantly, to clubs, pubs and happening events. It was around this time that Michael met the fashion designer and artist Leigh Bowery. Bowery subsequently designed Michael's new ballet **New Puritans**, a duet for himself and Ellen van Schuylenburch from New York. I saw it evolve at rehearsals. It was a spectacular piece, showcasing Ellen's immaculate technique and Leigh's iconic costumes with exposed arses and high 1970s platform shoes. It took modern dance into new realms. This was the beginning of Michael Clark and Company, with collaborators including the artist and film-maker Cerith Wyn Evans; David Holah and Stevie Stewart, designers for Bodymap; and the film-maker and lighting designer Charlie Atlas. I became an additional member of Michael Clark & Company, joining Ellen with Matthew Hawkins and Julie Hood. I stayed with the company until 1989 and was in most of his productions.

Michael wasn't afraid to use extreme theatrics in his productions, experimenting with props, costumes, lighting and stage design. He incorporated what was relevant to him, socially and personally, although he seldom disclosed the reasons for certain choices in costume, music or design. At times I found his choreography very difficult. Being a perfectionist, Michael was hard to emulate, with his long supple limbs – double-jointed shoulders – and those articulate feet that moved through space like white doves.

The critics often trivialised his work. They couldn't understand why this exceptional person with this exceptional gift appeared wayward and distracted. Michael was an incorrigible maverick and didn't play the game. Dance can be a very elitist and conservative world, and he wasn't socialising with the major players, who weren't easily accepting of difference. Looking back, I suppose the company was detached from that whole world. But there's no denying Michael's outstanding, breathtaking talent. This was confirmed by his audiences, which transcended the usual devotees of dance. He would have pop stars, footballers, artists, peers and people who lived on council estates. The performances were generally sold out. I can't think of any other artist who has attracted such a range of people from across the social spectrum.

Michael doesn't invite artists to collaborate with him on a superficial level. He lives, socialises, eats,

Leslie Bryant and Michael Clark performing **Parts I–IV**,
1983, Riverside Studios, London. P: Chris Harris.

shits, sleeps, with these people. Michael possesses an amazing humility, and he's just unaffected. It never ceases to amaze me.

I accompanied him to France where he was commissioned to do a piece for the Paris Opera, *a pas de trois* for the legendary Rudolf Nureyev, Patrick Dupond and Jean Guizerix. Michael was demonstrating steps in knee-high Doc Marten boots and a very holey Bodymap cardigan, probably still hung over from the night before but technically perfect. Nureyev was like an excited child, distracted by Michael's attire and his technically perfect transitions, giggling and commenting while learning the steps. It was a classic moment, sadly not filmed.

Seeing Michael's more recent work, I think his choreographic language becomes more coherent with a larger company, dancers who have an affinity with his work. Someone said there hasn't been a better dancer since Nijinsky. There's a cornucopia of extraordinary dancers today who can perform the most astounding things physically. They're gymnasts as well as dancers. But with Michael it's more than that. It's all the elements together – this incredible purity of form, equilibrium, symmetry, science, mathematics – like a sum that's correct.

Interview by Suzanne Cotter,
14 December 2008

Leslie Bryant, also known as Les Child, is a dancer and choreographer. He first worked with Michael Clark in 1981, touring with **Parts I–IV**. He joined Michael Clark & Company in 1984, working with him until 1989. He has since worked with Clark in **OH MY GODDESS** in 2003. Leslie has worked extensively as a choreographer with artists including Eartha Kitt, Marc Almond, the Rolling Stones, Pet Shop Boys and Erasure. He has also worked with film-makers John Maybury, Baillie Walsh and Sam Taylor Wood, among others.

Michael Clark in a publicity shot, c.1984.
P: Darryl Williams/ArenaPAL (above and opposite).

Simon Williams, Kate Coyne, Melissa Hetherington

ARABELLA STANGER How and when did you first start working with Michael?

SIMON WILLIAMS I started working with Michael in 2003. It was for a new piece he was doing called **OH MY GODDESS**. I had heard of Michael before, because like him I went to the Royal Ballet School, but I had never seen him dance live. He was looking for dancers for his new show, so I decided to go and audition. I thought it was a great opportunity to possibly start working with him. I've continued to work with him on and off since then.

KATE COYNE When I first worked with Michael, it was one of those long audition processes. At the time, I had been offered a contract with London Contemporary Dance Theatre, which I ended up taking. Then, 10 years later, in 1997, someone recommended to Michael that I might suit his work. Somehow or other I turned up at the studio and, again, it was an ongoing rehearsal and audition process. That was the start of a project called **current/SEE**. We had also done something before that when Jonathan Burrows curated a festival at the South Bank Centre in 1998. I've continued to work for Michael since then.

MELISSA HETHERINGTON I started working for Michael in August 2001. I was about a year out of college and had been working for another dance company. I auditioned for a couple of weeks – it was quite a long process. I did a short apprentice weekend with Michael and realised that was where I wanted to go, to steer away from the kind of work I was doing before. The first project I worked on was **Before and After: The Fall**. Since 2001 I have worked pretty much consistently with him.

SW For me, it wasn't really an audition in a traditional sense. I did a couple of classes, and then started doing some repertory with the company. That continued for about a week. Then I did some movement with Michael in the studio, which led me to come back so that I would work with him on **OH MY GODDESS**.

KC It seems to happen quite seamlessly. It comes to a point where you're the only person who's not aware that you're actually in the company. In the end I said to Michael, 'So, am I joining you?', and he looked at me, quite puzzled, as if to say: 'Yes, of course!' In those days we didn't work on the contract basis that we do now.

MH With other companies you are usually chosen from an audition and then you are employed. Michael prefers to work with you for a while beforehand and to feel comfortable with you in the studio. You may very well be an excellent dancer, but over the years we've seen that those relationships don't always work out.

SW It's a nice process as well, particularly for the dancer. It isn't that there is less pressure, but it's not dependent on this one audition where you've got to come up with the goods. It's more of a working process to see how you develop.

KC I get the impression Michael doesn't want to be restricted by the idea of having to make a snap decision.

Does Michael work with you individually when he's creating material, or does he choreograph on himself and bring it in to the studio?

KC He often has a clear idea about who he wants to do what. First of all he comes in armed with the material and we all learn it as a group. Then he might work with one person because he knows that person is going to be right for something in particular.

MH It also depends on our different facilities. We are trained in similar ways, but Kate and I have two different bodies with different strengths and weaknesses.

KC But we have to learn all the material.

MH We learn everything.

KC It's very rare that just one person learns something. And it is good to know the vocabulary, because chances are it will come up somewhere else.

MH And because we are a small company, injuries do happen and we have to be prepared to perform different parts.

All three of you are trained in classical ballet, but not all of Michael's dancers have had that background…

KC Classical ballet is a technique that most dancers would have knowledge of, but whether it's up to the standard of good ballet schools is another story. What Michael wants is a good knowledge of technique; it could be another dance technique, it's just that ballet is probably the most complete, so he knows that if you are trained in it you can be called on to do a lot.

MH It's fundamental, being taught how to stand on one leg properly or how to use your muscles. It does train you to be aware of what your body is doing.

SW It gives you a good base, so that if, for instance, you then move to Cunningham technique you've already got a placement that will help you

to understand movement. It depends on the dancer, as well. Even a lot of classically trained dancers who are exceptional in classical ballet find it difficult to move in a different way, when they come to do Cunningham or another style.

KC To be able to do ballet well you have to have a rigorous mind, to make the technique work. It's the repetition of basic exercises for many years. It's quite like Michael to keep wondering about simple and fundamental movements. It's that something about his personality that makes him a good ballet dancer; he sustains his interest in things that maybe to other people would be boring.

Do you think that a classical technique is important to be able to perform Michael's vocabulary of movement?

MH With Michael's work you have to be able to adapt very quickly to the type of material he is working on. Being able to move your body in different ways – fast, slow, backwards, forwards – ballet teaches you the basic posture, it makes you aware of what your body is doing. Then steering onto Cunningham technique, you use your body in a different way to ballet. For example, you have to be more aware of what your torso is doing, and use your limbs in a different way to how you would in a ballet class. But I think ballet technique is essential.

KC Sometimes I see ballet training as a series of set pieces – like in football they work on set pieces – where certain movements naturally lead on to others within a range of possibilities. We would do all of Michael's movements in a ballet class: we might do a set piece with the arms but then a different set piece with the legs. So you have that particular pattern ingrained within your body; then, because you have done it for a long time, you are able to reverse it or do other things with it because you know the pattern almost instinctively. It differs from other techniques where, say, your arms are very free. We rarely have free arms – they might be going into various positions, but they have a held quality.

SW It is necessary for the placement quality, and the line.

KC Michael's work is very aesthetic, and ballet is an aesthetic form of dancing. His work has a classicism.

MH Training from a young age in ballet gives you a solid understanding of alignment. This becomes very important when working with Michael, because he might produce something like the reverse of what you have already learnt to be correct. It might be what Michael wants, but you really have to see that – whether it's as simple as standing in parallel or turned out. You see classical dancers who are trained very well and who don't understand how to do something that's not natural to them. It's really about looking at what your body can do, against what you are taught to do.

KC Michael does use the poise that you're trained for in ballet, but he likes to have the sense of your being a normal person with poise. You're not pretending to be a fairy, in the ballet sense; it's an instinctive poise, an elegance that ballet certainly teaches you. It's one of the fundamentals. It's about an inner core of poise.

Could you say something about Michael's return to earlier material in his work?

KC It depends whether you're talking about chunks of material or specific motifs. There are certain motifs we use, like one leg parallel and one leg turned out, or moving from the pelvis, which come in every work because that's part of the way Michael moves. It's like a visual artist finding a pattern – for example Damien Hirst's 'spot' series, or Bridget Riley, who will keep using a pattern in different colours or slightly different tones. Michael uses material in the same way; it becomes part of his palette. But then there are little snippets that are just Michael moving.

In **OO**, *the prologue that accompanies* **Stravinsky Project**, *the dancers start walking on very slowly with the pelvis thrust forward. This section has been performed since 1992. What is your relationship to this movement, if you're performing it after such a long time?*

SW All Michael's movement is very precise. With this particular walk, the more I did it the more I understood how it was meant to be, what the shape was meant to be, what the feeling was. But it never got easier.

KC This walk is multifaceted. We have done it with different music, with different combinations of steps, so there is always something to think about.

MH And there's a particular kind of feeling and focus that comes with it. It's quite a menacing walk, and a lot of my focus as a performer goes on exactly that – how it's coming across to the audience, as well as how it's positioned.

KC It's difficult to master, particularly in the lights. It's not lit in the beginning, so you have to look into blackness and move very slowly. It's quite a challenge.

SW And there's the black-and-white flooring, so if you're looking down at it for a while it starts to blur.

KC You're exquisitely aware of how quickly it could go horribly wrong.

SW It's so slow, and the movement isn't particularly tricky but you have to get the exact placement, because you are pivoting after the walk. It's a scary experience, but when you get it, it's great!

MH You wouldn't think something so simple as walking across the stage would be so difficult.

KC When we first did it, it was placed in the middle of the first part of the piece. Michael was worried about the pressure of opening the whole work with a sequence like that. But in the end it was shifted to the front of the piece. It's a hard thing to start with when there's one dancer, so there's quite a lot of trust involved.

What was the experience of preparing for **Stravinsky Project**, *and performing it, when you have three works that are completely different in pace and style?*

MH Yes, they are completely different. **O** is languid and fluid, it's very classical and precise in movement. **mmm...** has a different style, it has a lot of vocabulary, some of it very unnatural to the body, and very quick. And **I Do** had its own style again. Preparing for the three different pieces was exhausting, not just physically but mentally. But it wasn't so much of a challenge to go from one piece to another.

KC As a dancer or an actor, it's part of your training and experience to be able to make this mental switch between the multiple pieces that you might be performing on one night. We also often have a change of costume and make-up between pieces, which helps. I don't think anyone in the company struggles with character reformation for the next piece, as it's an important part of the way we work. We approach each piece as a separate and individual work.

MH We had a lot to take in with the staging of **Stravinsky Project**. Preparing **I Do** was an ongoing process in terms of incorporating the set and the choir once it came to be staged. It was a lot of brainwork, going into each piece in its own right.

Michael Clark Company in rehearsal for **mmm...**, Barbican Theatre, London, October 2006. P: Hugo Glendinning.

KC And we'd performed those over the previous two years, so we'd had a good session with O, a good session the next year with mmm..., and it felt like they were much more sewn up. You know it as a piece, you don't know it as an evening.

Does Michael still make changes to these pieces?

KC Yes – maybe to keep us fresh, maybe, as Melissa said, he's constantly trying to better his own work. There's a constant tweaking.

SW We're always prepared to make changes to the pieces. It's part of the way Michael works – always improving the material.

MH It's a good challenge.

Before a performance, how much do you know about whether Michael will make an appearance?

MH More often than not we know if he is going to appear, and we know roughly what he is going to do. There have been times where he does like to surprise us.

Do you improvise at all on stage?

KC Only when Michael knows there's a bit of a gap. But it's not so much improvising as using some existing material to fill it. You'd never just improvise freely.

MH It would all be in context with what's just happened, or about to happen.

KC Quite often we do have to switch something to face a different way, so we have to work out where each facing will be during that shift. I do find it quite mathematical. And if you think about it mathematically, it's actually much simpler.

MH Michael does work very much like that. There is a logic to everything.

KC Sometimes you feel 10 paces behind him. He'll have a pattern in his mind and you'll have to work out how many steps it takes to get there; it's not always easy to catch up. He sets up a particular logic or a pattern and then we are expected to work it out individually. One thing I find myself doing, as part of the working-out process, is listening to the music we are working with. We all do that. Even if it's a familiar track, we have to work out what it is that Michael is listening to. I'm sure everyone hears music in a different way, so to decipher which bit he's working to is part of our job.

SW Sometimes he will start setting the piece with counts, but then when we listen to the music he'll actually be hearing a certain sound that the movement's on.

KC Michael doesn't usually work to counts; it's more what he's hearing. It's a rhythmic thing: if you learn the rhythm, you can decipher what he's listening to, and then we as a group would look at counts.

MH We work very well together at that sort of thing as a group. When he does leave the studio, we are always keen to make sure that we are all on the same page.

KC You might be able to work with the material if it's the basic material or the sound of someone's voice, but as it gets more complicated, or if someone else has to do it later on, then the actual counts become important. That's part of our job – to be very exact with the counts and to be able to do it at any time in the same way.

SW Working to counts is even more important in Michael's work, as we might end up using different music but the same steps.

KC Or we might even perform the same sequence in silence.

Can you think of a time when he has transferred a set of movement to a new piece of music?

MH All the time. Iggy Pop's 'Mass Production', which is at the very beginning of OO, we put that to Public Image Ltd. We're learning some new repertory at the moment, and he's already said 'We might not do it to this music'; it's good for the brain. When we were working with live music it's useful as well, that's another take on it.

Can you see a shift in Michael's movement vocabulary over time?

KC I don't think there's a shift in the vocabulary, but he does rely on us more to try things. Recently, he'll have worked out what he wants but he'll ask us if it's possible to do, because he's not in a position at the moment to try it out. So that's changed slightly. He knows exactly what he wants before coming into the studio, it's just whether it's physically possible – because he has always had more facility than anyone in that area. Also, it's not just about the ability to do something, it's the willingness to try. Michael is sometimes charmingly shy about his material. He won't introduce it greatly; he'll just deliver it in a sedate way. If he asks you to try something he really needs to trust you to know that you're not just going to throw it away, that you'll really try it. He has to have people around him who have that willingness. So I sense that having this type of facility is an important part of working with him.

What has been the reception to works you have performed internationally?

KC A lot of the questions are the same the world over, like: 'What is the significance of wearing a toilet?' That's what everyone wants to know. People in New York were very enthusiastic. I don't think one can

generalise with Europe: for example, Paris and a town called Maubeuge, which is close to Lille, have totally different audiences. Paris was very enthusiastic, and in Maubeuge you got the sense of people wondering what they were doing there. And, of course, you can see the same type of thing in Britain as well. Edinburgh or Glasgow will be receptive to Michael's work, whereas other towns will have a different perception.

MH There's always lot of people complaining about the volume…

KC In New York, they handed out earplugs because this guy stood up and yelled that it was too loud. They were so worried that they were going to be sued, they gave out earplugs for the following performances.

What makes Michael unique, compared to other choreographers you have worked with?

SW His music. I've never worked with anyone who has attempted to use rock or punk music. The work is extremely technical and very challenging. I enjoy the physicality of it and the fact that it is so particular, down to an angle of the head. These are things that you can miss by watching it sometimes. As we were saying, there is a logic to his choreography that makes sense in movement. It's very intelligent. Also, there's a challenge in that the work is always pushing the limits of the body with extreme positions that are very rarely comfortable. I love the shapes Michael creates, his choice of music, and him as a person.

KC I had seen a lot of his work before, and that's why I wanted to audition for him. It was the best thing I'd ever seen. He's always had fantastic dancers. Visually, as well, it's always striking and very rarely do we see that when we start a piece. When it all comes together with the staging, we don't get a chance to see it until it's on video, and then I think, 'My god, that's amazing.' But having that simple patterned floor, it's a whole other dimension. It's easy to get hooked. I particularly like his movement – physically, it suits my body; it's challenging but not painful. There is an energy, a rigour and a joy about his work that I love.

MH It's exciting to be involved in something that is so different, especially when you bring people along that have never seen dance before. They're always so overwhelmed by what they see, in a positive sense. Overall it is always an amazing production.

KC **Les Noces** amazed us when we saw it on video. The staging is genius. Michael never expands on all of that stuff in the studio. We don't know every detail; often it's a complete surprise. Once the set is up, Michael might change something, and that's when you've got to work really fast. In the past, people have felt like they're throwing stuff away – but it's about the total vision.

MH One other thing I like about working with Michael is that he comes into the studio with a very clear idea of what he wants. You have to do everything to his satisfaction, and you get so much out of working to his vision. He never works in a task-based way. We have our own tasks within what we do, but it's more about creating what he wants physically. That's what I enjoy; it's so precise.

KC It's the love of a craft. I love being a craftsman, rather than a creator. It's an undervalued thing in the dance world to be a craftsman or an artisan. While it's actually celebrated in other fields, to really refine your skills like a shoemaker, it's often not given its due in modern dance. I really enjoy that aspect – you have to work hard at Michael's material. There's always something in there.

MH We all admire what he does. For me, doing something creative myself, I wouldn't know where to start. Michael can take one small element, like a single step, and it will lead into a wonderful piece. I really admire how he can make that all happen.

Interview by Arabella Stanger,
11 February 2009

Kate Coyne trained at the Royal Ballet School and the London School of Contemporary Dance before joining London Contemporary Dance Theatre and then Rambert Dance Company. She has appeared with DV8, Jeremy James & Dancers, Martha Clarke and Mark Baldwin Dance Company. In 2008 Coyne was awarded the National Dance Awards' spotlight award, female artist (modern). Coyne first started working with Clark in 1998 and in the same year appeared in his **current/SEE** at London's Roundhouse. She has continued to dance in Clark's productions to the present, performing in works including **Before and After: The Fall** (2001), **OH MY GODDESS** (2003), **Stravinsky Project** (2005–7) and **come, been and gone** (2009). Coyne has also led workshops in Clark's repertory.

Melissa Hetherington trained as a junior associate of the Royal Ballet School and at London Studio Centre. On graduation she danced with Sheron Wray's JazzXchange Music and Dance Company. She has appeared in fashion shows by Alexander McQueen, photographic projects by David Bailey, Nick Knight and Miles Aldridge and in the film **Beyond the Sea** (2004), directed by Kevin Spacey. Hetherington has also worked as assistant rehearsal director for Shobana Jeyasingh Dance Company. Hetherington began working with Michael Clark in 2001 when she danced in his **Before and After: The Fall** (2001). She has appeared in most of Clark's subsequent productions, including **OH MY**

GODDESS (2003), **nevertheless, caviar** (2004) with Mikhail Baryshnikov, **Stravinsky Project** (2005–7) and **come, been and gone** (2009). Hetherington has also led workshops in Clark's repertory.

Simon Williams trained at the Royal Ballet School before dancing with the English National Ballet for two years. He has danced for Matthew Bourne's **Adventures in Motion Pictures** and in 2007 performed the Swan and the Prince in Bourne's **Swan Lake**. Williams has also toured with Sylvie Guillem's **Trois Histoires d'Amours** (2003) and appeared in the films **Beyond the Sea** (2004), directed by Kevin Spacey, and **Kinky Boots** (2005), directed by Julian Jarrold. Williams first worked with Michael Clark for his 2003 production **OH MY GODDESS**. He has subsequently danced in a number of Clark's productions including **nevertheless, caviar** (2004) with Mikhail Baryshnikov, **Stravinsky Project** (2005–7) and **come, been and gone** (2009).

Michael Clark in rehearsal for **mmm...**, Barbican Theatre, London, October 2006. P: Hugo Glendinning.

Ellen van Schuylenburch

I believe that a human being like Michael Clark, born with an exuberant and unique talent for dance, could not have emerged now. The arts are far more controlled and regulated than when it all started for him in 1982. The circumstances were right for a force of nature like Michael to erupt. David Gothard was the director of Riverside Studios and had made Michael choreographer-in-residence at the tender age of 19. The company's management started in 1984 with Erica Bolton and Jane Quinn, who were publicists at the time and new to the daily running of a dance company. Val Bourne, who had founded the Dance Umbrella festival, then in its pioneering first years, gave the company the chance to perform. We were allowed to be; Michael created non-stop with zest and was able to let his creative heart run free and rampant. Everyone and everything around us during those beginning years collaborated and co-operated. We were surrounded by tremendous and complex egos, but it was not about egos. What united us was the doing. We were led by a holy innocence, a holy fierceness and an unstoppable curiosity and love for life.

I met Michael in New York City in 1982, where I had been living and dancing since 1978. We met through Karole Armitage, in whose **Drastic-Classicism** he was performing. I went to visit him early one evening at the loft where he was staying; we had a drink and talked about bands, music and dancing and we became friends. He watched me dance my solo **Herod's Erection** and he liked it. I came to London each year to perform during Dance Umbrella. First I came over with Jim Self and the following year with Bill T. Jones and Arnie Zane. Michael asked in the winter of 1983 if I wanted to dance a new duet with him. In January 1984 he choreographed **New Puritans** to The Fall for me and for him (we were both massive Fall fans) and created a duet version out of **Parts I-IV**. We also had begun the first choreographic uttering of **Do you me? I Did**.

We toured this programme in Britain, the Netherlands and France. The tour was very basic. We had to carry some of our own lights and shared a hotel room with our sound and light technician. Every performance was unique and memorable; so many things would happen during the shows. The very first time Michael and I danced in our bare-bum costumes, our stomping around on platform shoes was so energetic that the masking flats came tumbling down on a row of screaming schoolgirls, who clearly loved it all. When we arrived in Paris we had become stars overnight. Well, Michael and his work had. His dancing was amazing. Together, we were an electric force, afraid of nothing and no one. What was so special about Michael's dancing was that it was so deeply connected with his divine essential self. He danced from his inside outward without reservation, and this was supported by a flawless technique – straight into where there is no right or wrong, only the moment (which can only be perfect). On 1 April 1984 we performed **New Puritans** at Riverside Studios as part of a mixed bill in a matinee performance. We danced our hearts out and the audience just loved it. We had both seen the future. Michael asked me if I wanted to stay and start his new dance company. I had to think long and hard before I made the decision to move to London. I loved my New York life. But if I was going to join a company, this was the one. I believed in him. So I got myself moved to London and started rehearsals with Julie Hood, Matthew Hawkins and Michael in June 1984.

As a duet, you work closely together. Michael was an outstanding dancer, but luckily I already had a lot of dancing behind me and I wasn't so bad myself. When I had met him in New York, he already had said no to the Royal Ballet, joined Ballet Rambert at 17 and left the company in order to become an independent dancer and choreographer. He came to New York and checked it out. At such a young age, he had no fear about anything. I don't think young people are taught like

Michael Clark and Ellen van Schuylenburch rehearsing
New Puritans, Riverside Studios, London, 1984.
P: Chris Harris.

Michael Clark and Ellen van Schuylenburch performing
Parts I–IV, Museum of Modern Art, Oxford, June 1984.
P: Chris Harris.

that any more, with that much passion, attention and artistic quest. Luckily, there were some good teachers at the Royal Ballet School at that time, like Richard Glasstone, who helped him to blossom. The school originally groomed him to step into Anthony Dowell's shoes, but to be a ballet dancer was something different to what he actually was. He started his own company at 21. I remember celebrating his 22nd birthday at Jeremy Fry's beautiful home in Bath and we still had to perform that evening.

During the eight weeks running up to the launch of the company at Riverside Studios, Michael created two 30-minute pieces, **Do you me? I Did** and **New Puritans**, which was expanded into a quartet with additional Fall tracks. The dance just poured out of him. And luckily, the three dancers he had chosen for the company, Julie, Matthew and me, could pick it up, process the choreography and dance it in a way that he liked. With us four, he could see what he needed to do and how to work things out. After that first foursome Michael would invite new dancers and new performers to join us for every new production. I liked that. It made it so very lively, as each time you had the entire experience of being part of a very new creation/universe. These experiences differed from a conventional dance company with rehearsal directors and tight scheduling. There were times we worked till midnight to finish the new work. We were more like a band and danced our life on stage. I remember Prince, Christine Binnie's dog, accidently crossing over on stage during a performance. It was just wonderful.

I like to quote Samuel Beckett to give some indication of what it was like to work with Michael in those days:

What I am saying does not mean that there will henceforth be no form in art. It only means that there will be new form, and that this form will be of such a type that it admits chaos and does not try to say that the chaos is really something else... To find a form that accommodates the mess, that is the task of the artist now.

I think that this quote sums up our creative universe during that period in Michael's life. We enjoyed the company of Leigh Bowery as costume designer and dancer/performer, and David Holah from the Bodymap team dancing and singing. Joe would be cooking miso soup on stage, which we ate after the show; the Neo Naturists in a secretive dance/act; Trojan's fried-egg trees; a lone bagpipe player; Laibach taking their curtain calls with Milan Fras holding a frozen rabbit by its ears; Lana Pellay, who demanded her own dressing room and enlarged her stage part by taking longer and longer before shooting me; Julie naked in little red boots swaying a chainsaw above us three girls dancing beautifully to Chopin **Preludes**; Cerith Wyn Evans's slideshows; many of our friends, sometimes leaping onto stage as they couldn't contain themselves and just had to join in; the wonderful and frightening Fall; Michael's dear sweet mum; exuberant and dynamic Les Child [aka Leslie Bryant]; Jeffrey Hinton's beautiful music compilations he had specially created to welcome the audience before showtime; Charlie Atlas, who kept us in the light from day one – everyone was part of that whole. So for me it was like another idea of coexistence. Michael juxtaposed our everyday life with our rigorous and disciplined life as dancers. I'm on stage dancing – maybe something very classical, very precise, very meticulous – and beside me is Leigh doing his Leigh thing. Michael didn't want an ivory tower of dance practice, but actively worked on no division between it and the audience.

The audience was in it from day one and we knew our audience. I remember when I came to London to dance in Dance Umbrella, I would hang out with Michael and go clubbing. We would hand out Xeroxed flyers of his upcoming show at Riverside Studios in clubs. These people and our friends were our audience in the beginning. It had nothing to do with write-ups in the papers; it was really a different thing. Michael had created, singlehandedly, a massive new audience for dance.

Michael was an exquisite classical and Scottish dancer with the ease and grace of Fred Astaire and the sex appeal of a young Rudolf Nureyev. He was so compelling and exciting to watch dancing, I would stand in the wings and think, This is the way God intends it. It is the same shock that nature gives one after a long car journey, like the wonder of being in the Alps or a red desert or a lake where all is still, silent and reflective. And this beautiful dancer has created all these original and sophisticated choreographies, like **I Am Curious, Orange** (which I love amongst many more), I wonder if people truly understand the enormous extent of his talent... all produced before the age of 26. But with Leigh on stage and the unconventional costuming, the loud rock music, the friends and everything else, the dance critics had a hard time understanding it. What they saw had to tally with what they knew, or is known, and with what one wanted/needed to see. These days, it is even more the case. Dance has become corporate and we have to be marketed and reflect the product in order

to sell and exist. Michael's concern is with his art and the freedom of creation. His work shifts into the world of the visual arts. Most of his friends are artists.

I have been working as Michael's assistant since January 2009. What is nice about the relationship is that we can be ourselves, like only old friends and family can. There is the question of what is the assistant's role, but here Michael blurs the edges once more. Our mistress is change. I love and admire Michael as dearly as in those very early days. He has deepened and matured in his work, with a finer detailed focus. He organises the dancers' bodies in space with his steady and sensitive eye, releasing poetic rendering. I dance with the company a little, teach company class, fill in for him when he is not around, help with the office, do his agenda, remind him, joke and laugh, let him be grumpy all in the same breath. I am on his side. Dancing with Michael in those early days had made me become a very fine and more beautiful dancer. He taught me where you must move in measure, in dance and in life.

Interview by Suzanne Cotter,
13 December 2009

Ellen van Schuylenburch was born in Amsterdam and trained at the Rotterdam Dance Academy. Upon graduation she danced with Werkcentrum Dans Theater and subsequently joined Nederlands Dans Theater 2. The Dutch Ministry of Culture awarded her a 12 month grant to study at the Merce Cunningham Studio in New York. During that time she had made New York her home, as an independent dancer working with experimental and postmodern dance companies. She danced with some of the city's leading choreographers including Bill T. Jones and Arnie Zane, David Gordon, Albert Reid, Jim Self, Ton Simons and Karole Armitage, also training in dance scholarship with the Merce Cunningham Studio. In 1983 Michael Clark invited Schuylenburch to dance in his duet programme **New Puritans**. In 1984 she became a founding member of Michael Clark & Company. She went on to dance the first five years of the company's productions, creating memorable roles in the duets **New Puritans** and **Do you me? I Did** (1984) as well as in the full-scale works **No Fire Escape in Hell** (1986), **Because We Must** (1987) and **I Am Curious, Orange** (1988). Schuylenburch has also danced with Laurie Booth and created and toured her own solo work. She is a Cunningham-based teacher and has taught many major companies and dance schools worldwide. Schuylenburch has been assistant to Michael Clark since January 2009 and Michael Clark Company's Special Projects and Artistic Documentation Officer since January 2011.

Leslie Bryant, Matthew Hawkins and Ellen van Schuylenburch with The Fall performing **I Am Curious, Orange**, Sadlers Well's Theatre, London, 1988. P: Richard Haughton.

COME,
BEEN
AND
GONE

Benjamin Warbis (page 325), Melissa Hetherington (above) and Oxana Panchenko and Clair Thomas (opposite) in publicity shots for **come, been and gone**, 2009. P: Jake Walters.

Oxana Panchenko (above) and Simon Williams
(opposite) in publicity shots for **come, been and gone**, 2009.
P: Jake Walters.

Oxana Panchenko and Clair Thomas (opposite), and Melissa Hetherington, Benjamin Warbis and Kate Coyne (above), performing Clark's **come, been and gone**, Edinburgh Playhouse, Edinburgh, 28 August 2009. P: Robbi Jack/Corbis (opposite), Jeff J. Mitchell/Getty Images (above).

NO

Arabella Stanger
Michael Clark: Chronology of Works

Michael Clark was born in 1962 in Aberdeen, Scotland, and began to dance at the age of four. He trained at the Royal Ballet School in London from 1975 to 1979, and then joined Ballet Rambert, working primarily with Richard Alston. Attending a 1981 summer school with Merce Cunningham and John Cage led him to work with Karole Armitage, through whom he met Charles Atlas. The first concert of his own choreography was in 1982 at London's Riverside Studios, where he became resident choreographer. By the time he launched Michael Clark & Company in 1984, he had already created 16 original pieces.

The company was an immediate success and toured internationally, collaborating with fashion designers Bodymap, artists Leigh Bowery and Trojan, as well as bands The Fall, Laibach and Wire. Clark's commissions for major dance companies include G.R.C.O.P. (Paris Opera), Scottish Ballet, London Festival Ballet, Rambert Dance Company, Deutsche Oper Berlin and Phoenix Dance Theatre. Clark's work for film and video includes **Hail the New Puritan** (1986) and **Because We Must** (1989) with Charles Atlas. He also choreographed and danced the role of Caliban in Peter Greenaway's **Prospero's Books** (1991).

In 1992 Clark created the original version of **mmm...** and in 1994, **O**. In 1998 he presented **current/SEE** in collaboration with Big Bottom, Hussein Chalayan, Simon Pearson and Susan Stenger, which became the subject of a BBC documentary directed by Sophie Fiennes, **The Late Michael Clark**. **Before and After: The Fall** (2001) was Clark's first major collaboration with the visual artist Sarah Lucas. In 2003, he created **Satie Stud** for William Trevitt of George Piper Dances, produced an evening titled **Would, Should, Can, Did**, for the Barbican Centre, London, and choreographed a solo for Mikhail Baryshnikov. In the same year, **OH MY GODDESS** opened Dance Umbrella's 25th anniversary season. In 2004 Rambert Dance Company revived **Swamp**, which received the Olivier Award for Best New Dance Production.

Michael Clark Company became an Artistic Associate of the Barbican Centre in 2005 and embarked on the **Stravinsky Project**, a collaboration to produce a trilogy of works to seminal dance scores by Igor Stravinsky. He radically reworked **O** and **mmm...** for this project, and in 2007 he premiered the final instalment, **I Do**. The **Stravinsky Project** had its USA premiere at the Lincoln Center, New York.

Clark's work **come, been and gone** premiered at the Venice Biennale in June 2009, and went on to tour internationally. In 2010 Michael Clark Company spent the summer in-residence at Tate Modern in preparation for a large-scale commission to be premiered in June 2011.

In July 2011, Michael Clark will receive an Honorary Degree of Doctor of Arts from the Robert Gordon University, Aberdeen, in recognition of his distinguished career in the field of choreography and dance.

Overground
1979

Choreography: Michael Clark
Music: performed in silence
Cast: students at The Royal Ballet School, London
Premiere date: 1979
Premiere venue: The Royal Ballet School, London

Trio C
1979

Choreography: Michael Clark
Music: Frédéric Chopin, piano prelude
Cast: students at The Royal Ballet School, London
Premiere date: 1979
Premiere venue: The Royal Ballet School, London

Belongings
1979

Choreography: Michael Clark
Music: manually-operated music box, playing melodies including Johannes Brahms, **Lullaby** (1868)
Cast: students at The Royal Ballet School, London
Premiere date: 1979
Premiere venue: The Royal Ballet School, London

As part of his training at The Royal Ballet's Upper School, Clark took classes in dance composition with Richard Glasstone, an early mentor who would nurture an emerging choreographic ability in his pupil. **Belongings**, one of the subsequent works that Clark produced for his fellow students, won the school's Ursula Moreton Choreographic Award, which was judged that year by Norman Morris, former Ballet Rambert and Royal Ballet artistic director. Clark arranged for live music for this work by stealing a hurdy-gurdy for the performance given at an end of term student showcase in 1979. The instrument was later returned and Clark left The Royal Ballet's Upper School in the same year, going on to attend Glen Tetley's International Dance Course for Professional Choreographers and Composers held at the University of Surrey, Guildford, before accepting his first professional contract with Ballet Rambert.

Surface Values
1980

Choreography: Michael Clark
Company: Ballet Rambert (Rambert Choreographic Workshop)
Music: structured improvisations sung by Miriam Claire Frenkel
Cast: Lucy Burge, Ann Dickie, Daniela Lorentz
Premiere date: 23 April
Premiere venue: Riverside Studios, London
Performances: 23, 25 April, Riverside Studios, London

Surface Values was Clark's first public presentation of work at Riverside Studios, which was at that point under the innovative directorship of Peter Gill, with David Gothard as programme director. Riverside was already developing its reputation as an important international venue for dance, having hosted, among others, parts of the original Dance Umbrella festival in 1978 and George Balanchine's New York City Ballet in 1979. The 1980 choreographic workshop programme for which **Surface Values** was created consisted of new works by Ballet Rambert dancers, including a work by Yair Vardi who would in 1984 invite Clark to create **Morag's Wedding** for his own company, English Dance Theatre.

Untitled Duet
1981

Choreography: Michael Clark
Company: Ballet Rambert (Rambert Choreographic Workshop)
Music: performed in silence
Design: Rachel Clare
Cast: Lucy Bethune, Michael Clark
Premiere date: 15 April
Premiere venue: Riverside Studios, London
Performances: 15–19 April, Riverside Studios, London

By the summer of 1981 Clark had left Ballet Rambert to explore possibilities as an independent artist, and in the same year attended the International Dance Course for Professional Choreographers and Composers at the University of Surrey, Guildford, directed that year by New York pioneers Merce Cunningham and John Cage. This encounter led Clark to New York where he danced for former Cunningham dancer and original punk ballerina Karole Armitage, through whom he met future collaborators Charles Atlas and Ellen van Schuylenburch.

Of a feather, FLOCK
1982

Choreography: Michael Clark
Company: Michael Clark & Dancers
Music (including): sound score by Eric Clermontet (c. 1955); Camille Saint-Saëns, **Le cygne** (1886)
Video projection (at Riverside): Cerith Wyn Evans
Design: Rebecca Neil
Cast: Gaby Agis, Karole Armitage, Claire Baylis, Michael Clark, Jon Peterson, Owen Smith
Premiere date: 29 August
Premiere venue: Riverside Studios, London

Upon his return to London Clark presented his first independent dance work, **Of a feather, FLOCK** at Riverside Studios. This production also marked his first collaboration with visual artist Cerith Wyn Evans who created the work's backdrop: a large video back-projection of 16mm roving cloud footage that had been captured during the artist's trip in a light aircraft. Billed as Michael Clark & Dancers, the group consisted of dancers and choreographers who hailed from diverse formal backgrounds including classical ballet and Cunningham technique (Karole Armitage), New Dance (Gaby Agis) and musical theatre (Jon Peterson). Clark developed his choreography by asking each of the dancers to create a phrase in response

to a set of his instructions. One of the sections became a solo for Armitage to Camille Saint-Saëns's Anna Pavlova-signature **The Dying Swan**. **Of a feather, FLOCK** premiered at the end of the summer of 1982 and, with seats sold at £2 a ticket, long queues for box office returns prompted Riverside to schedule an extra performance half an hour after the first showing. At the invitation of Val Bourne the work was revived in November of the same year as part of the Clark programme **Rush**, with additional cast members (including a spoken word role for the British poet cris cheek) as Clark's first production under the advocacy of Dance Umbrella.

A Wish Sandwich
1982

Choreography: Michael Clark
Company: Michael Clark & Dancers
Music: sound score by Eric Clermontet (c.1955)
Cast (duet): Michael Clark, Owen Smith
Premiere date: 16 October
Premiere venue: Cowdray Hall, Aberdeen Art Gallery (on a shared bill with Laurie Booth)

Rush
1982

Programme including
Of a feather, FLOCK
and **A Wish Sandwich**

Choreography: Michael Clark
Company: Michael Clark & Dancers
Cast (including): cris cheek, Michael Clark, Betsy Gregory, Matthew Hawkins, Owen Smith
Premiere date: 6 November
Premiere venue: Riverside Studios, London (Dance Umbrella '82)
Performances: 6–7 November, Riverside Studios, London (Dance Umbrella '82)

Rush was the name of the programme that Michael Clark & Dancers presented at Riverside for Dance Umbrella '82. The first half of the evening consisted of two recent works performed back to back: the Clark/Owen Smith duet **A Wish Sandwich** and the ensemble work **Of a feather, FLOCK**. The second half of the evening consisted of loosely-structured extractions of material from the pre-interval work **Of a feather, FLOCK**, but performed at high speed with vocal encouragement offered to the hurried dancers by poet cris cheek. Towards the end of the work Clark appeared on stage pushing a trolley containing a television set, which he steered around the space to rest centre stage. The monitor displayed a recording of Richard Alston's earlier solo for Clark, **Dutiful Ducks** (1982) and provided a choreographic score for the last section of **Rush** performed in imitation of the Alston/Clark recording by the whole cast before a blackout and television static closed the programme.

Parts I–IV
1983

First phase
Parts I–II

Choreography: Michael Clark
Music (Part I): Béla Bartók, Glenn Branca
Music (Part II): Béla Bartók, Glenn Branca, Tim Schellenbaum (commissioned score)
Video and film: Cerith Wyn Evans
Cast: Michael Clark, Cerith Wyn Evans
Video and film cast: Michael Clark, Stephen Goff, Annelies Stoffel
Premiere date (Parts I–II): 21 July
Premiere venue: Châteauvallon Festival, Provence
Performances (Parts I–II): 21 July, Châteauvallon Festival, Provence

Second phase
Parts I–IV

Choreography: Michael Clark
Company: Michael Clark & Dancers
Music (Part I): Glenn Branca, Tim Schellenbaum (commissioned score)
Music (Part II): Béla Bartók, Glenn Branca
Music (Part III): Pure
Music (Part IV): Hugh Griffiths and Robert Rental (commissioned score), John Marc Gowans and Mark Rowlatt, Tim Schellenbaum
Video and film: Cerith Wyn Evans
Cast: Gaby Agis, Michael Clark, Tracey Coutts, Hugh Craig, Stephen Goff, Ikky Maas, Gregory Nash, Catherine Price, Annelies Stoffel
Video and film cast: Michael Clark, Stephen Goff, Annelies Stoffel
Additional cast for later performances: Leslie Bryant (European/UK tour), Angus Cook (Dance Umbrella '83 performances), Catherine Tucker (Dance Umbrella '83 performances), Ellen van Schuylenburch (duet version as part of duet programme 1984)
Premiere date (Parts I–IV): 5 August
Premiere venue: Riverside Studios, London
Performances (Parts I–IV): 5–6 August, Riverside Studios, London; August, Edinburgh Festival Fringe, Edinburgh; 29 September, The Place, London, Greater London Arts Association tour; 30 September–1 October, Jacksons Lane Community Centre, Highgate, GLAA tour; 5 October, Middlesex Polytechnic, Barnet, GLAA tour; 7–8 October, Klapstuk International Festival, Leuven, Belgium; 29 October–5 November, Riverside Studios, London (Dance Umbrella '83); 1–2 November, Bonnar Hall, Dundee; 3–4 November, Traverse Theatre, Edinburgh; November, Glasgow; November, Aberdeen (Michael Clark solo show); 12 November, Midland Centre, Nottingham; 8 December, Albany Empire, Deptford, GLAA Tour

In March 1983 Clark was invited by David Gothard to become resident choreographer at Riverside, and was in the same month awarded his first Arts Council bursary to create a new work, **Parts I–IV**. This was a collaborative project conceived with Cerith Wyn Evans as a cycle in four parts for video and live performance. **Parts I–II** of the cycle were performed at the Châteauvallon Festival in France – the first formal showing of Clark's work outside of the UK – where Clark performed virtuoso solos while Wyn Evans manoeuvred a television monitor displaying his film around the stage to unexpected effect (see Cerith Wyn Evans interview in this publication). A series of video works were created for the cycle that would be incorporated into the later group productions, including a triptych of screens displaying a recorded trio for Clark, Stephen Goff and Annelies Stoffel, who danced within a gradually-shrinking enclosed studio space. Clark also created a series of live duets and trios for the four-part production that would unfold around Wyn Evans's video footage. In **Part IV** of the cycle and at the suggestion of Wyn Evans, Clark donned a white tutu skirt and Vivienne Westwood T-shirt to perform the work's closing solo; a dance that he would reprise for the 1986 Charles Atlas film, **Hail the New Puritan**.

1st Orange Segment
1983

Choreography: Michael Clark
Sound: Cerith Wyn Evans
Cast (solo): Stephanie Jordan
Premiere date: 16 October
Premiere venue: The Place, London

1st Orange Segment was commissioned by dancer Stephanie Jordan for her solo show of 1983. The work presented Jordan performing a series of slow movement phrases before stopping abruptly and sitting down on the floor of the stage. A singular orange was rolled from the wings toward Jordan who proceeded to peel the fruit and eat the first segment. A prompt blackout then closed the work. Clark also made three short interlude pieces for the programme, titled **Break 1**, **Break 2** and **Break 3**, which were set to a selection of television commercials.

The Artless Dodge
1983

I'm in an evil mood tonight, don't you want me baby?

Choreography: Michael Clark
Cast: Michael Clark, Cerith Wyn Evans; Neo Naturists: Christine Binnie, Jennifer Binnie, Wilma Johnson
Premiere date: 29 October
Premiere venue: Riverside Studios, London

I'm in an evil mood tonight, don't you want me baby? was the first production presented as part of Clark's two-evening event at Riverside Studios, titled **The Artless Dodge**. A one-off performance, this work was Clark's first collaboration with Neo Naturists Christine Binnie, Jennifer Binnie and Wilma Johnson and also marked a continued working relationship with Cerith Wyn Evans. The cast rehearsed the work in Regent's Park and the resulting production had a duration of one minute in performance at Riverside Studios.

Sexist Crabs

Choreography: Michael Clark
Cast: Michael Clark, Ellen van Schuylenburch, Cerith Wyn Evans; Neo Naturists: Christine Binnie, Jennifer Binnie, Wilma Johnson, Grayson Perry
Premiere date: 5 November
Premiere venue: Riverside Studios, London (Dance Umbrella '83)

Sexist Crabs was the second instalment of **The Artless Dodge** programme, an event presented by Clark at Riverside Studios over two evenings of dance. The work included selections from **Parts I–IV** (1983) and formed Clark's contribution to Dance Umbrella '83. The second half of the evening featured an improvised appearance by Ellen van Schuylenburch as well as scenarios performed by the Neo Naturists live art group. The latter were draped in transparent tape, had their bodies painted in blue pigment on stage by Grayson Perry and handed out seafood to the Riverside audience while all performers ate shrimp and Clark danced on.

12XU
1983

Choreography: Michael Clark
Company: Extemporary Dance Theatre
Music: Wire, '12XU', '106 Beats That', 'Lowdown', 'Straight Line', 'Strange', from **Pink Flag** (1977)
Design: Ashley Martin-Davies
Lighting design: Brod Mason
Cast: Lloyd Newson, Yaakov Slivkin
Premiere date: 21 September
Premiere venue: Townsgate Theatre, Basildon
Performances: October, Riverside Studios, London (as part of **Excerpts from Counter Revolution**, Dance Umbrella '83); 7 February 1984, University of Surrey Campus, Guildford; 16–17 November 1984, Manchester; 3 October – 18 November 1984, London (Dance Umbrella '84)

Mission Accomplished: Tutu Invisible
1983

Choreography: Michael Clark
Cast: Michael Clark
Premiere date: 13 November
Premiere venue: Riverside Studios, London

Clark presented **Mission Accomplished: Tutu Invisible** in a one-off performance as part of the Dance Umbrella '83 festival finale programme, which also included works by choreographers Richard Alston, Tom Jobe and Ashley Page.

Flippin' eck oh thweet myth-tery of life
1984

Choreography: Michael Clark
Company: Mantis Dance Company
Music: PiL, 'The Cowboy Song' from **Public Image** (1978); Teenage Jesus & the Jerks, 'Baby Doll', 'Burning Rubber', 'Red Alert', from **Teenage Jesus & the Jerks** (1979); Traditional Ancient Greek music; Lulu, 'Shout', from **Something to Shout About** (1965)
Costume design: Leigh Bowery
Lighting design: Tim Barwick
Cast: Micha Bergese, Lucy Fawcett, Stephen Goff, Charlotte Hacker, Caroline Pope, Michael Popper
Premiere date: January
Premiere venue: Riverside Studios, London
Performances (Mantis Dance Company UK tour) including: 22–25 February, The Place, London; October, Institute of Contemporary Arts, London; 23 October, Haçienda, Manchester

Flippin' eck oh thweet myth-tery of life was Clark's first work to feature Leigh Bowery-designed costumes. Around this time Clark began to work with artists he had met on the clubbing scene in London: with the incorporation of costume design from Bowery and make-up design from Trojan, a collaborative relationship was established that would extend across future productions. This was also the year in which Clark was awarded a Greater London Arts Association Bursary, a grant which enabled the creation of his duet programme with Ellen van Schuylenburch (1984).

Morag's Wedding
1984

Choreography: Michael Clark
Company: English Dance Theatre
Music: Jeffrey Hinton, Mark Rowlett, Tim Schellenbaum
Costume design: Leigh Bowery
Cast: Nick Burge, Neville Campbell, Julie Hood, Gary Nichols, Stella Vardi
Premiere date: 20 January
Premiere venue: Bishop Grosseteste College, Lincoln
Performances: (English Dance Theatre UK tour) 14 February, Darlington Arts Group, Darlington; 3 March, Jackson School, Guisborough; summer, Edinburgh Festival Fringe, Edinburgh; 9 November, Manchester; 3 October – 18 November, London (Dance Umbrella '84)

Wood Beez
music video
1984/5

Band: Scritti Politti
Producer: Aldabra Films
Cast: Michael Clark, Scritti Politti
Filming date: March 1984
Music (track title): 'Wood Beez'
Album title: Cupid & Psyche 85 (1985)

12 extemporary, thank yoU
1984

Choreography: Michael Clark
Costume design: Leigh Bowery, Trojan
Cast: Michael Clark, Ellen van Schuylenburch
Premiere date: February
Premiere venue: The Place, London
Info: gala performance at The Place

New Puritans / Parts I–IV
duet version
1984

Choreography: Michael Clark
Music (New Puritans): The Fall, 'New Puritans', 'Kicker Conspiracy' (both 1983)
Music (Parts I–IV): Béla Bartók, Glenn Branca, Hugh Griffiths and Robert Rental, John Marc Gowans and Mark Rowlatt, Tim Schellenbaum
Spoken text: Michelle Wales
Costume design (New Puritans): Leigh Bowery
Lighting design (New Puritans): Tim Ball
Cast: Michael Clark, Ellen van Schuylenburch
Premiere date: 8 March
Premiere venue: Bluecoat Arts Centre, Liverpool
Performances: 8–9 March, Bluecoat Arts Centre, Liverpool; 15–16 March, Theater Kikker, Utrecht, the Netherlands; 20–25 March, Theatre de la Bastille, Paris; 1 April, Riverside Studios, London; May, Rouen, France; 1–2 June, Bath; June, MOMA, Oxford; 9 July, Palais de Justice, Rouen, France (Festival d'été 1984)

New Puritans was conceived by Clark as a duet for himself and Ellen van Schuylenburch, whom Clark had invited from New York to dance with him in London at the start of 1984. The work marked Clark's first use of music by The Fall, a band whose collaboration he would secure in creating **I Am Curious, Orange** (1988). The duet programme, which also included a new version of **Parts I–IV**, toured through Europe in the spring of 1984 to great success and especially caught the attention of the French press who labelled Clark 'le météore'. The performance which opened the tour, given at Liverpool's Bluecoat Arts Centre in March 1984, also incorporated some nascent sections of **Do you me? I Did**, a work that would be developed as a quartet for the launch of Michael Clark & Company that August.

Do you me? I Did / New Puritans
quartet version
1984

Choreography: Michael Clark
Company: Michael Clark & Company
Lighting design: Charles Atlas
Production management: Steven Scott

Do you me? I Did
Music: 'Do You Me?', 'I Did',
Bruce Gilbert (commissioned work)
Costume design: Bodymap

New Puritans
Music: The Fall, 'Gramme Friday', 'Kicker Conspiracy', 'Lie Dream of a Casino Soul', 'Ludd Gang', 'New Puritans', 'Spectre vs Rector'
Costume design: Leigh Bowery
Cast: Michael Clark, Matthew Hawkins, Julie Hood, Ellen van Schuylenburch
Premiere date: 2 August
Premiere venue: Riverside Studios, London
Performances: 2–8 August, Riverside Studios, London; 27 August – 1 September, Assembly Rooms, Edinburgh (Edinburgh International Festival; 12 September, Salisbury Arts Centre, Salisbury; September/October, Kaaitheater Brussels, Belgium (Kaaitheater Festival); October, open air performance, La Grande Place, Brussels; 12–13 October, Canterbury Festival, Canterbury; 22–23 October, Duke's Playhouse, Lancaster; 26–27 October, Royal Northern College of Music, Manchester; 16–17 November, Riverside Studios, London (Dance Umbrella '84); 18–19 November, Gateway Theatre, Chester

In the summer of 1984 Clark reworked the existing duet version of **New Puritans** and created a new work, **Do you me? I Did**, for a quartet of dancers: Clark, Ellen van Schuylenburch and new cast members Matthew Hawkins and Julie Hood. **Do you me? I Did** marked Clark's first collaboration with fashion label Bodymap and was set to a commissioned score by Wire's Bruce Gilbert; the work would also provide choreographic material for the evolving future productions of **Swamp**, in 1986, 1992 (as **Bog 3.0**), 2004 and 2009–10. The quartet's first performance at Riverside Studios on 2 August signalled the official launch of Michael Clark & Company and the double bill subsequently played at venues across Europe and the UK. The fledgling company's performances at the Edinburgh Festival were attended by Rudolf Nureyev, who subsequently commissioned Clark to create **Le French Revolting** for the Ballet de l'Opéra National de Paris in the winter of that year.

Le French Revolting
1984

Choreography: Michael Clark
Company: G.R.C.O.P. (Groupe de Recherche Chorégraphique de l'Opéra de Paris)
Music: The Fall, 'Copped it', 'Disney's Dream Debased', 'Lay of the Land' and 'Pat-Trip Dispenser' from **The Wonderful and Frightening World of The Fall** (1984)
Costume design: Leigh Bowery
Lighting design: Charles Atlas
Cast: Jean-Claude Ciappara, Martine Clary, Fabienne Compet, Marie-Eve Edelsen, Renaud Fauviau, Katia Grey, André Lafonta, Florence Lambert (*Les sans tête*); Jean-Christophe Paré, Anne Pruvost, Jean-Hugues Tanto, Loic Touzé (*Les sans culottes*)
Premiere date: 10 December
Premiere venue: Grande Salle, Centre Pompidou, Paris
Performances: 10, 12–16 December, Grande Salle, Centre Pompidou, Paris

Clark's first overseas commission came at the personal request of Rudolf Nureyev, who was at the time director of the Ballet de l'Opéra National de Paris. **Le French Revolting** was created for the company's experimental wing the G.R.C.O.P., and took a surrealist look at the French Revolution, as pronounced in the titles for the first two acts of the ballet, **1 PROL(E)ogue** and **2 demoCRASSy**, listed by Clark in the Paris programme. The work also continued Clark's placement of classical dance against a post-punk soundtrack, provided by tracks from The Fall's most recent album, **The Wonderful and Frightening World of The Fall** (released October 1984). The opening track of the album, 'Lay of the Land', had been performed previously by the band on the BBC's television music show **The Old Grey Whistle Test**, for which Michael Clark & Company performed choreography from **Le French Revolting**, along with a pantomime cow and in their costumes for **New Puritans**.

HAIL the classical
1985

Choreography: Michael Clark
Company: The Scottish Ballet
Music: Maurice Ravel, **Introduction and Allegro** (1907); The Fall, 'The Classical', from **Hex Enduction Hour** (1983)
Lighting and costume design: Charles Atlas
Cast (including): Kenn Burke, Michael Clark, Vincent Hantam, Elaine McDonald, Linda Packer
Premiere date: 29 March
Premiere venue: Theatre Royal, Glasgow
Performances: 29 March, Theatre Royal, Glasgow; 10–13 April, His Majesty's Theatre, Aberdeen

HAIL the classical was commissioned by Peter Darrell for Scottish Ballet's 1985 **Gut Reactions** programme. The work included a quick-change series of sets borrowed from Scottish Ballet's existing repertoire, a pastiche reworking of Auguste Bournonville's **Napoli** and an appearance by Clark wearing a black rubber phallus – a costume inspired by one of Leigh Bowery's designs.

Angel Food
1985

Choreography: Michael Clark
Company: G.R.C.O.P. (Groupe de Recherche Chorégraphique de l'Opéra de Paris)
Music: Bruce Gilbert/Wire
Design: Bruce Gilbert
Costume design: Angela Conway
Cast: Patrick Dupond, Jean Guizerix, Charles Jude, Rudolf Nureyev (Jude and Nureyev share the role)
Premiere date: 13 April
Premiere venue: Opéra Comique, Paris

Angel Food was Clark's second work to be commissioned by Rudolf Nureyev. On this occasion Clark was to make a *pas de trois* for Nureyev himself and two of the Paris Opera's male *étoiles* (leading dancers), Patrick Dupond and Jean Guizerix. Nureyev was ultimately replaced by Charles Jude. Angela Conway designed costumes, including a hobby horse worn by Dupond and Bruce Gilbert produced the work's score and backdrop design, both based on the traditional English round 'Sumer Is Icumen In'.

not H.AIR
1985

Choreography: Michael Clark
Company: Michael Clark & Company
Music: The Fall
Sound mix: Jeffrey Hinton (Bach/Jeffrey Hinton)
Inflatable props: designed by Trojan, made by Maurice Agis and Alan Kelly
Costume design: Leigh Bowery
Cast: Michael Clark, Matthew Hawkins, Julie Hood, Ellen van Schuylenburch
Premiere date: 9 May
Premiere venue: Théatre 140, Brussels (Kaaitheater Festival)
Performances: 9–11 May, Théatre 140, Brussels (Kaaitheater Festival); 14–16 May, Akademie der Künste, Berlin (Berlin Festival); 18–19 May, Szene, Vienna (Vienna International Music Festival); 22 May, Schouwburg Arnhem, Arnhem, the Netherlands; 24 May, Schouwburg Maastricht, Maastricht, The Netherlands; 26 May, Schauspiel, Cologne; 30–31 May, Northcott Theatre, Exeter (Exeter Festival); 7–8 June, Theatre Royal, Bath (Bath Festival); 13–15 June, Mercure Theatre, Copenhagen (Copenhagen International Theatre Festival); 17–19 June, Operettenhaus, Hamburg (Hamburg Festival); 23–24 June, Zuercher Theater Spektakel, Zurich (Zurich Festival)

not H.AIR was the only Michael Clark production choreographed entirely to music by The Fall and with costumes designed exclusively by Leigh Bowery and a set designed by Trojan.

Walker Art Center

Michael Clark and Company

our caca phoney H.our caca phoney H.
1985

Choreography: Michael Clark
Company: Michael Clark & Company
Music: Tim Dimoline (guitar soloist); Julia Fodor (lead vocalist); Jeffrey Hinton (sound mix, Bach/Jeffrey Hinton); The Fall; T. Rex, 'Cosmic Dancer', from **Electric Warrior** (1971); songs from musicals: **Hair** (1967) James Rado/Gerome Ragni/Galt MacDermot; **Godspell** (1970) Stephen Schwartz/John-Michael Tebelak
Inflatable props: designed by Trojan, made by Maurice Agis and Alan Kelly
Costume design: Bodymap, Leigh Bowery
Lighting design: Charles Atlas
Cast: Leslie Bryant, Michael Clark, Matthew Hawkins, Julie Hood, Ellen van Schuylenburch; guests for Riverside dates Aug/Sept: Lana Pellay; Neo Naturists: Christine Binnie, Jennifer Binnie, Wilma Johnson
Premiere date: 11 August
Premiere venue: Royal Lyceum Theatre, Edinburgh (Edinburgh International Festival)
Performances: 11–14 August, Royal Lyceum Theatre, Edinburgh (Edinburgh International Festival); 27 August – 8 September, Riverside Studios, London; 17–18 September, His Majesty's Theatre, Aberdeen; 20–21 September, macrobert, Stirling; 3–5 October, Ordway Music Theater (presented by the Walker Arts Center), St Paul, Minneapolis (USA debut); 4–6 November, Warwick Arts Centre, Coventry; 8–9 November, Danceabout Northwest, Manchester; 11–13 November, Oxford Playhouse, Oxford; 15–16 November, Theatr Hafren, Powys, Wales; 20–21 November, Parma, Italy; 27 November – 1 December, Alabamahalle, Munich

Bodymap show
London Fashion Week
1985

Design: Bodymap (David Holah and Stevie Stewart)
Choreography: Michael Clark
Cast (including): Michael Clark, Boy George
Date: 11 October
Venue: London

Art for Money
1986

Choreography: Michael Clark
Company: Michael Clark & Company
Music: Lizzie Tear
Cast: Leigh Bowery, Leslie Bryant, Michael Clark, Matthew Hawkins, Julie Hood, David Holah, Eric Holah, Ellen van Schuylenburch; Neo Naturists: Christine Binnie, Jennifer Binnie, Wilma Johnson
Premiere date: 9 February
Premiere venue: The Royal Opera House, London

Art for Money was created by Clark for the gala 'Save The Wells' in aid of Sadler's Wells Theatre, held at the Royal Opera House, Covent Garden. Clark's work was presented alongside that of Richard Alston (Ballet Rambert) and Robert Cohan (London Contemporary Dance Theatre) as well as that of Royal Ballet stalwarts Kenneth MacMillan and Frederick Ashton and creator of the late 19th-century classical canon, Marius Petipa. Clark's production for the gala featured an appearance by Leigh Bowery as well as a section performed by Christine and Jennifer Binnie and Wilma Johnson, aka the Neo Naturists, costumed as cheerleaders and chanting 'money money money' as the work came to a close. The cast took their gala bow dressed in costumes from the costume department of the Royal Opera House.

Drop Your Pearls and Hog It, Girl
1986

Choreography: Michael Clark
Company: LFB2 (London Festival Ballet 2)
Music: The Fall, 'Wings', from **Perverted By Language** (1983); Camille Saint-Saëns, **Le cygne** (1886); Kecak (Ramayana Monkey Chant) Balinese traditional; Jeffrey Hinton, swansong collage
Costume design: Bodymap
Lighting design: Charles Atlas
Floor design: Charles Atlas and Bodymap
Production management: Steven Scott
Cast: Kevin Darvas, Karen Gee (Pearl [a girl approaching swanhood]), Jane Haworth, Susan Hogard, Josephine Jewkes, Janette Mulligan, Gretchen Newburger, Craig Randolf (PIG), Trinidad Sevillano
Premiere date: 13 March
Premiere venue: Theatre Royal, Bath

Drop Your Pearls and Hog It, Girl was commissioned by Peter Schaufuss during his directorship of London Festival Ballet (now the English National Ballet). The work plotted a warped re-telling of the Petipa/Ivanov ballet **Swan Lake** and featured the characters Pearl (a girl approaching swanhood) and PIG, Clark's stand-in for the Prince Siegfried role.

Hail the New Puritan
a film by Charles Atlas
1986

Director/editor: Charles Atlas
Choreography: Michael Clark
Producers: Best Endeavors; Channel 4, London (Francesca Moffatt, Jolyon Wimhurst); New Television, Boston (executive producers: Lois Bianchi, Susan Dowling)
Music: Glenn Branca, The Fall, Bruce Gilbert, Jeffrey Hinton, Elvis Presley
Costume design: Bodymap, Leigh Bowery
Cast (including): Gaby Agis, Rachel Auburn, Christine Binnie, Jennifer Binnie, Wilma Binnie, Leigh Bowery, Leslie Bryant, Michael Clark, Matthew Hawkins, Julie Hood, Grayson Perry, Ellen van Schuylenburch, Brix Smith, Mark E. Smith, Sue Tilley, Trojan, Dick Witts, Cerith Wyn Evans
Broadcast premiere date: 21 May, Channel 4, London
Broadcast dates: 21 May, Channel 4, London; 1987, **New Television Workshop**, Episode 301, for WGBH, Boston; 1987, **Alive from Off-Center**, Episode 308, for KTCA TV, St Paul, Minneapolis. Segments of film shown as 'New Puritan Dances'

Charles Atlas's fantasy TV documentary bore Jolyon Wimhurst's alternative title **Dream Dancer** during production and follows 'a day in the life' of Clark, his dance company and extended circle of friends. (Charles Atlas had wanted to call it **Not Michael Clark**.) The film features rehearsal footage, a boardroom-style discussion with Clark, Mark E. Smith and Brix Smith, domestic scenes at Leigh Bowery and Trojan's flat and extended sections of dance performance, including a solo specially choreographed for the film, with Clark performing to Elvis Presley's 'Are You Lonesome Tonight?'

Swamp
1986

Choreography: Michael Clark
Company: Ballet Rambert
Music: Bruce Gilbert, 'Do You Me?', 'I Did' (1984); Wire, 'Feeling Called Love' (played live), from **Pink Flag** (1977)
Costume design: Bodymap, Leigh Bowery
Lighting design: Charles Atlas
Cast: Mark Baldwin & Mary Evelyn, Lucy Bethune & Amanda Britton, Ben Craft & Catherine Becque, Gary Lambert & Catherine Price
Premiere date: 17 June
Premiere venue: Sadler's Wells, London

Swamp, commissioned by Richard Alston for Rambert's Diamond Jubilee season, was loosely based on Clark's earlier work **Do you me? I Did** (1984) and was partly inspired by Mike Nichols's film version (1966) of Edward Albee's play **Who's Afraid of Virginia Woolf?** The set included back-projected stills from the film which off-set the pure-movement sequences and neutral performance style Clark drew from the Rambert dancers. The stills included close-up shots of Elizabeth Taylor, anticipating the projection of Andy Warhol's **Liz** that was used for Clark's later work **mmm...** (1992).

No Fire Escape in Hell
1986

Choreography: Michael Clark
Company: Michael Clark & Company
Music (Act 1 Then): The Fall, 'US 80s–90s', from **Bend Sinister** (1986); Drostan Madden (commissioned work); Simon Rogers (commissioned work)
Music (Act 2 Then): Bruce Gilbert (commissioned work); Jeffrey Hinton, 'Deathmix' (collage including songs by John Lennon, Mama Cass); The Fall, 'Living Too Late', from **Bend Sinister** (1986)
Music (Act 3 Now Gods): Laibach (live on stage)

Costume design: Bodymap, Leigh Bowery, Charles Atlas (fish, lawnsuit, veil), Michael Clark (big dress), Eric Holah
Lighting design: Charles Atlas
Production management: Steven Scott
Cast: Leslie Bryant, Joachim Chandler, Michael Clark, Dawn Hartley, David Holah, Amanda King, Joseph Lennon, Ellen van Schuylenburch, Carol Straker
Extras (students from Laine Theatre Arts): Jennifer Chin, Michelle Codrington, Beth Robson, Carl Roachford, Ian Stanley, Angus Michael Todd, Rachel Yorke
Premiere date (gala in aid of Pete Townshend's charity Double O): 17 September
Premiere venue: Sadler's Wells, London
Performances: 17–27 September, Sadler's Wells, London; 21–26 October, Lepercq Space, Brooklyn Academy of Music, Brooklyn (Next Wave Festival); 16 January – 6 February 1987, Everest Theatre, Sydney (Sydney Festival); 10–21 February 1987, Playhouse, Victorian Arts Centre, Melbourne; 5 March 1987, Tel Aviv; 8 March 1987, Yagur, Israel; 11–12 March, Jerusalem; 22–27 March 1987, São Paulo and Belo Horizonte, Brazil (Carlton Dance Festival)
Television broadcast: 28 March 1987, BBC Two Scotland (directed by Mike Barnes, produced by Keith Alexander)

Clark picked out the title for **No Fire Escape in Hell** from a religious pamphlet that had been handed to him recently on the street. During the rehearsal period for the work, Clark's long-term collaborator and friend Trojan died of an accidental drug overdose and a dedication to the artist was included in the programme: 'In memory of Trojan: way out was his way in.' Music for the work was commissioned from the Slovenian industrial rock band Laibach, who performed their soundtrack live on stage, provoking Sadler's Wells to offer earplugs to the audience prior to the show. In October 1986 Clark was approached to present the work at Brooklyn Academy of Music's Next Wave Festival in New York. On the strength of these performances Bodymap and Leigh Bowery won the 1987 'Bessie' Award for their costume designs and Clark was nominated in the same year for a Laurence Olivier Award in recognition of his personal contribution to dance.

The Shivering Man
1987

Director: Angela Conway
Choreography: Michael Clark
Music: Bruce Gilbert, 'The Shivering Man', from This Way To The Shivering Man (1987)
Cast: Michael Clark, Julie Hood, Ian Longmuir
Television broadcast: 5 May, **Alter Image** (producers Jane Thorburn and Mark Lucas), for Channel 4, London

Pure Pre-Scenes / Now Gods
1987

Choreography: Michael Clark
Company: Michael Clark & Company
Music (Pure Pre-Scenes): Frédéric Chopin
Piano Preludes nos: 1, 2, 4, 7, 9, 12, 13, 15, 16, 18, 19 (played live by Leigh Bowery and David Earl), Barry Manilow, T. Rex

Music (Now Gods): Laibach (live on stage)
Costume design: Bodymap, Leigh Bowery
Lighting design: Charles Atlas
Slides (Pure Pre-Scenes): Cerith Wyn Evans
Cast: Leigh Bowery, Leslie Bryant, Joachim Chandler, Michael Clark, Dawn Hartley, David Holah, Amanda King, Ellen van Schuylenburch
Premiere date: 5 May
Premiere venue: Theatre Royal, Brighton (Brighton Festival)
Performances: 5 May, Theatre Royal, Brighton (Brighton Festival); 12 May, Teatro de Valladolid, Valladolid, Spain; May, Madrid; May, Barcelona; 27–30 May, Haymarket Theatre, Leicester; June, Belgrade, former Yugoslavia; June, Ljubljijana, former Yugoslavia; 23–26 June, Teatro Olimpico, Rome; 30 June – 4 July, Leeds Grand Theatre, Leeds; 4–6 September, UCLA James Doolittle Theater, Los Angeles (Los Angeles Festival)

For his next production Clark presented **Now Gods**, Act 3 of **No Fire Escape in Hell**, in a double bill alongside the brand new material of **Pure Pre-Scenes**. Both works were accompanied by live music: Laibach continued their accompaniment of **Now Gods** and the young concert pianist David Earl was joined by Leigh Bowery to perform selections of Chopin's piano preludes for **Pure Pre-Scenes**. This was Clark's first full-length work in which Bowery would feature as a core performer, delivering dialogue and song within an opening vignette for himself and Leslie Bryant. **Pure Pre-Scenes** also included a section danced to a telephone sex conversation and concluded against a background of Barry Manilow, whose image was slide-projected whilst a medley of his songs played as the closing soundtrack to the work.

Because We Must
1987

Choreography: Michael Clark
Company: Michael Clark & Company
Music (Part 1 Pure Pre-Scenes): Frédéric Chopin
Piano Preludes nos: 1, 2, 4, 7, 9, 12, 13, 15, 16, 18, 19 (performed by David Earl); Drostan Madden, taped collage (commissioned work); traditional pub song medley
Music (Part 2 Get Real): 'Ear Trumpet' (Neil Mouat, drums; Stephen Sheppard, guitar; Geoffrey Vivian, bass guitar); Bruce Gilbert/Graham Lewis, 'Get Out of That Rain', 'Hole in the Sky' (commissioned tracks, 1987); Graham Lewis, 'Pump', from **Hail!** (1987); the national anthem of Great Britain; 'Only One I', traditional Scottish music (performed by Pipe Major Bob Murphy, bagpipes)
Costume design: Bodymap, Leigh Bowery
Lighting design: Charles Atlas
Production management (premiere): Steven Scott

Cast: Leigh Bowery, Leslie Bryant, Joachim Chandler, Michael Clark, Ben Craft, Dawn Hartley, Matthew Hawkins, David Holah, Julie Hood, Amanda King, Ellen van Schuylenburch
Premiere date: 16 December
Premiere venue: Sadler's Wells, London
Performances: 16 December – 2 January 1988, Sadler's Wells, London; 1990 world tour (see entry below)

Part 1 of **Because We Must** reprised **Pure Pre-Scenes**, and Part 2 presented the world premiere of **Get Real**. Scenography for Clark's Christmas-time ballet **Because We Must** included a backdrop to Bournonville's **La Sylphide** and the Picasso-designed horse from the Massine/Cocteau ballet **Parade**, which were on loan for the occasion from London Festival Ballet. For the bagpipe section of **Get Real**, Clark reprised typical phrases from Scottish Highland Dancing and for the work's finale the cast appeared naked, strumming electric guitars with the band Ear Trumpet while Clark danced out his final solo against a bright white lighting design.

I Am Curious, Orange
1988

Choreography: Michael Clark
Company: Michael Clark & Company
Music: The Fall (live on stage), **I Am Kurious Oranj** (1988, commissioned album); the national anthem of the Netherlands; the national anthem of Great Britain
Track list for the Netherlands (Part I I Am Curious Orange): 'Jerusalem', words: William Blake/M.E. Smith, music: M.E. Smith; 'Kurious Oranj', words: M.E. Smith, music: M.E. Smith/B. Smith/S. Hanley/ S. Wolstencroft; 'Yes O Yes', words: M.E. Smith, music: M.E. Smith/B. Smith; 'Wrong Place, Right Time', words & music: M.E. Smith; 'Hip Priest', M.E. Smith/The Fall
Track list for the Netherlands (Part II Take out the trash? I wouldn't know where to begin): 'Frenz', words & music: M.E. Smith; 'Bad News Girl', words: M.E. Smith, music: B. Smith; 'In These Times', words & music: M.E. Smith; 'An Older Lover', M.E. Smith/The Fall; 'Cab it up', words & music: M.E. Smith; 'Bremen Nacht', words: M.E. Smith, music: S. Rogers/M.E. Smith
Additional tracks performed at Edinburgh and London: 'Overture' (theme from **I Am Curious, Orange**), music: B. Smith; 'Hip Priest/Big New Prinz', words: M.E. Smith, music: S. Hanley/M. Riley/C. Scanlon/P. Hanley/ M.E. Smith/M. Schofield; 'MMLXXXVIII AD', words: M.E. Smith, music: M. Schofield; 'The Plague', words: M.E. Smith, music: C. Scanlon
Set design: Michael Clark
Costume design: Bodymap, Leigh Bowery
Additional costumes: Eric Holah, Clive Ross
Lighting design: Charles Atlas
Production management: Steven Scott
Cast: Leigh Bowery, Leslie Bryant, Michael Clark, Matthew Hawkins, David Holah, Julie Hood, Amanda King, Ellen van Schuylenburch; The Fall: Steve Hanley, Craig Scanlon, Marcia Schofield, Brix Smith, Mark E. Smith, Simon Wolstencroft
Extras (the Netherlands): Jasmijn Antonisse, Suzy Blok, Marco Dekker, Gonda Dharmaperwira, Kora Greene, Désirée de Groote, Miek d'Herripon, Hilda Kokshoorn, Marjolein van Nieuwkent, Janis Pearson, Marieke Perlstein, Yvonne Popeijns, Maxine Railton, Lies Schuring, Chris Steele, Albert Jan van der Stel, Jildou Straat, Mirjam Vos, Paul Waarts, Karim J. Yousfi
Extras (Edinburgh): Kirsty Alexander, Winnie Armitage, Leigh Falconer, David Orgles, Maxine Railton, Alison Scott, Alison Steele
Extras (London): Kirsty Alexander, Jennifer Chin, Duncan Glasse, Rachel Lynch-John, Gisela Moreau, David Orgles, Katie Puckrik, Alison Steele
Premiere date: 11 June
Premiere venue: Stadsschouwburg, Amsterdam, (Holland Festival)
Performances: 11–13 June, Stadsschouwburg, Amsterdam, the Netherlands (Holland Festival; 15–20 August, King's Theatre, Edinburgh (Edinburgh International Festival); 20 September – 8 October, Sadler's Wells Theatre, London

I Am Curious, Orange was commissioned by Sadler's Wells and the Holland Festival to commemorate the tercentenary of William of Orange's accession to the English throne. The Fall wrote the album **I Am Kurious Oranj** as the ballet's soundtrack and the band performed their score behind and around the dancers; during the song 'Cab it Up' in Act 2 of the work, Brix Smith playing her guitar atop a giant hamburger. The work included a solo for Clark, dressed in a Celtic strip with football attached to his foot and a solo for Ellen van Schuylenburch, half of which she danced *en pointe* before removing her shoes, throwing them offstage and continuing the dance barefoot.

Because We Must
a film by Charles Atlas
1989

Director: Charles Atlas
Choreography: Michael Clark
Executive producer: Jolyon Wimhurst
Production management: Steven Scott
Distributors: Electronic Arts Intermix, Channel 4, London
Music: Frédéric Chopin, Dome, Graham Lewis, T. Rex, The Velvet Underground
Costume design: Bodymap, Leigh Bowery
Cast: Leigh Bowery, Leslie Bryant, Joachim Chandler, Michael Clark, Dawn Hartley, Matthew Hawkins, David Holah, Amanda King, Rachel Lynch-John, Russell Maliphant, Gisela Mariani, Leesa Phillips
Broadcast date: 1 January 1990, Channel 4, London

Wrong
1989

Director: Daniel Wiles
Producers: Frances Dickenson, Steve Jenkins for London Weekend Television
Choreography: Michael Clark and Stephen Petronio
Music: Big Hard Excellent Fish (Josie Jones/ Jake Walters/Robin Guthrie [producer])
Imperfect List (1990)
Costume design: Leigh Bowery
Cast: Michael Clark, Stephen Petronio
Broadcast date: 1989, The South Bank Show, 'Arts Review '89' (London Weekend Television)

Rights
1989

Choreography: Michael Clark
Company: Phoenix Dance Theatre
Music: Big Hard Excellent Fish, (Josie Jones/ Jake Walters/Robin Guthrie [producer])
Imperfect List (1990)
Costume design: Leigh Bowery, assisted by Lee Benjamin
Cast: Neville Campbell, Chantal Donaldson, Dawn Donaldson, Rick Holgate, Pamela Johnson, Booker T. Louis, Seline Thomas, Douglas Thorpe
Premiere date: 6 September
Premiere venue: Leeds Playhouse, Leeds
Performances (including): 19–20 October, Shaw Theatre, London; 9–13 October 1990, Sadler's Wells Theatre, London

Heterospective
1989

Choreography: Michael Clark
Music (including): Big Hard Excellent Fish (Josie Jones/Jake Walters/Robin Guthrie [producer]), Imperfect List (1990); Stephen Sondheim, 'Send in the Clowns', from **A Little Night Music** (1973), performed by Elizabeth Taylor; The Velvet Underground, 'Heroin', from **The Velvet Underground & Nico** (1967)
Costume design: Bodymap, Leigh Bowery
Production management: Steven Scott
Cast: Leigh Bowery, Michael Clark, Dawn Hartley, Russell Maliphant, Gisela Mariani, Pearl, Stephen Petronio
Premiere date: 14 October
Premiere venue: Anthony d'Offay Gallery, London
Performances: 14–24 October, Anthony d'Offay Gallery, London

Heterospective was performed over 10 days at the Anthony d'Offay Gallery, London. A press release for the production reads: 'The title refers to both the art gallery setting of the work and to the theme of the attraction of opposites which the piece will explore.' The work featured a central, intimate duet named 'Bed Peace' performed by Clark and his then-partner, American choreographer Stephen Petronio, with whom he would make work over the next two years. Clark's virtuoso solo to The Velvet Underground's 'Heroin', in which he wore a skin-coloured body suit covered in plastic hypodermic needles, would be revived for dancer Kate Coyne in the 2009 production of **come, been and gone**.

Solo
1990

Choreography: Michael Clark
Premiere date: 7 October (Dance Umbrella '90)
Premiere venue: Riverside Studios, London

Nicholas Dromgoole, writing for **The Sunday Telegraph**, 14 October 1990, reviewed Clark's dancer-less solo for Dance Umbrella '90: 'In the gala the irrepressible Michael Clark's solo was simply a large Nazi flag, crawling slowly across stage to our national anthem – a splendid use of movement and music to make a heavily loaded political point.'

Because We Must
tour
1990

Choreography: Michael Clark
Music (Part 1 Pure Pre-Scenes): Frédéric Chopin Piano Preludes nos: 2, 4, 13, 15, 16, 17, 18, 19, 20; Drostan Madden, taped collage (commissioned work); traditional pub song medley; The Velvet Underground, 'Venus in Furs', from **The Velvet Underground & Nico** (1967)
Music (Part 2 Over E): Michael Christobel, 'DemoCrappy'; The Fall, 'New Puritan' (1983); Jeffrey Hinton, taped collage (commissioned work); Graham Lewis, 'Pump', from **Hail!** (1987); commissioned tracks: Wire, 'Get Out of That Rain', 'Hole Instrumental' (1987); the national anthem of Great Britain; Sex Pistols, 'Submission', from **Never Mind the Bollocks, Here's the Sex Pistols** (1977); Stephen Sondheim, 'Send in the Clowns' (1973), performed by Elizabeth Taylor
Set design: Charles Atlas, Michael Clark
Costume design: Bodymap, Leigh Bowery, Michael Clark, Rifat Özbek
Lighting design: Charles Atlas
Cast: Joanne Barrett (joined tour in Brazil), Leigh Bowery, Bessie Clark, Michael Clark, Carol Foster, Rebecca Hilton, Julie Hood, Rachel Lynch-John, Alessandro Nahman, José Navas, Stephen Petronio
Premiere date: 23 November
Premiere venue: PARCO Department Store Theater, Tokyo (Tokyo International Theatre Festival)
Performances: 23 November – 2 December, PARCO Department Store Theater, Tokyo; 4 December, Osaka; 6 December, Nagoya

Prospero's Books
a film by Peter Greenaway
1991

Director: Peter Greenaway
Producer: Kees Kasander
Art department production: Sophie Fiennes
Production companies: Allarts Enterprises, Caméra One, Cinéa, Penta Pictures
Editor: Marina Bodbijl
Director of photography: Sacha Vierny
Choreography (for Caliban): Michael Clark
Cast: Michael Clark (Caliban), John Gielgud (Prospero)
UK release date: 30 August

Prospero's Books was Peter Greenaway's film version of Shakespeare's **The Tempest**. Greenaway cast Clark as his non-verbal Caliban and gave him responsibility for the choreography, costuming and interpretation of the role.

Modern Masterpieces
1991

Triple-bill programme with Stephen Petronio
Cosmic Over E (Clark, 1991)
MiddleSex Gorge (Petronio, 1990)
Wrong Wrong (Clark and Petronio, 1991)

Cosmic Over E
Choreography: Michael Clark
Music: Stephen Sondheim 'Send in the Clowns', from **A Little Night Music** (1973), performed by Elizabeth Taylor; T. Rex, 'Cosmic Dancer', from **Electric Warrior** (1971); Sex Pistols
Costume design: Bodymap, Leigh Bowery, Michael Clark
Lighting design: Charles Atlas

MiddleSex Gorge
Choreography: Stephen Petronio
Music: Wire, 'Ambitious Plus', original music by Gareth Jones arranged by Paul Kendal
Costume: H. Petal
Lighting design: Ken Tabachnick

Wrong Wrong
Choreography: Michael Clark, Stephen Petronio
Music: Igor Stravinsky, **The Rite of Spring** (1913)
Costume design: Leigh Bowery, assisted by Lee Benjamin
Lighting design: Charles Atlas

Cast: Joanne Barrett, Kristen Borg, Leigh Bowery, Kathleen Bowness, Gerald Casel, Bessie Clark, Michael Clark, Ori Flomin, Rebecca Hilton, Mia Lawrence, Jeremy Nelson, Stephen Petronio
Premiere date: 2 October
Premiere venue: Centre Pompidou, Paris
Performances: 2–6 October, Centre Pompidou, Paris (Festival d'Automne)

Modern Masterpieces was a collaborative project with Stephen Petronio, co-commissioned by the Centre National de Danse Contemporaine, Angers, the Festival d'Automne, Paris, and Dance Umbrella, London. A programme of three works was created by the choreographers during their joint residency at Angers: **Cosmic Over E** was choreographed by Clark, **MiddleSex Gorge** by Petronio and **Wrong Wrong**, choreographed together. This project cradled Clark's first exploration of Igor Stravinsky's **The Rite of Spring**, a score to which he would return in 1992 and again in 2006.

Rite Now
1992

Choreography: Michael Clark
Music (including): Sex Pistols, 'Submission', from **Never Mind the Bollocks, Here's the Sex Pistols** (1977); Stephen Sondheim, 'Send in the Clowns', from **A Little Night Music** (1973), performed by Elizabeth Taylor; Igor Stravinsky, **The Rite of Spring** (1913, orchestral score); T. Rex, 'Cosmic Dancer', from **Electric Warrior** (1971)
Cast: Can Arslan, Joanne Barrett, Leigh Bowery, Bessie Clark, Michael Clark, Matthew Hawkins, Julie Hood
Premiere date: 29 January
Premiere venue: PARCO Department Store Theater, Tokyo
Performances: 29 January–6 February, PARCO Department Store Theater, Tokyo; 8 February, Osaka; 10 February, Nagoya

Mmm...
1992

Choreography: Michael Clark
Company: Michael Clark & Company
Music (in original running order with interval between Act 1 and Act 2 of The Rite of Spring):
PiL, 'Theme', from **First Issue** (1978); Sex Pistols, 'Submission', from **Never Mind the Bollocks, Here's the Sex Pistols**, (1977); Stephen Sondheim 'Send in the Clowns', from **A Little Night Music** (1973), performed by Elizabeth Taylor; Igor Stravinsky, **The Rite of Spring** (1913, recording of orchestral score); T. Rex, 'Cosmic Dancer', from **Electric Warrior** (1971); The Velvet Underground, 'Venus In Furs', from **The Velvet Underground & Nico** (1967)
Set design: Michael Clark, Steven Scott
Costume design: Leigh Bowery
Lighting design: Charles Atlas
Type projection: Malcolm Garrett
Production: Sophie Fiennes
Cast: Joanne Barrett, Leigh Bowery, Bessie Clark, Michael Clark, Matthew Hawkins, Julie Hood
Premiere date: 25 March
Premiere venue: Nottingham Playhouse, Nottingham
Performances: January – February, Japan, preview tour as **Rite Now**, see above entry; 25–26 March, Nottingham Playhouse, Nottingham; 8–9 May, Theatre Royal, Brighton; 14–16 May, Cambridge Arts Theatre, Cambridge; 22–23 May, Crucible Theatre, Sheffield; 26–27 May, Blackpool Grand Theatre, Blackpool; 29–30 May, Newcastle Playhouse, Newcastle; 2–6 June, Tramway Theatre, Glasgow; 19–28 June, King's Cross Depot, London; c. 10 July (additional dates) King's Cross Depot, London; 29–30 September 1993, Théâtre Maisonneuve, Place des Arts, Montreal (Festival International de Nouvelle Danse)

Named **Michael Clark's Modern Masterpiece** during its early UK tour dates, **Mmm...** saw the re-launch of Michael Clark & Company after a UK absence of three years. The work included roles for Leigh Bowery and Clark's mother Bessie (as the Sage) and placed Stravinsky's monumental score alongside a montage of short punk and rock tracks, which came to form the prologue for the later productions of Clark's **Stravinsky Project**. A section choreographed to Elizabeth Taylor's rendition of 'Send in the Clowns' was also featured, with the cast dancing against a slow-motion slide-dissolve of the **Mona Lisa** into Andy Warhol's **Liz**. For its London performances the work was installed into the vaulted space of the King's Cross Depot, Clark explaining in the **Evening Standard**, 4 June 1992: 'It's as close to a cave as I could find in central London.' Based on the success of these King's Cross performances **Mmm...** won the 1992 **Time Out** award, with Joanne Barrett named 'Dancer of the Year' by the same magazine for her bravura performance of the Chosen Maiden solo.

Bog 3.0
1992

Choreography: Michael Clark
Company: Deutsche Oper Berlin
Music: Bruce Gilbert, 'Do You Me?', 'I Did' (1984); Wire, 'Feeling Called Love', from **Pink Flag** (1977)
Costume design: Michael Clark
Lighting design: Charles Atlas
Production management: Steven Scott
Choreographic assistant: Joanne Barrett
Répétiteurs: Michelle Braban, Ellen van Schuylenburch
Cast: Arantxa Argüelles, Franck Balbi, Christine Camillo, Vladimir Damianov, Xavier Ferla, Marie-Pierre Flechais, Maximiliano Guerra, Stefan Zeromski
Premiere date: 5 April
Premiere venue: Deutsche Oper Berlin,

Bog 3.0, a reworking of **Swamp** (1986), was commissioned by Peter Schaufuss, artistic director of Deutsche Oper Berlin.

O
1994

Choreography: Michael Clark
Company: Michael Clark & Company
Music: PiL, 'Theme', from **First Issue** (1978); Sex Pistols, 'Submission', from **Never Mind the Bollocks, Here's the Sex Pistols**, (1977); Igor Stravinsky, **Apollon Musagète** (1928)
Costume design: Leigh Bowery
Production design: Michael Clark, Steven Scott
Cast: Tammy Arjona, Shelley Baker, Bessie Clark, Michael Clark, Daniel Squire, Vivien Wood
Premiere date: 6 May
Premiere venue: Newcastle Playhouse, Newcastle
Performances: 6–7 May, Newcastle Playhouse, Newcastle; 12–14 May, Royal Northern College of Music, Manchester; 17–18 May, Crucible Theatre, Sheffield; 20 May, Oxford Playhouse, Oxford; 24–25 May, Theatre Royal, Brighton; 21–25 June, Brixton Academy, London; 29 July, Edinburgh Festival Theatre, Edinburgh (Edinburgh International Festival)

O was Clark's second engagement with a Stravinsky ballet and re-envisioned the composer's **Apollon Musagète**, a score definitively associated with George Balanchine's neo-classical **Apollo** of 1928. Clark reiterated his distinctively classical heritage across all aspects of the work's production. The centrepiece pose from Balanchine's Apollo/Terpsichore duet, drawn from Michelangelo's **Creation of Adam** for the Sistine Chapel, was restaged within a duet between Clark and Vivien Wood and a composite image of Clark and Michelangelo's **David** was produced for the tour's publicity flyer. The 1994 tour for **O** also formed the tenth anniversary celebrations for Michael Clark Company and Arts Council funding, acquired in the previous year, enabled the creation of a core group of dancers with whom Clark could develop his work.

Yet
1998

Choreography: Michael Clark
Cast: Michael Clark, Antonia Franceschi
Premiere date: May
Premiere venue: Sandfield Centre, Nottingham

After a three-year absence from dance-making and an eight-week course at the New York Film School, Clark prepared for his comeback by taking regular ballet classes with former tutor Richard Glasstone in the run-up to a series of new productions. With **Yet**, Clark created a duet for himself and former Balanchine dancer Antonia Franceschi that explored the clear and legible shapes of basic ballet technique. The only production design for the work was in the form of a solitary handbag suspended over the performance space: a gift from Leigh Bowery before his death in 1994.

~
1998

Choreography: Michael Clark
Spoken text: The Fall, 'The Classical', from **Hex Enduction Hour** (1983)
Cast: Michael Clark, Kate Coyne
Premiere date: July
Premiere venue: Queen Elizabeth Hall, London

~ was commissioned by British choreographer Jonathan Burrows for his curated programme at London's South Bank Centre and presented alongside works by choreographers including William Forsythe and Amanda Miller. The work was Clark's first collaboration with dancer Kate Coyne and marked a continued exploration of two formative influences: the basic lexicon of classical ballet and the lyrical trajectories of The Fall's Mark E. Smith.

current/SEE
1998

Choreography: Michael Clark
Company: Michael Clark Company
Music (Part 1 Y and The): composed and performed by Simon Pearson
Music (Part 2 Or): Susan Stenger, 'Waltz' (1998), performed by Susan Stenger
Music (Part 3 Trio ©): Susan Stenger, 'No. 2' (1997), performed by Big Bottom
Music (Part 4 The Handbag Theory): Susan Stenger, 'VPL' (1997), performed by Big Bottom
Costume design: Hussein Chalayan
Lighting design: Charles Atlas
Cast: Michael Clark, Kate Coyne, Julie Hood (after London Roundhouse performances), Lorena Randi, Dominik Schoetschel; Big Bottom: Angela Bulloch, Tom Gidley, J. Mitch Flacko, Susan Stenger (leader), Cerith Wyn Evans
Premiere date: 8 October
Premiere venue: Epsom Playhouse, Epsom
Performances: UK autumn tour: 8–9 October, Epsom Playhouse, Epsom; 13–14 October, Birmingham Rep Theatre, Birmingham; 19–20 October, Marlowe Theatre, Canterbury; 23–24 October, Oxford Playhouse, Oxford; 26 October, Theatre Royal, Bath; 30–31 October, Crucible Theatre, Sheffield; 3 November, Wycombe Swan Theatre, Wycombe; 5–8 November, Roundhouse, London (extra date added on the 8th); 10–11 November, Cambridge Arts Theatre, Cambridge; 13–14 November, Blackpool Grand, Blackpool; UK spring tour 2000: 10 May, Crucible Theatre, Sheffield; 12 May, The Hawth, Crawley; 14 May, Theatre Royal, Bath; 19–20 May, The Lowry, Salford

In autumn 1998 Clark invited the collaboration of musician Susan Stenger to devise original music for a new full-length production, **current/SEE**. Stenger composed a score that consisted of hyper-amplified rock riffs performed onstage by her all-bassist band Big Bottom, which included visual artists Angela Bulloch, Tom Gidley and Cerith Wyn Evans, as well as musician J. Mitch Flacko. Clark's choreography for this work continued to mine the technical stockpile of classical ballet while developing an increased vocabulary of contorted floor-work. The last section of the work was named for the same Leigh Bowery handbag that had appeared in **Yet** (1998) and that descended from above the stage in a scenographic minimalism that aligned with Hussein Chalayan's all-black costume designs.

The Late Michael Clark
a film by Sophie Fiennes
2001

Director: Sophie Fiennes
Choreography: Michael Clark
Producers: Sophie Fiennes, John Wyver (series producer for **TX**, BBC Two)
Editor: Zam Baring
Camera: (dance sequences) Reiner Van Brummelen
Music: Susan Stenger/Big Bottom
Cast: Michael Clark, Kate Coyne, Julie Hood, Lorena Randi, Dominik Schoetschel; Big Bottom: Angela Bulloch, Tom Gidley, J. Mitch Flacko, Susan Stenger (leader), Cerith Wyn Evans
Broadcast date: 23 February, 11.25 pm, BBC Two

The Late Michael Clark was a documentary portrait of Clark made by director Sophie Fiennes that charts the run-up to and tour of **current/SEE** (1998). After her direct involvement in producing Clark's original **mmm...** (1992) and **O** (1994), Fiennes took a personal and non-intrusive approach to documenting the rehearsals and daily routines that prepared for Clark's return to the stage.

fig-1
2001

Choreography: Michael Clark
Cast: Michael Clark, Richard Court, Lisa Dinnington, Victoria Insole, Lorena Randi
Premiere date: 2 July
Premiere venue: Notre Dame Hall, London

Clark was invited to perform at the launch of a commemorative book for the **fig-1** visual arts project. This was a year-long exhibition curated by Mark Francis, which commissioned work by 50 artists and exhibited over 50 weeks at a gallery space in London's Soho. Artists involved in the project included previous Clark-collaborators Hussein Chalayan, Grayson Perry and Cerith Wyn Evans. The performance venue of Notre Dame Hall boasted a fitting pedigree, having previously housed gigs by Wire and the Sex Pistols.

Before and After: The Fall
2001

Choreography: Michael Clark
Music (Part 1 Fall): The Fall, 'An Older Lover', 'Copped It', 'Gramme Friday', 'Hip Priest', 'Lie Dream of a Casino Soul', 'Ludd Gang', 'New Puritan', 'Prole Art Threat', 'Spector vs Rector 2'
Music (Part 2 Rise): Magazine, 'Boredom', 1978; PiL, 'Fodder; Stompf', 'Public Image', from **First Issue** (1978), and 'Four Enclosed Walls', from **Flowers of Romance** (1981); Primal Scream, 'Shoot Speed Kill Light', from **Xtrmntr** (2000, added for London 2001); Nina Simone, 'Four Women', from **Wild Is The Wind** (1966); Mikis Theodorakis, 'Zorba's Dance'
Set design: Trojan (Part 1 **Fall**); Sarah Lucas (Part 2 **Rise**)
Costume design: Leigh Bowery (Part 1 **Fall**); Sarah Lucas (Part 2 **Rise**)
Lighting design: Charles Atlas
Cast: Kerry Biggin, Richard Court, Lisa Dinnington, Melissa Hetherington, Victoria Insole, Lorena Randi
Premiere date: 17 August
Premiere venue: Hebbel Theatre, Berlin
Performances: 17–19 August, Hebbel Theatre, Berlin; 19–20 October, Lyceum Theatre, Sheffield;

24–28 October, Sadler's Wells, London;
2–3 November, His Majesty's Theatre, Aberdeen;
6 November, The Lowry, Salford; 13 November, Warwick Arts Centre, Coventry; 16–17 November, Corn Exchange, Brighton; 23–25 November, Teatro de Madrid, Madrid; 6 March 2002, Opera, Rouen, France; 23–26 May 2002, Theatre National de Chaillot, Paris

With **Before and After: The Fall** Clark both returned to his oeuvre of the 1980s and embarked on a new collaborative relationship with visual artist Sarah Lucas. The first half of the production presented a composite programme of early works to music by The Fall, incorporating sections from **New Puritans** (1984) and **not H.AIR** (1985). Costumes and props by Leigh Bowery and Trojan were also recreated for this retrospective. The second half of the programme was conceived with Lucas, for whom Clark had previously worked by gluing cigarettes to pieces for **The Fag Show**, her solo exhibition held at the Sadie Coles Gallery, London, in 2000. For their collaborative section 'Rise', Lucas constructed a huge mechanised cast of Clark's arm, which operated on stage as a giant articulation of the work's repeated theme of masturbation. Lucas's stage design was echoed in the increased choreographic use of arm work – discussed by Clark in an interview for **Artforum** in October 2001 as a deliberate development from the stripped-down aesthetic of **current/SEE** (1998).

For the performance in Rome in October 2001, the following two short pieces were added to the programme before the full performance:

Nature Morte
Music: Russell Haswell, Erik Satie
Production design: Sarah Lucas
Lighting design: Charles Atlas

R'n'R'n'R (or THE 3 Rs)
Music: an anthology of rock 'n' roll, including Bo Diddley and Primal Scream
Costume design: Hussein Chalayan
Lighting design: Charles Atlas

Satie Stud
2003

Choreography: Michael Clark
Company: George Piper Dances
Music: Erik Satie, **Prelude: Fêtes données par des Chevaliers normand en l'honneur d'une demoiselle**; **4 Ogives**
Costume design: Shelley Fox
Cast: William Trevitt
Premiere date: 25 March
Premiere venue: Queen Elizabeth Hall, London

Satie Stud was commissioned by Michael Nunn and William Trevitt (aka the Ballet Boyz) for their all-star programme **Critic's Choice*****
that also included works by Matthew Bourne, Akram Khan, Russell Maliphant and Christopher Wheeldon. For this understated solo Clark turned to the quiet 'furniture music' of Erik Satie. With Satie's piano compositions Clark developed material that had originally toured in the early versions of **Before and After: The Fall** and which would appear in productions over the next year.

Would, Should, Can, Did
2003

Choreography: Michael Clark
Company: Michael Clark Company
Music: Cerith Wyn Evans (sound concept)/Bruce Gilbert (sound realisation); Big Bottom, 'P.S.', arranged by Susan Stenger (live on stage); Can, 'Oh, yeah', from **Tago Mago** (1971); Erik Satie, **Prelude: Fêtes données par des Chevaliers normand en l'honneur d'une demoiselle**, **4 Ogives**; Nina Simone, 'Wild is the Wind', 'Four Women', from **Wild is the Wind** (1966); Susan Stenger, 'Sss'
Film (shown during interval): excerpt of live performance from **Can** (1972), directed by Peter Przygodda
Design: Sarah Lucas
Costume design: Hussein Chalayan, Prada
Light installation: Cerith Wyn Evans
Cast: Michael Clark, Melissa Hetherington, Lorena Randi, Tom Sapsford, Kimball Wong
Special guests include: Les Child, Bessie Clark, Kate Coyne, Pauline Daly, William Trevitt
Premiere date: 25 April
Premiere venue: Barbican Theatre, London

Produced as a one-off performance for the Barbican's multi-genre **Only Connect** season, **Would, Should, Can, Did** further showcased Clark's cross-disciplinary partnerships. The work played as a truly collaborative affair, with a light installation by Cerith Wyn Evans, music by Susan Stenger, sculptures by Sarah Lucas, costume design by Hussein Chalayan and Prada, and an appearance by gallery director Pauline Daly. In lieu of a conventional intermission, the audience was offered a screening of a rare documentary by film editor Peter Przygodda, showing the Krautrock band Can live in concert.

Rattle Your Jewellery
2003

Choreography: Michael Clark
Music: The Beatles, 'Back in the USSR', from **The Beatles/The White Album** (1968); Nina Simone 'Everyone's Gone to the Moon', from **And Piano!** (1969)
Costume design: Deanna Berg
Cast: Mikhail Baryshnikov
Premiere date: 22 May
Premiere venue: The Belding Theatre, Hartford, Connecticut
Performances: USA tour: 22 May, The Belding Theatre, Hartford, Connecticut; 28–29 May, Curtis M. Philips Center for the Performing Arts, Gainsville, Florida; 3 June, Hayes Hall, Naples, Florida; 6–7 June, McCarter Theater, Princeton, New Jersey; 12–14 June, Sirote Theater, Birmingham, Alabama; 17–18 June, Lobero Theater, Santa Barbara, California; 20–22 June, Zellerbach Playhouse, Berkeley, California; 25 June, Grand Opera House, Wilmington, Delaware; 28–29 June, James Rouse Theater, Columbia, Maryland; 2 July, Ann Arbor Summer Festival, Ann Arbor, Michigan; 21–22 July, Eldorado Showroom, Reno, Nevada; 25–26 July, Capital Theater, Columbus, Ohio

In 2003 Clark was invited to create a solo for Mikhail Baryshnikov for inclusion alongside works by Lucinda Childs and Eliot Feld in the legendary dancer's touring programme, **Solos with Piano or Not … An Evening of Music and Dance**. Clark composed **Rattle Your Jewellery** as a light-hearted yet technically challenging solo that would set Baryshnikov's assured classical virtuosity against the rock-pop sound of the Beatles' 'Back in the USSR'.

OH MY GODDESS
2003

Choreography: Michael Clark
Company: Michael Clark Company
Music (Part 1 Prologue): T. Rex, 'Childe', from **T. Rex** (1970)
Music (Part 2 Dreams): The Human League, 'The thing that dreams are made of', from **Dare** (1981)
Music (Part 3 Satie Stud): Erik Satie, **Prelude: Fêtes données par des Chevaliers normand en l'honneur d'une demoiselle**, **4 Ogives** (played live by Piano Circus: David Appleton, Kate Halsall, Semra Kurutac, Graham Rix)
Music (Part 4 Can, Did): Can, 'Oh yeah', from **Tago Mago** (1971)
Music (Part 5 OH MY GODDESS:) PJ Harvey, 'Dress', 'Water', from **Dry** (1992), 'Reeling', 'm.bike', from **Four Track Demos** (1993), 'To bring you my love', 'Meet ze monsta', 'I think I'm a mother', from **To bring you my love** (1995)
Music (Part 6 Submishmash): Sex Pistols, 'Submission', from **Never Mind the Bollocks, Here's the Sex Pistols** (1977)
Film (shown during interval): excerpt of live performance from **Can** (1972), directed by Peter Przygodda
Costume design: Michael Clark, Shelley Fox, Stevie Stewart
Wigs: Donald McInnes
Lighting design: Charles Atlas
Cast (premiere, 2003): Kerry Biggin, Michael Clark, Kate Coyne, Melissa Hetherington, Lorena Randi, Tom Sapsford, Simon Williams, Kimball Wong;
Cast (UK/European tour 2004): Kerry Biggin, Catherine Busk, Michael Clark, Kate Coyne, Melissa Hetherington, Lorena Randi, Tom Sapsford, Simon Williams, Kimball Wong
Premiere date: 1 October
Premiere venue: Sadler's Wells, London
Performances: 1–4 October 2003, Sadler's Wells, London; (UK/European tour, 2004:) 4 March, Theatre Royal, Glasgow (New Territories/New Moves Festival); 12 March, Brighton Dome, Brighton; 23–24 April, Oxford Playhouse, Oxford; 11–13 May, Sadler's Wells, London; 18 July, Kalamata, Greece (Kalamata Festival); 12–14 August, Hebbel Theatre, Berlin, (Internationales Tanzfest Berlin); 1 November, The Lyceum, Sheffield; 5 November, Carl-Orff-Saal, Munich (Dance 2004 festival)

After focusing with recent solos on material for male dancers, Clark explained the title for **OH MY GODDESS** in an interview with **The Independent**, 9 May 2004, as 'a testament to all the goddesses in my life'. The production marked a return to Clark's collaborative partnerships with Stevie Stewart (costumes) and Charles Atlas (lighting) and developed his exploration of a meticulous classicism in movement design against the amplified riffs of rock and punk. As with **Would, Should, Can, Did** (2003) Clark offered his audience a screening of **Can** live in concert, during the show's interval.

Alexander McQueen
Paris Fashion Week
2003

Design: Alexander McQueen
Choreography: Michael Clark
Cast (including): Melissa Hetherington, Lorena Randi, Tom Sapsford, Simon Williams, Richard Windsor
Date: October
Venue: Paris (Paris Fashion Week)

Clark was invited to choreograph the Paris catwalk show for Alexander McQueen's Spring/Summer 2004 collection. The show featured Depression-era designs and placed Clark's dancers in choreography alongside McQueen's models.

Look at that picture …
2003

Choreography: Michael Clark
Music (chosen and arranged by Susan Stenger): John Cage, **Fontana Mix** (1958), solo for flute, from **Concert for Piano and Orchestra** (1957-8); Susan Stenger, 'Diary of a Girl Lost', after Claude Debussy (1912); Edgard Varese, **Density 21.5** (1936)
Exhibition installation: Cerith Wyn Evans
Cast: Michael Clark, Melissa Hetherington, Simon Williams
Premiere date: 26 November
Premiere venue: White Cube, Hoxton Square, London

For his solo show, **Look at that picture … How does it appear to you now? Does it seem to be Persisting?** at the White Cube gallery in London's Hoxton Square (31 October – 6 December 2003), artist Cerith Wyn Evans invited Clark and Susan Stenger to stage a collaborative performance. As described by Suzanne Cotter in **Afterall 9**, 2004, the performance took place beneath Wyn Evans's exhibition of five crystal chandeliers, each designating a distinct historical period. The light fittings each flashed a Morse-code transmission of texts by one of five different writers (including John Cage and Eve Kosofsky Sedgwick), textual transcriptions of which were displayed on the wall-mounted monitors that framed the space. The coded light flashes that emitted from Wyn Evans's chandeliers punctuated both the flute solos performed by Stenger and the movement performed by Clark and new company members Melissa Hetherington and Simon Williams, creating a multi-formal collaboration for this one-off performance.

nevertheless, caviar
2004

Choreography: Michael Clark
Music: The Beatles, 'Back in the USSR', from **The Beatles/The White Album** (1968); Nina Simone 'Everyone's Gone to the Moon', from **And Piano!** (1969)
Costume design: Deanna Berg (Baryshnikov), Stevie Stewart (Clark and dancers)
Lighting design: Stan Pressner
Cast: Mikhail Baryshnikov, Michael Clark, Melissa Hetherington, Lorena Randi, Tom Sapsford, Simon Williams
Premiere date: 17 February
Premiere venue: Barbican Theatre, London

nevertheless, caviar was a revised version of Clark's earlier solo for Mikhail Baryshnikov's **Solos with Piano or Not … An Evening of Music and Dance**, which also featured Clark's **Rattle Your Jewellery** (2003). Clark expanded this work especially for its Barbican performances to include five extra dancers and a central duet for himself and Baryshnikov in which the two performed as doppelgängers, executing slow-motion transitions to Nina Simone's 'Everyone's Gone to the Moon'.

Alexander McQueen
Black
2004

Design: Alexander McQueen
Choreography: Michael Clark
Cast (duet): Michael Clark, Kate Moss
Date: 3 June

In association with sponsor AMEX, **Black** showcased a restaging of key moments from Alexander McQueen's fashion show history. The event included a short duet choreographed by Clark for himself and Kate Moss.

Nick Knight/ Alexander McQueen/ Michael Clark
MAC III
2004

film for SHOWstudio

Direction: Nick Knight
Art direction: Alexander McQueen
Choreography: Michael Clark
Styling: Katy England
Production: Gainsbury & Whiting
Cast: Glen Ball, Melissa Hetherington, Michela Meazza, Edward Hayes-Neary, Lorena Randi, Micheal Roznick, Tom Sapsford, Irad Timberlake, Simon Williams
Date: 30 July

A collaboration between Clark, Alexander McQueen and photographer Nick Knight, this short video was a filmic version of an image created for **Numéro** magazine. The project was broadcast through Knight's SHOWstudio website, which contains the film in its archives.

Swamp
2004

Choreography: Michael Clark
Company: Rambert Dance Company
Music: Bruce Gilbert, 'Do You Me?', 'I Did' (1984); Wire, 'Feeling Called Love', from **Pink Flag** (1977)
Costume design: Bodymap, Leigh Bowery
Lighting design: Charles Atlas
Cast: Simon Cooper & Peter Symonds, Angela Fowler & David Mack, Amy Hollingsworth & Alex Whitely, Mikaela Polley & Gemma Wilkinson
Premiere date: 22 September
Premiere venue: The Lowry, Salford
Performances: 22–25 September, The Lowry, Salford; 6–9 October, High Wycombe; 19–23 October, Theatre Royal, Newcastle; 2–6 November, Sadler's Wells, London; 10–12 November, Festival Theatre, Edinburgh; 16–20 November, Bath; 1–4 December, Theatre Royal, Plymouth

The revival of **Swamp** saw Clark's original work performed by the company for which it had been created almost two decades earlier. Mark Baldwin, artistic director of Rambert and original cast member of the 1986 performances, invited Clark to rework the production for a new generation of dancers, including Amy Hollingsworth for whom Clark would recreate his Chosen Maiden solo for **mmm…** (2006). The work went on to win the 2005 Olivier Award for Best New Dance Production.

A Physical Dialogue
2005

Choreography: Michael Clark
Exhibition: Sarah Lucas
Cast: Michael Clark, Pauline Daly, Vanessa Fenton, J. Mitch Flacko, Olivier Garbay, Sarah Lucas
Film recording: Nina Koennemann
Date: 11 September
Venue: Kunstverein, Hamburg

A Physical Dialogue was a performance at the Sarah Lucas exhibition **50 Works, 1900 to Present**, at the Kunstverein, Hamburg.

Stravinsky Project

Part 1

O

2005

Choreography: Michael Clark
Company: Michael Clark Company
Music (Part 1 OO): Iggy Pop, 'Mass Production', from **The Idiot** (1977); Wire, 'Mercy', from **Chairs Missing** (1978), 'Straight Line', 'Strange', from **Pink Flag** (1977)
Music (Part 2 O): Igor Stravinsky, **Apollon Musagète** (1928)
Conductor: Robin Ticciati
Orchestra: Aurora Orchestra, Thomas Gould (leader)
Original costume design: Leigh Bowery
Costumes: Stevie Stewart
Set design: Michael Clark, Steven Scott
Lighting design: Charles Atlas
Cast: Ashley Chen, Michael Clark, Kate Coyne, Melissa Hetherington, Alina Lagoas, Adam Linder, Tom Sapsford, Quang Kein Van; musicians for London, 2005
Premiere date: 1 November
Premiere venue: Barbican Theatre, London
Performances (O tour, 2005/6): 1–5 November, Barbican Theatre, London; 15–17 November, The Dramatyczky Theatre, Warsaw; 31 January–1 February 2006, Oxford Playhouse, Oxford; 7–8 February 2006, Lyceum Theatre, Sheffield; 9 February 2006, Quarry Theatre, West Yorkshire Playhouse, Leeds; 28 February 2006, Brighton Dome, Brighton; 2–3 March 2006, Nottingham Playhouse, Nottingham; 7–8 March 2006, The Point, Eastleigh; 11 March 2006, Tramway, Glasgow; 30 June – 1 July 2006, Marseille (Festival de Marseille); (**Stravinsky Project** tour, 2007/8:) 31 October–10 November 2007, Barbican Theatre, London; 9 May 2008, Norfolk and Norwich Festival; 4, 6 June 2008, Lincoln Center, New York

Stravinsky Project

Part 2

Mmm...

2006

Choreography: Michael Clark
Company: Michael Clark Company
Music (Part 1): PiL, 'Theme', from **First Issue** (1978); Sex Pistols, 'Submission' from **Never Mind the Bollocks, Here's the Sex Pistols** (1977); Wire, 'Mercy', from **Chairs Missing** (1978), 'Straight Line', 'Strange', '106 Beats That', '12XU', from **Pink Flag** (1977)
Music (Part 2): Igor Stravinsky, **The Rite of Spring for two Pianos** (played live)
Tour pianists (2007/8): Daniel Becker, Philip Moore, Sarah Nicholls, Huw Watkins, Andrew West
Set design: Michael Clark, Steven Scott
Original costume design: Leigh Bowery
Costumes: Michael Clark, Stevie Stewart
Lighting design: Charles Atlas
Cast: Joanne Barrett, Ashley Chen, Michael Clark, Kate Coyne, Fred Gehrig, Melissa Hetherington, Amy Hollingsworth (Chosen Maiden solo), Alina Lagoas, Adam Linder, Tom Sapsford, Daniel Squire, Simon Williams
Pianists: Philip Moore, Andrew West;
Tour cast (2007/8): Michael Clark, Kate Coyne, Melissa Hetherington, Patricia Hines, Amy Hollingsworth, Fiona Jopp, Adam Linder, James Loffler, Elisa Monguillot, Stefano Rosato, Hannah Rudd, Tom Sapsford, Andrea Santano
Premiere date: 27 October
Premiere venue: Barbican Theatre, London
Performances (Mmm... tour, 2006/7): 27–28, 30 October, 1–4 November, Barbican Theatre, London; 27–28 February 2007, Tramway, Glasgow; 19 May 2007, The Dome, Brighton; 25–26 May 2007, Lyceum Theatre, Sheffield; 1–2 June 2007, The Rep Theatre, Birmingham; 27 June 2007, Marseille (Festival de Marseille);
Performances (Stravinsky Project tour, 2007/8): 31 Oct – 10 Nov 2007, Barbican Theatre, London; 21–22 March 2008, La Luna de Maubeuge, Maubeuge, France; 28–29 March 2008, Maison des Arts, Creteil, France; 3–4 April 2008, Sherman Theatre, Cardiff; 10 May 2008, Norfolk & Norwich Festival; 5–7 June 2008, Lincoln Center, New York; 28–29 September 2008, Arko Arts Theater, Seoul, South Korea; 21–22 October 2008, Grand Théâtre de Luxembourg, Luxembourg; 30 October 2008, Grand Opera House, Belfast; 7–8 November 2008, Snape Maltings Concert Hall, Suffolk

Merce's Nurse

2006

Choreography: Michael Clark
Cast: Ashley Chan, Michael Clark, Fred Gehrig, Tom Sapsford
Premiere date: 5 November 2006
Premiere venue: Sadler's Wells, London

Merce's Nurse was a tribute performance by Michael Clark for Val Bourne on her departure from Dance Umbrella at a gala at Sadler's Wells.

Stravinsky Project

Part 3

I Do

2007

Choreography: Michael Clark
Music (Part 1 O): Igor Stravinsky, **Apollon Musagète** (1928)
Music (Part 2 Mmm...): Igor Stravinsky, **The Rite of Spring for Two Pianos** (score for two pianos)
Music (Part 3 I Do): Igor Stravinsky, **Les Noces** (1923)
Set design: Michael Clark, Steven Scott
Original costume design: Leigh Bowery
Costumes: Michael Clark, Stevie Stewart
Lighting design: Charles Atlas
Co-producers: Commissioned by **barbicanbite07**
Co-producers: Michael Clark Company,

barbicanbite07 as part of Dance Umbrella with Festival de Marseille (Parts 1, 2, 3) Danceworks UK (Parts 1, 2) and Seoul Performing Arts Festival (Part 1)
Cast: Ashley Chen, Michael Clark, Kate Coyne, Stephanie Elstob, Samuel Guy, Melissa Hetherington, Fiona Jopp, Stefano Rosato, Hannah Rudd, Andrea Santato, Kialea-Nadine Williams, Simon Williams, Kimball Wong
Conductor: Jurjen Hempel
Orchestra: Britten Sinfonia
Pianists: Daniel Becker (**I Do**), Philip Moore (**mmm...** and **I Do**), Huw Watkins (**I Do**), Andrew West (**mmm...** and **I Do**)
Choir: New London Chamber Choir (**I Do**)
Soloists: Sylvia Clarke (mezzo-contralto), Julian Close (bass), Constance Novis (soprano), Gediminas Varna (tenor)
Tour cast (2008): Eryck Brahmania (Lincoln Center, New York), Michael Clark, Kate Coyne, Melissa Hetherington, Amy Hollingsworth (Lincoln Center, New York), Fiona Jopp, James Loffler, Christopher Marney, Elsa Monguillot, Stefano Rosato, Hannah Rudd, Andrea Santato, Tom Sapsford, Alexander Whitley (Lincoln Center, New York), Simon Williams
Conductor: Jurjen Hempel
Orchestras: Britten Sinfonia (Norfolk & Norwich Festival), Orchestra of St Luke's (Lincoln Center, New York)
Pianists: Daniel Becker (**I Do**), Philip Moore (**mmm...** and **I Do**), Huw Watkins (**I Do**), Andrew West (**mmm...** and **I Do**)
Choirs: New London Chamber Choir (Norfolk & Norwich Festival), Concert Chorale of New York (Lincoln Center, New York)
Premiere date: 2 November
Premiere venue: Barbican Theatre, London
Performances: 31 October – 10 November, Barbican Theatre, London (**O**, **mmm...** and **I Do**); 9–10 May 2008, Norfolk & Norwich Festival (Programme One: **OO** and **O** [9 May]); (Programme 2: **mmm...** and **I Do** [10 May]); 4–7 June 2008, Lincoln Center, New York (Programme 1: **OO** and **O** [4, 6 June]); (Programme 2: **mmm...** and **I Do** [5, 7 June])

In 2005 Michael Clark became an Artistic Associate of the Barbican, London, a venue that Clark adopted as the base from which he would develop his **Stravinsky Project**. The venture consisted of a trilogy of works created to seminal dance scores by Igor Stravinsky, the works premiering at the Barbican in 2005, 2006 and 2007 and touring internationally as both individual pieces and a full-evening triptych in 2007/8. **Stravinsky Project** saw reworkings of two of Clark's early-1990s productions **O** (to Stravinsky's **Apollon Musagète**) and **mmm...** (to **The Rite of Spring**) as well as a brand new production, **I Do**, Clark's version of the Bronislava Nijinska ballet **Les Noces**. Marking a continuation of Clark's placement of live music at the core of dance performance, each production was accompanied at the Barbican by classical musicians ranging from a full orchestra (**O**) to **The Rite of Spring for Two Pianos** (**mmm...**) to a full choir presented onstage (**I Do**). In an interview with Donald Hutera for **Dance Umbrella News**, 29 October 2007, Clark reiterated the importance of his musical selection: 'Stravinsky's nature appeals to me because it's so quicksilver. It's full of surprises. He takes you down a path, but he's got a keen sense of when it's time to move on. And what a high it is to have live music!' A post-punk prologue section **OO** was developed for the first two years of the project, showcasing Clark's unique strand of classicism as an overture to the historical ballets he reimagined through Stravinsky.

come, been and gone
2009

First version
world premiere, Venice 2009
Swan Lack
Thank U Ma'am

Choreography: Michael Clark

Part 1
Swan Lack
Music: Bruce Gilbert, 'Do You Me?', 'I Did' (1984); Wire, 'Feeling Called Love', from **Pink Flag** (1977)
Costume design: Bodymap
Lighting design: Charles Atlas
Cast: Stephen Beagley & Oxana Panchenko, Simon Williams & Melissa Hetherington, Ellen van Schuylenburch & Clair Thomas, Benjamin Warbis & Kate Coyne

Part 2
Thank U Ma'am
Music: David Bowie, 'Aladdin Sane', 'The Jean Genie', from **Aladdin Sane** (1973), 'Future Legend', 'Chant of the Ever Circling Skeletal Family', from **Diamond Dogs** (1974), 'Sense of Doubt', from **Heroes** (1977), 'After All', from **The Man Who Sold the World** (1970); David Bowie/Brian Eno, 'Heroes', from **Heroes** (1977); Iggy Pop, 'Mass Production', from **The Idiot** (1977)
Costume design: Michael Clark, Stevie Stewart
Lighting design: Charles Atlas
Cast: Kate Coyne, Melissa Hetherington, Oxana Panchenko, Clair Thomas, Benjamin Warbis, Simon Williams
Premiere date: 25 June

Premiere venue: Teatro alle Tese, Venice (Venice Biennale)
Performances: 25–26 June, Teatro alle Tese, Venice (Venice Biennale); 11 July, Conjunto Arqueológico de Itálica, Itálica, Spain (Italica Festival Internacional de Danza); 15–18 July, Black Box Theatre, Galway, Ireland (Galway Arts Festival)

Second version
Edinburgh 2009, London 2009
and spring tour 2010

Choreography: Michael Clark

Part 1
Swamp
Music: Bruce Gilbert, 'Do You Me?', 'I Did' (1984); Wire, 'Feeling Called Love', from **Pink Flag** (1977)
Costume design: Bodymap
Lighting design: Charles Atlas
Cast: Stephen Beagley & Oxana Pnchenko, Simon Williams & Melissa Hetherington, Ellen van Schuylenburch & Clair Thomas, Benjamin Warbis & Kate Coyne

Part 2
come, been and gone
Music: David Bowie: 'Aladdin Sane', 'The Jean Genie', from **Aladdin Sane** (1973), 'Future Legend', 'Chant of the Ever Circling Skeletal Family', from **Diamond Dogs** (1974), 'Sense of Doubt', from **Heroes** (1977), 'After All', from **The Man Who Sold the World** (1970); David Bowie/Brian Eno, 'Heroes', from **Heroes** (1977); Iggy Pop, 'Mass Production', from **The Idiot** (1977); The Velvet Underground, 'Heroin', 'Venus in Furs', from **The Velvet Underground & Nico** (1967) [added at Barbican 2009], 'Ocean', from **VU** (1969/85) [added at Barbican 2009], 'White Light/White Heat', from **White Light/White Heat** (1968)
Costume design: Michael Clark, Stevie Stewart
Lighting design: Charles Atlas
Cast: Kate Coyne, Melissa Hetherington, Oxana Panchenko, Clair Thomas, Benjamin Warbis, Simon Williams
Premiere date: 28–31 August
Premiere venue: The Edinburgh Playhouse, Edinburgh (Edinburgh International Festival)
Performances: 2–3 October, Dansens Hus, Stockholm; 28 October – 7 November, Barbican Theatre, London; 10–11 May, Norwich Theatre Royal, Norwich (Norfolk & Norwich Festival); 18–19 May, Warwick Arts Centre, Coventry; 21–22 May, Sheffield Lyceum, Sheffield (in partnership with Danceworks UK)

I like my job
7964-949491

Third version
London 2010 and summer/autumn 2010 tour

An evening of two works in four acts

Part 1
gone
Act 1
Swamp
Music: Bruce Gilbert, 'Do You Me?', 'I Did' (1984); Wire, 'Feeling Called Love', from **Pink Flag** (1977)
Costume design: Bodymap

Part 2
come, been and gone
Act 2
been
Music: The Velvet Underground, 'Heroin', 'Venus in Furs', from **The Velvet Underground & Nico** (1967), 'Ocean' from **VU** (1969/85), 'White Light/White Heat' from **White Light/White Heat** (1968)
Costume design: Michael Clark, Stevie Stewart

Part 2
come, been and gone
Act 3
come
Music: David Bowie, 'Sweet Thing/Candidate/Sweet Thing (Reprise)', from **Diamond Dogs** (1974)
Lighting design: Charles Atlas
Costume design: Richard Torry
Lighting design: Charles Atlas

Part 2
come, been and gone
Act 4
come again
Music: David Bowie, 'Aladdin Sane', 'The Jean Genie', from **Aladdin Sane**, 'Chant of the Ever Circling Skeletal Family', 'Future Legend', from **Diamond Dogs** (1974), 'Sense of Doubt', from **Heroes** (1977), 'After All', from **The Man Who Sold the World** (1970); David Bowie/Brian Eno, 'Heroes', from **Heroes** (1977); Kraftwerk, 'Hall of Mirrors', from **Trans-Europe Express** (1977); Iggy Pop, 'Mass Production', from **The Idiot** (1977)
[For performances in Melbourne and Luxembourg, autumn 2010, and Glasgow and Cologne, spring 2011, the section previously performed to Iggy Pop's 'Mass Production' was replaced by a newly choreographed section performed to Kraftwerk's 'Hall of Mirrors'.]
Cast: Harry Alexander (excl. Brighton), Nathan Cornwell, Kate Coyne, Melissa Hetherington, Oxana Panchenko, Brooke Smiley, Benjamin Warbis, Simon Williams

Premiere date: 3 June 2010
Premiere venue: Barbican Theatre, London
Performances: 3–5, 7–12 June 2010, Barbican Theatre, London; 15 June 2010, Concert Hall, Brighton Dome, Brighton; 8–10 October 2010, State Theatre, Melbourne (Melbourne International Arts Festival); 9–12 November 2010, Grand Théâtre de Luxembourg, Luxembourg; 7–9 April 2011, Tramway, Glasgow; 14–15 April 2011, Schauspiel, Cologne

come, been and gone saw a sustained association with the Barbican as well as a new commissioning relationship with the Venice Biennale and Dansens Hus, Stockholm. Within the double programme of **Swamp** and an eponymous section of brand-new material (initially billed at its Venice premiere as **Swan Lack** and **Thank U Ma'am**, respectively), Clark first returned to material he had been developing since **Do you me? I Did** with Ellen van Schuylenburch in 1984 and next proceeded to a fresh exploration of the music of three rock icons: David Bowie, Iggy Pop and Lou Reed. In an interview with Judith Mackrell for **Dance Umbrella News**, 1 July 2009, Clark contextualised his engagement with rock's 'holy trinity' as an extension of his recent working process: 'I have been thinking in threes a lot, and after the trilogy of Stravinsky I was interested in the trilogy of Iggy Pop, Lou Reed and Bowie. When I listen to **Aladdin Sane** I think I can hear **The Rite of Spring** in there.' Over its touring period, **come, been and gone** evolved through three distinct versions, its third incarnation including paintings by Peter Doig, hung from the flies and marking a new collaborative venture for Clark. During this time Clark continued to consolidate his work with a core group of dancers who would inherit the vocabulary and style that he had developed over his career. The expert solo danced by Kate Coyne to The Velvet Underground's 'Heroin', reworked from a solo danced in 1989 by Clark as part of **Heterospective**, offered a particularly striking affirmation of the choreographer's performance legacy.

First published in 2011 by Violette Editions,
an imprint of Violette Limited

Violette Limited
25 Lexington Street
London W1F 9AG
England
T: +44 (0)20 7734 5843
www.violetteeditions.com

Edited and devised by Suzanne Cotter and Robert Violette
Produced by Robert Violette
Editorial adviser for Michael Clark Company,
Ellen van Schuylenburch
www.michaelclarkcompany.com

Design and art direction by Studio Frith
www.studiofrith.com

Editorial assistance by Tamsin Perrett
Editorial research by Arabella Stanger
Picture research by Suzanne Cotter, Arabella Stanger,
Ellen van Schuylenburch, Robert Violette and Jo Walton
Interview transcription by Karen Garratt
Copy-editing and proofreading by Stephen Patience and Ariella Yedgar
Retouching and re-press assistance by Steve Evans
Chris Harris photographs printed by Robin Bell

Pre-press and digital retouching by Violette Editions
Printed and bound in China

Copyright © 2011 Violette Limited
Essays © 2011 the authors
Photographs © 2011 the photographers
Art direction and design © 2011 Studio Frith

All rights reserved. No part of this publication
may be reproduced in any form or by any electronic
or mechanical means (including photocopying,
recording or information storage and retrieval)
without permission in writing from the publisher.

ISBN 978-1-900828-33-8
A CIP record for this book is available from the British Library

The views and opinions expressed in this book do
not necessarily represent those of the publisher or its
employees and affiliates. Where the identity of a contributor
is unknown or incomplete, efforts have been made to
identify and contact contributors.

Pages of this book are printed on recycled paper,
made with 50–75% post-consumer waste or are printed
on certified virgin fibre (FSC and/or other standard).

Endpapers: **THE END** and **INTERMISSION**, created by Malcolm Garrett
for stage projections and the printed programme for Michael Clark's
come, been and gone, 2009, Barbican Centre, London;
pages 236–37: from the programme for **OH MY GODDESS** (2003),
created by Scott King; pages 18–19: Cheesecake, courtesy Image Source/Alamy;
pages 206–07, Pot Noodle, photographed by Robert Morris.